free

D0605463

CALIFORNIA COLLEGE OF ARTS AND CRAFTS ★ THE LIBRARY ★

WITHDRAWN

free

THE SECOND PAINTER'S PROBLEM BOOK

THE SECOND PAINTER'S PROBLEM BOOK

BY JOSEPH DAWLEY AS TOLD TO GLORIA DAWLEY

CALIFORNIA COLLEGE OF ART AND CRAFTS * THE LIBRARY *

WITHDRAWN

WATSON-GUPTILL PUBLICATIONS, NEW YORK
PITMAN PUBLISHING, LONDON

751.45
D38
S43

MAR 25 1980 80-164

First published 1978 in the United States and Canada by Watson-Guptill Publications,
a division of Billboard Publications, Inc.,
1515 Broadway, New York, N.Y. 10036

Published in Great Britain by Pitman Publishing Ltd.,
39 Parker Street, London WC2B 5PB
ISBN 0-273-01209-6

Library of Congress Cataloging in Publication Data
Dawley, Joseph.
 The second painter's problem book.
 Continues The painter's problem book.
 Bibliography: p.
 Includes index.
 1. Painting—Technique. 2. Artists' materials.
3. Painting—Themes, motives. I. Dawley, Gloria,
joint author. II. Title.
ND1500.D38. 1977 751.4'5 77-27427
ISBN 0-8230-4749-0

All rights reserved. No part of this publication may be
reproduced or used in any form or by any means—graphic,
electronic, or mechanical, including photocopying, recording,
taping, or information storage and retrieval systems—
without written permission of the publishers.

Manufactured in Japan

First Printing, 1978

Our heartfelt thanks to a few people who helped make this book possible. In particular, our special thanks go to Rita, Toot, Ronnie, Cindy, and Cathy.

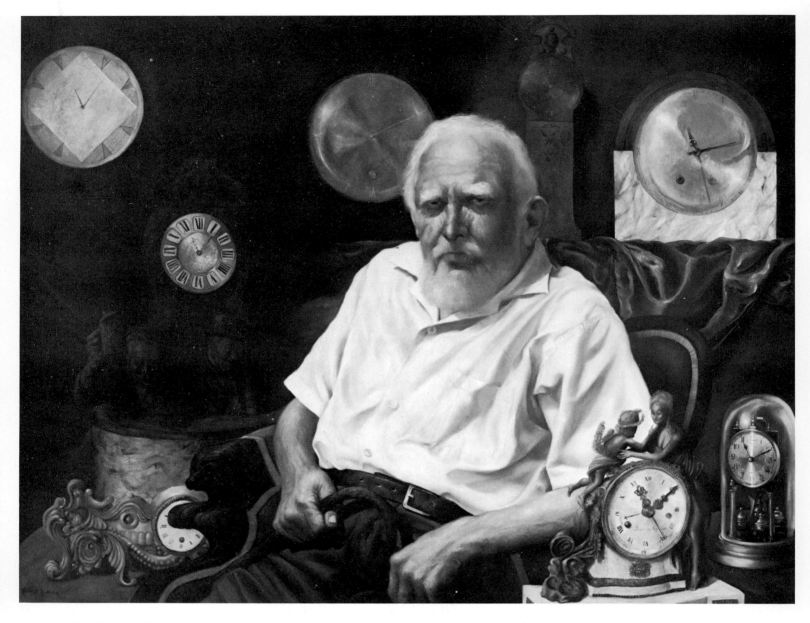

The Clock Collector, *oil on Masonite, 30" x 40" (76 cm x 102 cm), collection of A. Schecterman. This painting combines many of the techniques discussed in the book. The striated surface of marble is evident on the upper right hand clock and the base of the table on the lower left. Notice how the glass was rendered on the faces of the clocks, especially the dome-shaped one on the lower right. Lush velvet fabric contrasts the cottony fabric the gentleman wears.*

CONTENTS

INTRODUCTION 9

MATERIALS AND METHODS 13

Painting Mediums 13

Colors 13

Palette and Knives 15

Brushes 15

Painting Surfaces 16

Painting Methods 16

Other Tips 17

DEMONSTRATION 1. COPPER TEA KETTLE 21

DEMONSTRATION 2. BRASS UMBRELLA STAND 27

DEMONSTRATION 3. PEWTER 33

DEMONSTRATION 4. DUSTY LANTERN 39

DEMONSTRATION 5. PEELING PAINT 45

DEMONSTRATION 6. CONCH SHELL 51

DEMONSTRATION 7. STRAW BASKET 57

DEMONSTRATION 8. PORCELAIN BOWL WITH DESIGN 63

DEMONSTRATION 9. CRYSTAL BOWL WITH FLOWERS 69

DEMONSTRATION 10. MARBLE 75

DEMONSTRATION 11. GLASS OF WATER WITH ICE 81

DEMONSTRATION 12. CONDENSATION DROPLETS ON GLASS 87

DEMONSTRATION 13. VELVET BERET 93

DEMONSTRATION 14. HEAVY FABRIC WITH DESIGN 99

DEMONSTRATION 15. ROSES 105

DEMONSTRATION 16. APPLES 111

DEMONSTRATION 17. GRAPES 117

DEMONSTRATION 18. WATERMELON 123

DEMONSTRATION 19. PEACHES 129

DEMONSTRATION 20. FIREPLACE 135

SUGGESTED READING 141

INDEX 142

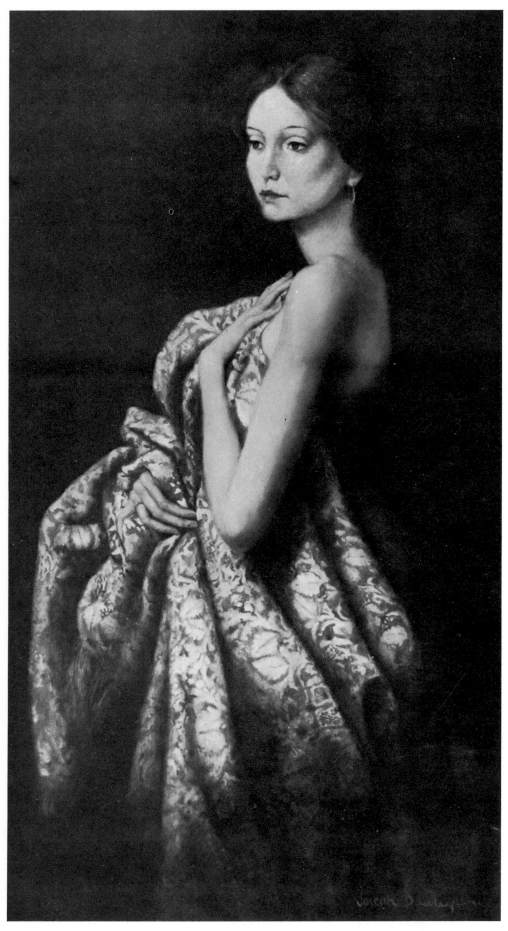

Girl in Green, *oil on canvas, 15" x 30" (38 cm x 76 cm), private collection. This is the entire painting of the heavy fabric with design demonstration. Not only is it a study in rendering texture, but it provides a good contrast to the delicate bone structure of the girl. It is also important to note how heavy fabric drapes on the figure.*

INTRODUCTION

This book is designed to help you master the skills you need in order to paint twenty realistic subjects in oil. In my first book, *The Painter's Problem Book*, I painted twenty difficult subjects in step-by-step demonstrations, but as you know the list of challenging realistic subjects is far greater than twenty. As a result, I have thought hard and long about the types of subjects most artists have difficulty painting and want to know how to paint, and have written this sequel to my first book.

Have you ever tried to capture the movement of a roaring fire? Or have you ever wondered how to paint the texture of peeling paint, or the softness of rose petals? Maybe you've attempted to paint the complex patterns in a straw basket or the intricate designs in a heavy fabric. These are tricky subjects, but, nevertheless, they can be mastered and I will show you how. In the introduction to each demonstration in this book, I list all the colors on my palette and explain how I mix them and what I use them for. I also tell what brushes I prefer and why, as well as what painting surface I use. In addition, I offer some painting tips on techniques to use—ones which have been helpful to me and which I hope will be useful to you. Then, as I paint each subject, I explain in complete detail just how I go about building up the form and bringing it to a finish so it looks convincing and real.

You may even want to copy these demonstrations. This is an acceptable way of learning and I have heard of some artists who have done that with the demonstrations in my first book, and had great success. But I also think you can learn a great deal simply by studying the techniques I use in each demonstration and then by incorporating them into your own paintings. Obviously you will use these demonstrations in a way best suited to your personal learning and painting style, but I do hope that however you use this book, it will help and encourage you to paint many more realistic subjects in oil.

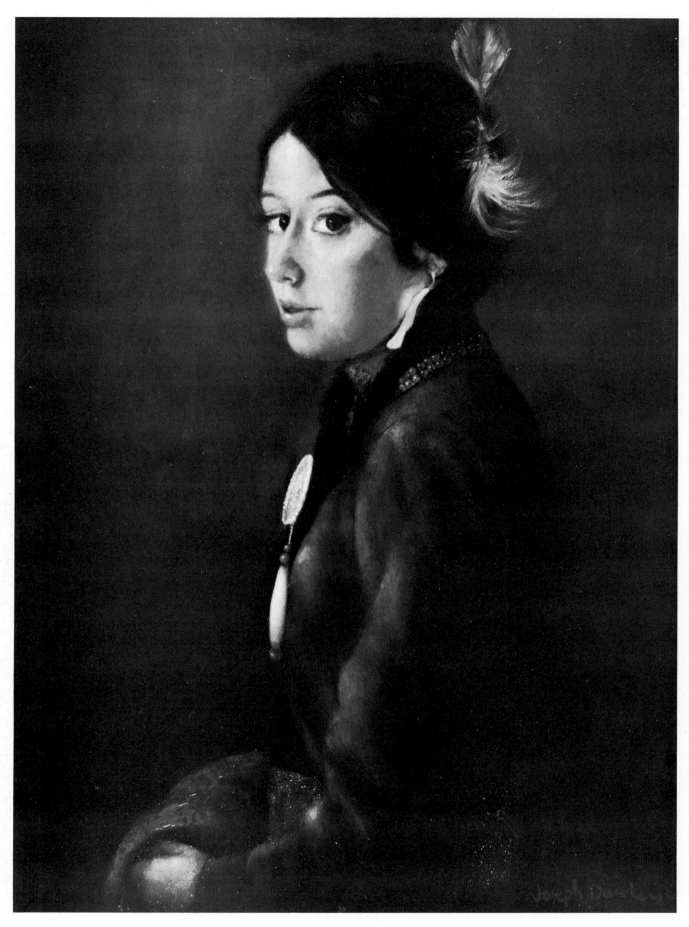

Crow Maiden, *oil on canvas, 18" x 24" (46 cm x 61 cm), private collection. There are several rendering problems to consider here: the feather in the girl's hair, the glass beads around her neck, and the lush heavy fabric of her dress. Although there is a soft, muted look to the painting, highlights were essential here to convey the various textures.*

MATERIALS
AND
METHODS

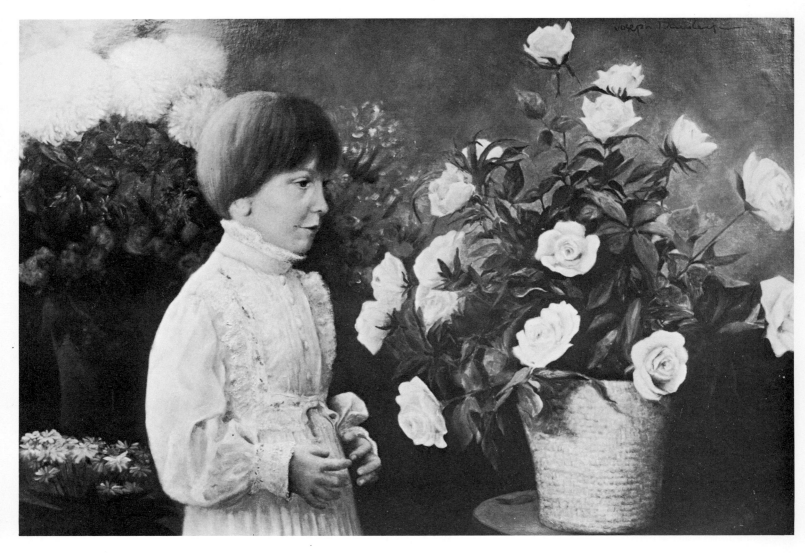

In the Flower Shop, *oil on canvas, 24" x 36" (61 cm x 91 cm), collection of Mr. and Mrs. Jack Weiner. This painting contains several studies in texture. Compare the smoothness of the rose petals, the brittle surface of the straw basket, and the folds on the child's dress. Notice the difference in the soft fabric of the dress as opposed to the stiffness of the lace trim.*

MATERIALS
AND METHODS

Like most artists, I have certain materials, colors, and painting methods that I prefer to use. I believe it would be helpful to see what I work with and to define some of the techniques I use throughout the demonstrations.

Painting Mediums
These are the painting mediums I like to use, plus some notes on their important characteristics.

Copal. I prefer Taubes copal mediums: Light, Heavy, and Copal concentrate. Generally, I use the light in the early stages of the painting, saving the heavy and copal concentrate for the later stages.

Damar. I mix my own medium using a formula of one part Damar varnish (5 lb. cut), one part stand oil, five parts gum turpentine, and one drop of cobalt drier per every two ounces of medium. Sometimes I use a heavier mixture identical to this one except it contains four parts gum turpentine.

Win-Gel. This Winsor and Newton thixotropic (a synthetic resin-based, oil-modified medium that speeds up drying considerably) painting medium in a tube helps speed up the drying of paint.

Oleo Pasto. This jelly in a tube is another thixotropic painting medium that is even faster-drying than Win-Gel and is also produced by Winsor and Newton.

Liquin. A Winsor and Newton thixotropic medium in a bottle that is liquid in form rather than jelly.

Turpentine. I use this as a medium only in the earliest stages of any painting.

Varnishes. The only varnish to put on a freshly painted work is retouch. A final varnish may be applied after a year or more depending on the thickness of the paint. For a spray retouch varnish I've had good luck with Grumbacher retouch varnish (damar). For a brush on (which I usually do), I use Winton Retouch Varnish (Winsor and Newton), but there are many other good brands. I use about a 1″ (2.5 cm) wide sable for brushing on retouch varnish. The only problem with this is when the brush gets old it sometimes starts to lose hairs, and when this happens, I immediately discard it.

For a final varnish I've had good results with Damar Copal, but I now recommend Winton Picture Varnish (Winsor and Newton) or some other new reliable colorless synthetic varnish.

Colors
These are the colors I use throughout the demonstrations:

Underpainting White. I use Winsor and Newton though there are probably other good brands. It is a titanium-based, thixotropic white that dries extremely fast. I use it basically for underpainting and scumbling, but it is very permanent and, according to tests I have conducted over a period of years, will not yellow.

Flake White. My favorite brand, made by Utrecht Linens, is pure lead carbonate ground in linseed oil. Unfortunately, other flake whites are ruined because of their zinc additives. This is because paint companies are not run by painters. The workability of pure lead carbonate is so much better because of its drying power, but this white has two drawbacks:

1. It's poisonous. Be careful not to get paint on anything you might stick in your

mouth (such as the end of the brush). Also, prolonged usage without adequate ventilation may be dangerous.

2. It yellows. My tests show it yellows to a certain degree, then stops. However, I claim no expertise and advise the artist not to use this in the final stages of a painting in which a yellowing effect would be harmful to the color of the painting.

Cremnitz White. Winsor and Newton brand is excellent, and I use it especially for the finishing stages of painting people. However, it has a high oil content, and because of the oil used (safflower) it is better not to paint over it or cracking may occur. My tests on this color only date back to 1974, but I find very little or no yellowing depending on what medium is used. This is strictly an educated guess, but I believe if used with good thixotropic painting mediums such as Win-Gel or Liquin, there would be no yellowing or very little, if any.

I like this particular paint because of its rapid drying and heavy workability. For those who wish to paint like an old master (who doesn't?) it's great, especially for painting people. It did not lend itself to many of the problems in this book, but sometimes when the term flake white is used (especially in the final stages), cremnitz can be substituted. Like flake white, it is poisonous because it is a basic lead carbonate white, so the same precautions should be taken for safety.

Ultramarine Blue. Not only a great blue, but it mixes well too. Mixed with raw umber, it makes a good, basic black; with cadmium red deep, a subtle purple or violet; with alizarin crimson or rose madder, a brighter purple or violet. It is used in all sorts of mixtures throughout this book, and is rated as a good durable color. I believe it to be even more permanent than some of the colors rated absolutely permanent, but time will tell. I combine it with Venetian red often as a good neutral purple underpainting color.

Phthalo Blue. A beautiful dye, though it has a few drawbacks. It is so strong you should use very little when mixing with other colors. Also, it will color your turpentine and is extremely hard to get off your brushes. It is worth it, however, when you require its vivid color. Mixed with yellow ochre and burnt sienna or Venetian red it makes a terrific brown.

Cerulean Blue. This color is very high in oil content, and is very permanent. I seldom use it except when mixed with other colors for backgrounds or Indian jewelry, etc. Neither this nor cobalt blue should be used for underpainting because of the very high oil content.

Rose Madder. Rose madder is reputed to be more permanent than alizarin crimson in tints or glazes. I think it's a better color; it's also a lot more expensive. I use Winsor and Newton's rose madder deep.

Alizarin Crimson. May be as good as rose madder except in tints and glazes, and is almost identical in color and texture.

Venetian Red. One of my favorite colors—an earth color with much more vibrance than burnt sienna. I use it so often in this book it needs no more explanation.

Cadmium Red, Cadmium Red Light, and Cadmium Red Deep. I use these colors not only throughout the demonstrations in this book, but in skin tones when painting people. They also mix well with other colors.

Cadmium Orange. This is not only a beautiful color, but it also mixes well. With ultramarine blue it makes a great brown.

Burnt Sienna. An excellent permanent earth color that I use more in painting people than in the demonstration pieces in this book.

Burnt Umber. Good for glazing more than anything else. A permanent warm brown earth tone.

Raw Sienna. A very permanent earth color used throughout the demonstrations in this book. Mixed with ultramarine blue, it makes a great brown. I always use it for portraits.

Raw Umber. In this book I do not distinguish between the different types of raw umber. This is one of my favorite colors and rather than tell you each time which one I use, I'll let you be the judge. Half the time I use the Winsor and Newton raw umber, which is a Cypress umber more greenish in tint by comparison to the warmer American brands. It is a matter of preference; I use both—oftentimes in the same painting. It is absolutely permanent.

Paynes Gray. A blue-black mixture that I occasionally use, mostly for backgrounds and glazes.

Transparent Yellow Ochre. Similar to raw sienna except more transparent. One of my favorites.

Yellow Ochre. I'd be lost without it. It is a subtle yellow earth color used frequently throughout this book.

Naples Yellow. A great color for toning down certain other colors. A good mixer but it contains lead.

Cadmium Yellow, Cadmium Yellow Light, and Cadmium Yellow Deep. These are good bright yellows that mix well with other colors. They usually need to be toned down except when you want something very bright such as in the fireplace demonstration.

Lemon Yellow. A more subtle lighter color, this is especially good in delicate situations such as in the yellow rose demonstration.

Chromium Oxide Green. A beautiful opaque green that is absolutely permanent. There is nothing quite like it.

Terre Verte. This is a more subtle transparent earth green.

Viridian. The permanence of this color is its biggest asset, though it doesn't hold a candle to sap green for sheer color.

Sap Green. This is a green that Winsor and Newton rates as a good durable color. I love its beautiful color and cannot resist using it. It is a transparent dye-type color with a very high oil content and should be used only in overpainting—never underpainting.

Ivory Black. This is my favorite black. It is a cool black and absolutely permanent according to color makers. I have a few doubts, but have to take the word of the experts. It should never be painted over with any other color unless it is mixed with some other color. For example, a black and white gray can safely be glazed over with raw umber. The thixotropic painting mediums seem to have a good effect on this color and make it more usable in its raw form.

Palette and Knives
The standard use of the wooden palette is for the birds from this artist's viewpoint. I use a paper palette and throw away the paint when I'm finished with it. These tear-away paper palettes are great time-savers and can be found at any good art store.

 Use whatever palette knife is most comfortable for you. The only time I use one is when I'm mixing colors on my palette. I tend to use any knife that's handy because particular palette knife characteristics aren't important to me.

Brushes
I use several types of sable or bristle brushes to achieve many different effects in my paintings.

#2 Watercolor Brush. This is a favorite of mine. I use both Grumbacher and Winsor and Newton, giving a slight edge to Grumbacher for the point they seem to maintain. These brushes are inconsistently manufactured, and one is likely to be far superior to another. Occasionally one will separate in the middle and become impossible to use. These brushes are wonderful detail brushes, and I would feel lost without them. When rinsed with turpentine after each use and carefully

pointed again, these brushes can last a long time. *Do not* leave these brushes in a jar of turpentine for any length of time because they become bent and may be impossible to reshape. Treat them with care and they will do the job for a long time. *Do not* scrub with these brushes. They are precision tools meant to do intricate detail. The long-handled brushes that paint companies put out especially for oil paint are not as useful as these.

Bristle. I use only filbert, naturally curved brushes because they give me the results I want. Sometimes the old brushes serve as the best tools for scumbling. An occasional washing with Ivory soap and water may be good for these brushes if they are not scrubbed too hard. Be sure and wash them out well after doing this. I find the shorter-hair brushes do the best job for rendering texture.

Brights. These flat sables otherwise known as brights are my favorites for glazing, tinting, and thin painting—usually at the end of a painting. I use them in all sizes and do not hesitate to put them aside when they begin to lose hairs. This can ruin a painting.

Fan Brushes. You will have to find a good art store to obtain one of these. They come in sable and bristle. I prefer the sable in most cases, but have both available always. I use it for fur, grass, and all sorts of things, but it is not a brush I use frequently.

Cleaner for Brushes. Though many people may disagree with me, I have never found anything as good as gum turpentine. However, be sure you have proper ventilation. Continuous use of this cleaner without adequate ventilation over the years could prove to be a health hazard.

Brush Holders. A large coffee can or glass jar will do the job. Just be sure the handle is down and the brush is up, otherwise you will get bent brushes. This may sound absurd, but I've seen artists do it.

Rags. I use white rags about 12″ to 16″ (30.5 cm x 41 cm) square (just a personal preference). Keep them within reach at all times.

Painting Surfaces

There are two types of surfaces that I like to work on, hardboard panels and canvas, and here are some of their characteristics:

Hardboard Panels. Masonite brand is a sure bet here, but there may be other brands just as reliable. If you want to be safe, buy the untempered variety, but I do not think the tempered hardboard is unsafe. The truth is nobody knows for sure.

For a primer I use acrylic gesso by simply wiping it on with a rag in several thin coats. Each coat, of course, has to dry completely before the next one is applied. To be safe, wait a day between each coat if you wish to try this method. I give the back of the board one good coat with a bristle paint brush. When the painting is completely finished and all the edges have been sanded well, I use raw umber or some other fast drying paint to "edge" the painting, that is to paint all around the outside. I don't believe in leaving one of the four sides unpainted so that the board can "breathe." However, it probably won't hurt to leave one edge raw (unpainted) as long as the painting is backed with paper.

Canvas. I use Belgian linen and buy it raw. It is then sized with rabbit skin glue (the directions are on the sack if you buy from Utrecht Linens) mixed with water. I then use Winsor and Newton Oil Painting Primer (it comes in cans) applied with a large bristle brush. After this first coat has dried, sand the surface, but be sure to sand it lightly. Then another coat is applied if needed.

Painting Methods

These are the painting methods I use throughout the demonstrations:

Underpainting. This is the first layer of paint which should not have too high an oil content. A good way to start is just to use turpentine as your medium in this early stage if you have a technique similar to mine.

Overpainting. This is the final painting brushed over what is already there. It is simply painting over an already dry surface of paint. It should be high in oil content. Keep in mind the fat over lean method—that is to say, use paint with as much oil content as used in earlier stages of the painting.

Glazing. Transparent painting done with painting medium over a dry surface of paint.

Tinting. Semi-transparent painting done with the use of painting medium over a dry surface of paint.

Dabbing. This is a method of placing the brush, loaded with paint, onto the painting surface and then lifting it back up. Dabbing is my own term and really is just what it sounds like. It is usually done to produce a certain textural effect—like that found in a shag rug, grass, etc.

Scumbling. This is a technique of "dragging" fresh paint across a partially dry, tacky surface. It can be done with either a bristle or sable brush and allows some excellent "controlled accidents." It can be applied in glazing, tinting, or overpainting, and is extremely effective in getting translucent wet-into-wet results. In other words, while you are overpainting in this scumbling method, you can get the impasto (wet-into-wet) painting method and also get translucence at the same time.

Fat Over Lean. To avoid cracking canvases, you should know the oil content of each paint you use. Paint with less oil content, such as yellow ochre, should not be applied over paint with a high oil content, such as raw umber. This rule is not as strict as it sounds. You can get away with it except in cases where there is a great difference in oil content.

Other Tips
Here are extra painting tips that will help you paint more effectively.

Removal of Brush Hairs. Unfortunately, brushes are not as well made as they should be, and often we spot an unsightly brush hair in the painting. To remove these I use a straight pin, and sometimes tweezers.

Paint Buildup. If you've made an error in brushstrokes and the paint is too heavy to paint over, put the painting away for a few weeks. When you're sure it's good and dry, then sand it down with sandpaper.

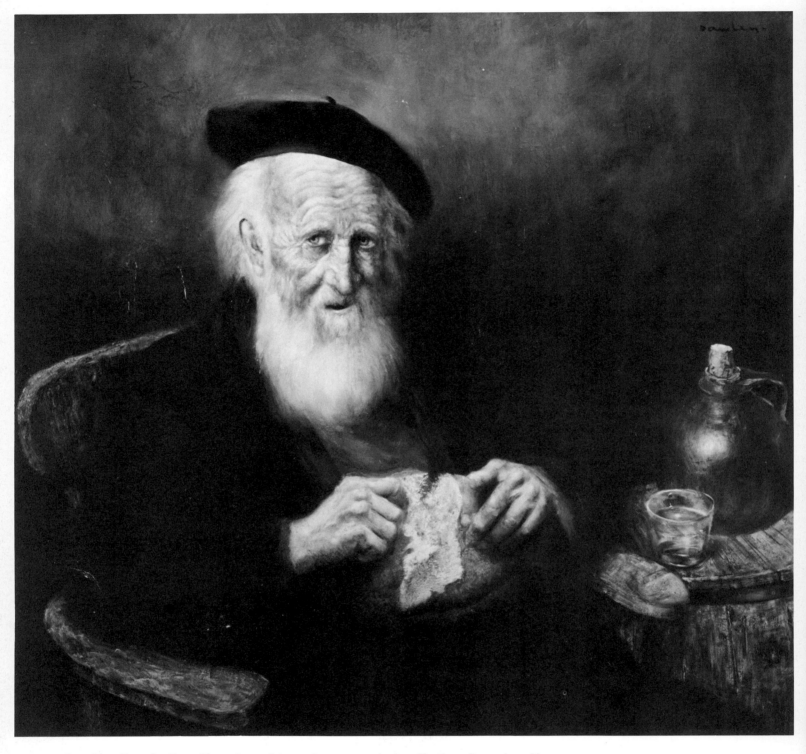

Breaking Bread, *oil on Masonite, 36" (91 cm) square, private collection. Several problem subjects are presented in this painting. I have tried to contrast the bread's spongy interior texture with its hard outer crust. I rendered the glass in the same manner as the glass of water with ice demonstration. The key to rendering glass, or any reflective surface, is to capture the highlights.*

DEMONSTRATIONS

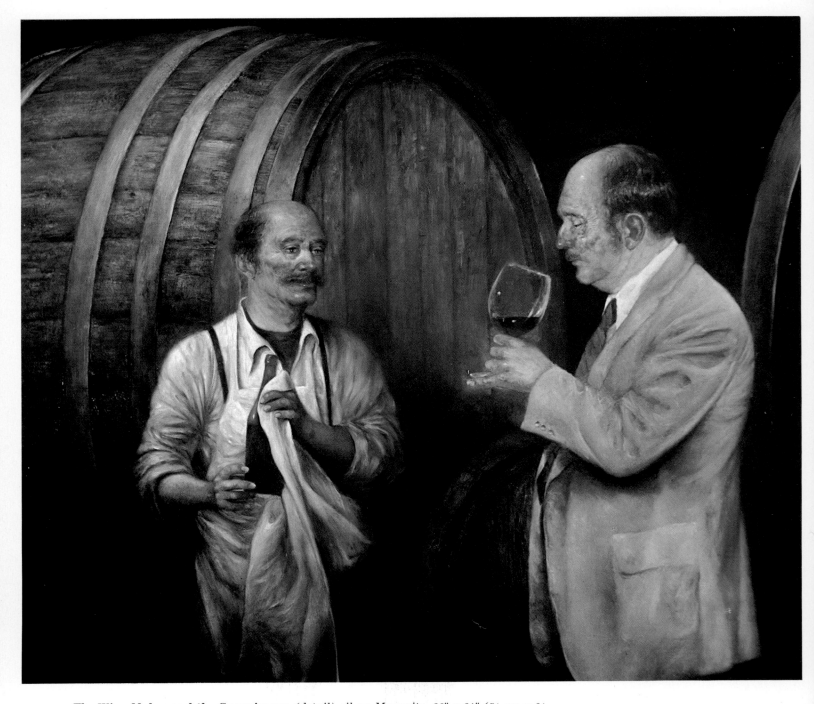

The Wine Maker and the Connoisseur, *(detail) oil on Masonite, 20" x 24" (51 cm x 61 cm), collection of Dr. and Mrs. Wayne Ramsey. Copper is more difficult to render than other metals, which you will see when you read the next demonstration. For example, the iron bands around this wine barrel are a lot easier to render because they don't have any reflections. They are done primarily with a mixture of ultramarine blue, raw umber, and flake white.*

DEMONSTRATION 1

COPPER TEA KETTLE

The chief problem in this demonstration is to render the color of the copper kettle. While copper looks orange and certainly has an orange cast, there are many other colors reflected in the surface. It is important to see these colors and paint them into the basic copper in order to solve this painting problem.

Palette
Ultramarine blue
Cadmium orange
Naples yellow
Raw umber
Raw sienna
Flake white

Color Mixtures

1. Ultramarine blue and raw sienna are mixed for the initial dark reflections.

2. Naples yellow and flake white are combined for the first stage of the light highlights.

3. Raw umber, ultramarine blue, and flake white are the preliminary colors of the wooden handle.

4. Naples yellow and raw umber are blended for a greenish tone in the handle.

5. Raw sienna and raw umber are mixed for the brown in the underpainting.

6. Cadmium orange and ultramarine blue create a dark reflection.

7. I mix raw umber and ultramarine blue for the black in the spout and under the kettle, and for the shadow on the table.

8. Raw umber, ultramarine blue, and flake white are combined for the background.

9. Raw umber, cadmium orange, and ultramarine blue are blended for the brown in the hot plate.

10. Cadmium orange and raw sienna are used for the final glaze of the kettle.

11. Ultramarine blue and cadmium orange are mixed together for some of the final dark reflections.

12. Raw umber and cadmium orange are combined for the remaining final dark reflections.

Brushes
I use bristle brushes to render the bold strokes I prefer for the underpainting in this demonstration, and use sable brushes to render the smoother strokes needed when glazing.

 1/8″ (.32 cm) flat sable
 1/4″ (.64 cm) flat sable
 3/8″ (.95 cm) flat sable
 1/4″ (.64 cm) naturally curved bristle
 3/8″ (.94 cm) naturally curved bristle
 #2 round watercolor brush with fine point

Painting Surface
Since the copper kettle has a very smooth shiny surface, it makes sense to choose a smooth painting surface. So I use 1/8″ (.32 cm) untempered Masonite, thinly coated with gesso.

Painting Tips
The surface of a copper kettle is highly reflective, so don't hesitate to paint in a lot of highlights even in the underpainting stage. It is better to overdo them in the early stages, since they can easily be subdued later on, if necessary.

Stage 1. My palette consists of cadmium orange, Naples yellow, ultramarine blue, flake white, and raw sienna. My painting medium is turpentine.

First, using a 3/8″ (.95 cm) flat sable, I brush in the general shape of the kettle with thinned raw sienna. To emphasize the darkest tones, I use unthinned raw sienna for the shadow under the lid and on the right side of the kettle. Then I mix ultramarine blue with the raw sienna for the dark streak on the far left.

Next I begin to paint in an orange tone on the spout and right half of the kettle using thinned cadmium orange. All of the work up to this point has been done with a 3/8″ (.95 cm) flat sable brush. For the very large light highlight on the left half of the kettle, I mix Naples yellow and flake white, and brush it on rather thickly with a 3/8″ (.95 cm) naturally curved bristle brush. I move on to Stage 2 while this stage is still wet.

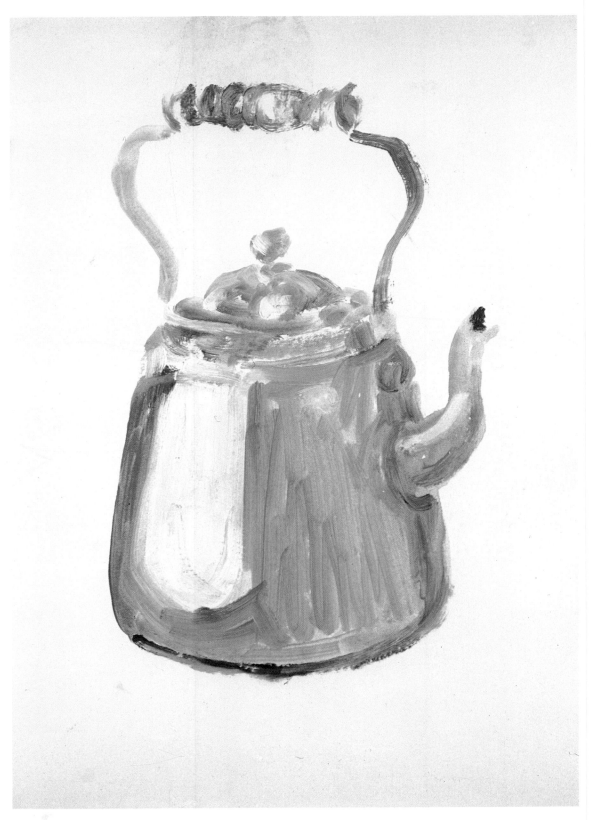

Stage 2. My palette is the same in this stage except for the addition of raw umber. Turpentine is still my painting medium. I use 1/4″ (.64 cm) and 3/8″ (.95 cm) naturally curved bristle brushes.

I continue to define the various parts of the kettle, and primarily strengthen the underpainting, which produces the complex tones in the copper color.

I add the handle and render the wooden center portion with raw umber mixed with a little ultramarine blue and white. Naples yellow mixed with raw umber creates a greenish tone which I use for the left side of the handle. This greenish tone is also added in a few spots on the lid

and brushed under the large light reflection on the kettle itself. For the right side of the handle, I mix a brown which is a combination of raw sienna and raw umber. This same brown is brushed in along the far left side of the kettle, along the lower portion, and into parts of the top.

The dark reflection along the right side of the kettle and under the spout is a mixture of cadmium orange and ultramarine blue. Raw umber and ultramarine blue create the black which I paint inside the spout and under the kettle. Finally, I smooth out the light reflection on the left and deepen the orange on the right with cadmium orange. While this stage is wet I go right into Stage 3.

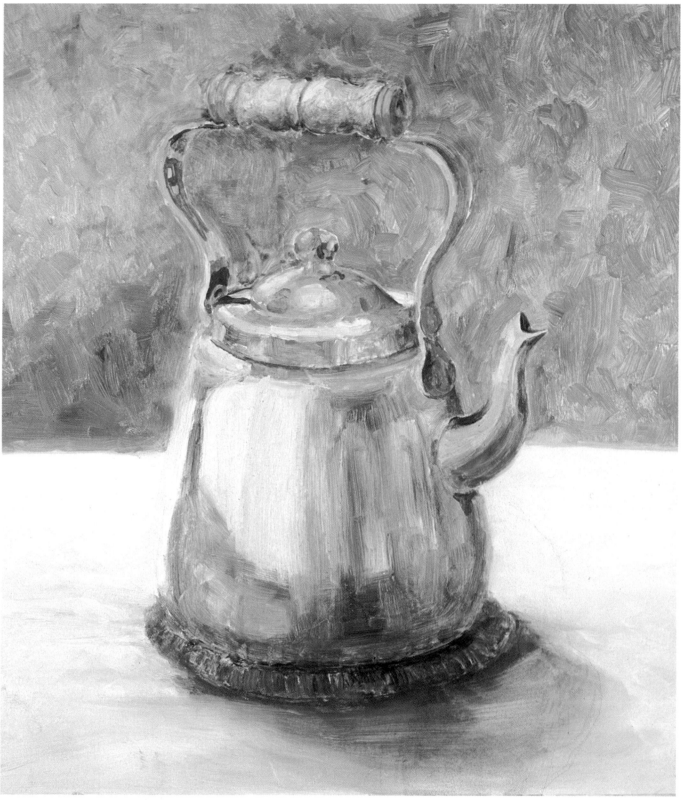

Stage 3. My palette remains the same and I add no new brushes. The painting medium changes to Winsor and Newton Win-Gel and Winsor and Newton Oleopasto.

Using a combination of raw umber, ultramarine blue, and flake white, I brush in the background. The white table is basically flake white with various tones of raw umber and ultramarine blue worked in for variation. I use a combination of raw umber and ultramarine blue for the shadow cast by the kettle on the table, and then I blend the mixture into the table color.

To render the brown portions of the hot plate, I mix raw umber, cadmium orange, and ultramarine blue. I reserve raw umber alone for the darkest portions, and dab on white for the lightest small streaks. I paint in the wooden handle much more thoroughly with a combination of raw umber and white.

Now I will paint the actual copper areas. At this point, my main concern is to try and capture the copper's highly reflective surface, so I use all the colors on my palette to render the various reflections which produce the effects of copper. I let this stage dry before moving to Stage 4.

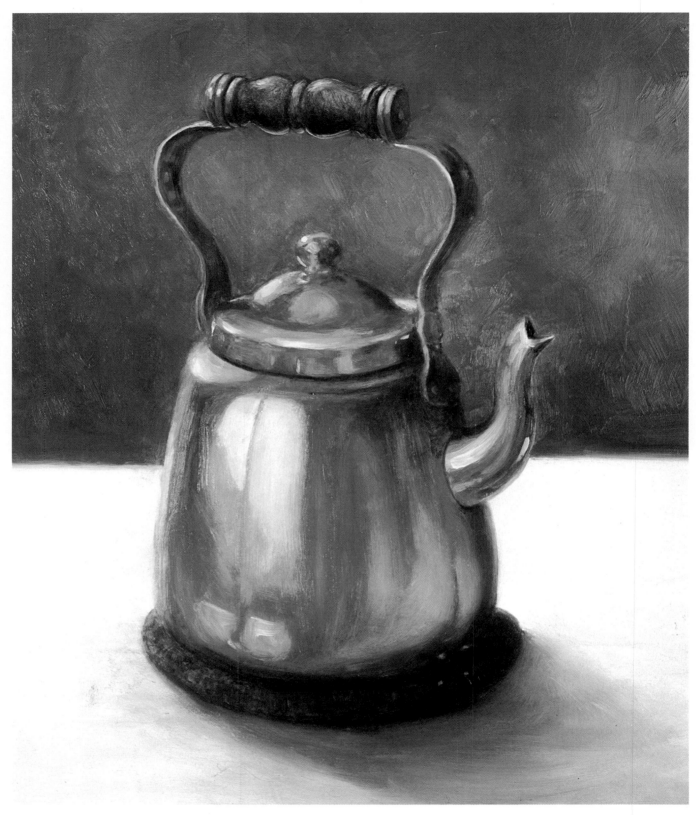

Stage 4. I do not add any colors to my palette in this stage, but I've changed my painting medium to Liquin. My brushes are: a #2 watercolor brush and two flat sables, a 1/8″ (.32 cm) and a 1/4″ (.64 cm).

I finish the background by smoothing it over with a combination of raw umber, flake white, and ultramarine blue. With raw umber and ultramarine blue, though mostly ultramarine blue, I render the shadow on the table more precisely.

To complete the hot plate, I glaze over it with raw umber. I finish the brown wooden handle with a mixture of raw umber and white and use pure white for the highlights. The kettle is finished with a glaze of cadmium orange and

raw sienna over the entire copper portions. Then I proceed to paint into this glaze in the following manner.

I use two mixtures to accentuate the dark reflections. The dark areas that have a slightly bluish cast, such as some of the vertical streaks in the center and the darks on the lower left part of the lid, are accentuated with ultramarine blue and cadmium orange. For the dark brown areas on the far left and right sides of the kettle, I use a combination of raw umber and cadmium orange. The very darkest areas, like those directly under the lid and underneath the kettle are raw umber and ultramarine blue. For the bright highlights, I use either flake white alone or dots of cadmium orange.

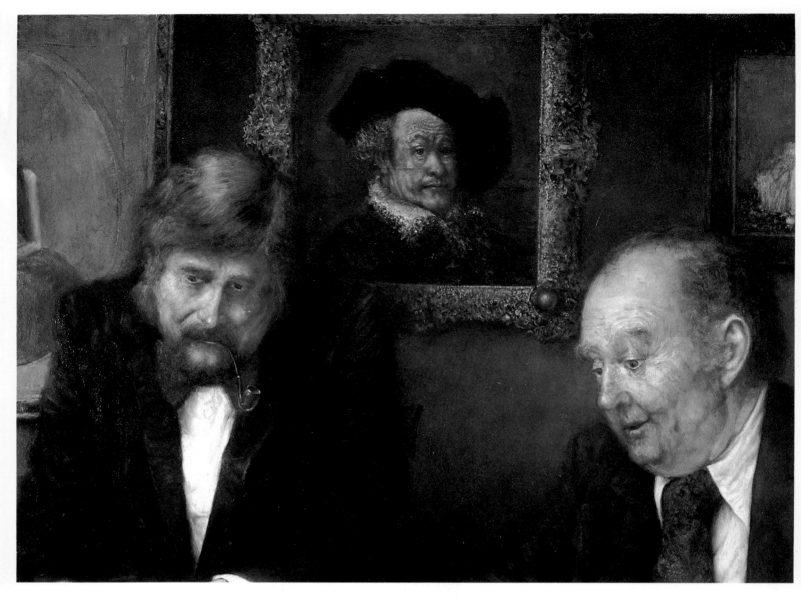

The Connoisseurs, *(detail) oil on Masonite, 30" x 40" (76.2 cm x 102 cm), collection of Mr. and Mrs. William Burford, Texas Art Gallery, Dallas. Painting the gold carved frame in back of the two gentlemen presents an entirely different problem from painting brass. For one thing there are no pronounced reflections in gold as in brass, especially in this type of antique gold leaf. For another, the gold is a deeper color with more browns in the darker areas. Yellow ochre, raw umber, and cadmium yellow deep with some burnt umber glazing at the finish were the main colors I used here.*

BRASS UMBRELLA STAND

Like copper, the problem with brass is to render its unique color while capturing the various colors reflected in its surface. In addition, the surface of brass is not only highly reflective but is also very smooth and polished, and should be rendered so.

Palette
Ultramarine blue
Phthalo blue
Venetian red
Cadmium red deep
Viridian green
Naples yellow
Cadmium yellow
Yellow ochre
Raw umber
Raw sienna
Flake white

Color Mixtures
1. Yellow ochre, Naples yellow, and flake white form the initial brass color.
2. Raw umber and phthalo blue are mixed for my initial shadow color and dark fabric color.
3. Flake white is mixed with the shadow mixture for the first stages of the background.
4. Raw umber, viridian green, and flake white are mixed for the final background.
5. Raw umber and ultramarine blue create the final black fabric color and the darkest shadows and reflections on the stand.
6. Raw sienna and ultramarine blue are blended for the lighter reflections.
7. Yellow ochre and cadmium yellow mix to create the final brass tone.

Brushes
I work exclusively with sable brushes since everything I will render is smooth. Specifically they are:
 1/8" (.32 cm) flat sable
 1/4" (.64 cm) flat sable
 3/8" (.95 cm) flat sable
 #2 round watercolor brush with fine point

Painting Surface
Since the brass umbrella stand is a smooth, slick object, I purposely choose a smooth gessoed Masonite panel to work on. A textured surface would only complicate the rendering.

Painting Tips
When painting reflections on a highly polished, shiny surface like brass, I try not to capture every minute detail in the reflection. Instead, I "fake" the reflection by putting in colors where I think they will most effectively produce a reflective surface.

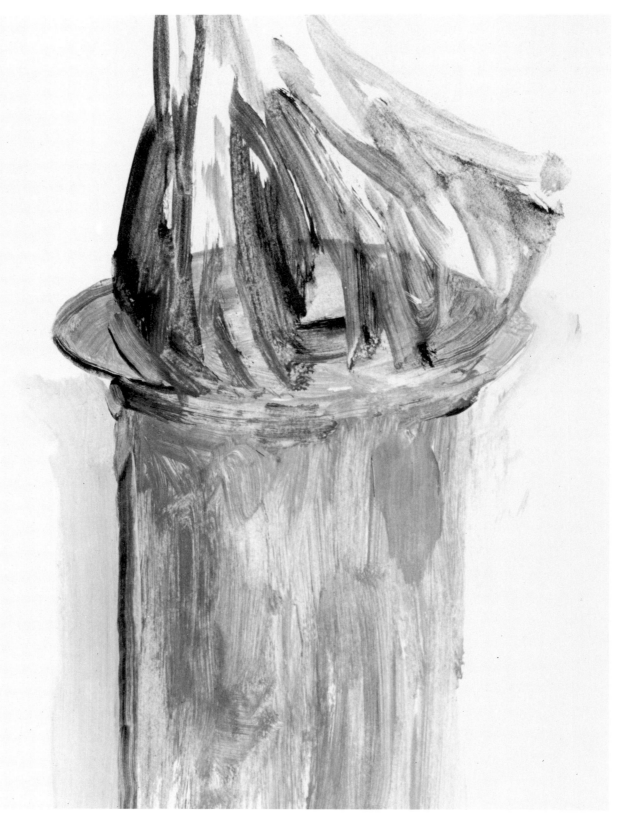

Stage 1. My palette consists of yellow ochre, Naples yellow, flake white, raw umber, and phthalo blue. Turpentine is my painting medium at the moment.

The subject of the painting is a brass umbrella stand with a striped umbrella in it. I will not explain the umbrella handles because they were not pertinent to the problem. In this stage my main interest lies in capturing the general shapes, tonal effects, and values.

With my palette colors I create two mixtures. First, I mix yellow ochre, Naples yellow, and flake white for the initial yellow brass tone. Then I combine raw umber and phthalo blue for the shadows on the brass.

Using a 3/8″ (.95 cm) flat sable, I begin to brush in the shape of the stand with the yellow mixture. To render the dark shadows, such as on the left side and around the lip, I brush the dark mixture into the shadowy areas with a 1/4″ (.64 cm) flat sable. For the beginning of the background, I add white to the shadow mixture and brush this lightly around the stand. To capture the general position and shape of the umbrellas, I use raw umber and a 1/4″ (.64 cm) flat sable. I move on to Stage 2 immediately while this is still wet.

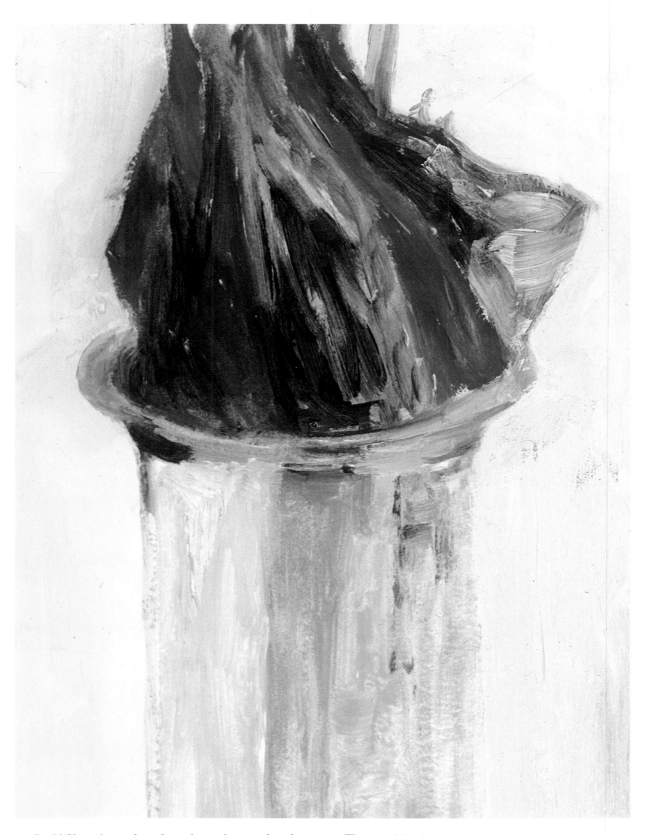

Stage 2. I add Venetian red to the palette, but my brushes and painting medium remain the same.

In this stage, I lay the color groundwork for the red and black striped umbrella. Also, I define the umbrella stand a bit. For the umbrella fabric, I use Venetian red for the red part, darkened with the shadow mixture described in Stage 1, where it is in shadow. I use the shadow mixture for the dark fabric, adding white where the lighter areas appear.

The stand begins to acquire a bit more of its rounded shape through the use of dark shadows and reflections. To strengthen the yellow portions add yellow ochre. The shadow color is used both thinly and thickly for the varying degrees of shadow tone and for the vertical reflections seen on the stand. I continue on to the next stage while this is still wet.

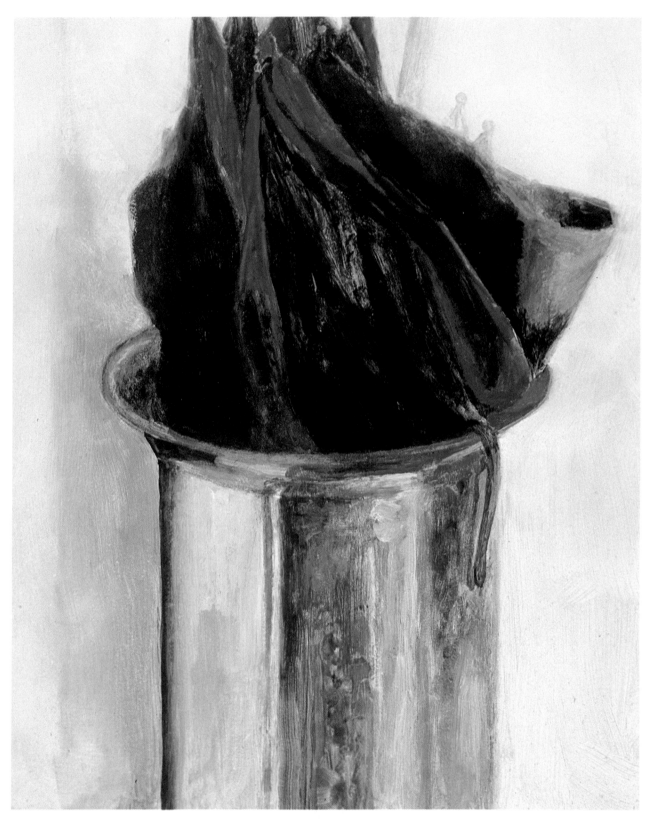

Stage 3. My palette, mixtures, and painting medium remain the same, but I add a #2 watercolor to my brushes.

Even though this stage is quite a bit more advanced than Stage 2, nothing new or different is done; Stage 2 is simply embellished upon. To complete the background I use the original background mixture from Stage 1, and add more shadow mixture where a darker shade is needed. The background includes the corner in which the stand is sitting and the shadow on the wall cast by the stand and umbrella.

The umbrella cloth is worked in the same manner as in Stage 2, until it acquires a more finished appearance. On the umbrella stand, I strengthen the vertical reflections very strongly with the shadow color mixture. Notice that this is the darkest on the left side of the reflection and gradually lightens toward the right, helping to capture the roundness of the object. In between these reflections I strengthen the brass by adding more yellow ochre and work in some white to indicate the lighter shiny reflections found there.

As for the rim, I render its form with the same colors used in the base, the darkest portions again being the shadow color mixture. The outermost lip is emphasized with both white and the darkened brass color streaked on with a #2 watercolor brush. This stage remains wet as I move on to the next stage.

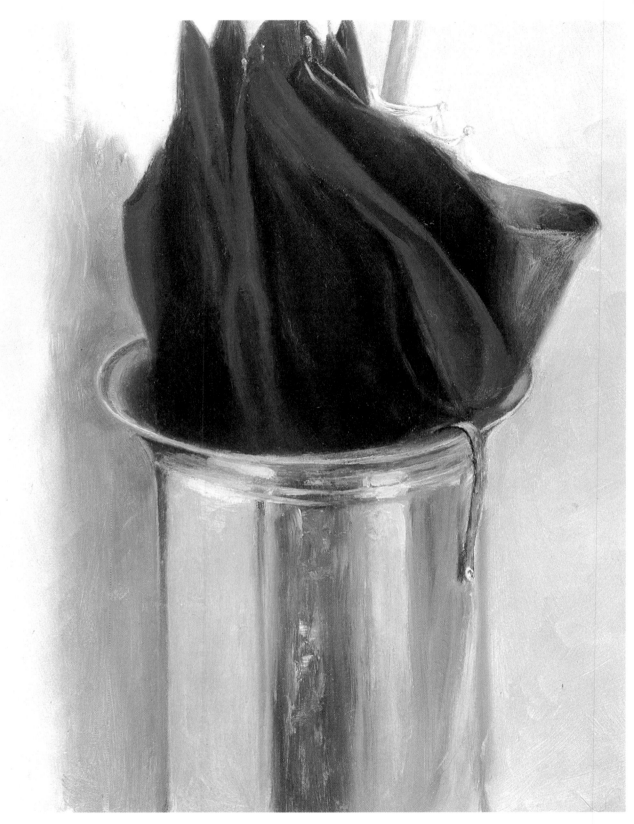

Stage 4. My painting medium changes to Winsor and New-
ton Liquin. I add a 1/8″ (.32 cm) flat sable to the brushes,
and ultramarine blue, viridian green, cadmium yellow, cad-
mium red deep, and raw sienna to my palette.

For the background I mix raw umber, viridian green, and
flake white, adding more raw umber where the tone needs
to be darker. The black part of the umbrella fabric is ren-
dered with raw umber and ultramarine blue with a little
flake white added for the lighter portions. For the red part,
I use cadmium red deep with a little yellow ochre brushed
in for the highlighted areas.

On the stand itself, the very darkest shadows and reflec-
tions, such as the thin streak on the far left, the large

center reflections, and some of the dark spots under the lip,
are a mixture of raw umber and ultramarine blue. The
lighter shadows and reflections, such as the vertical shadow
on the right, are raw sienna and ultramarine blue. The ac-
tual yellow of the brass is a combination of yellow ochre and
cadmium yellow. Cadmium yellow is stronger in the lightest
areas, and yellow ochre is stronger in the darker areas. The
yellow highlights are pure cadmium yellow.

For a final touch on the large center reflection, I dab in
some raw sienna, ultramarine blue, and white mixed to in-
dicate some of the minor, secondary reflections which
appear.

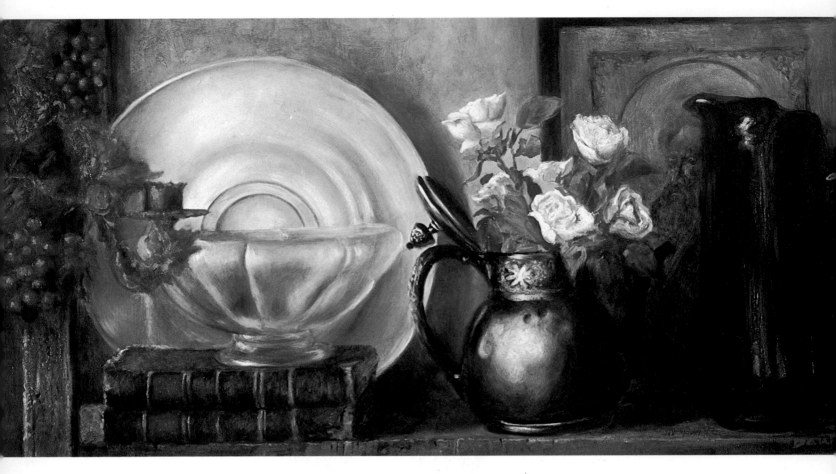

Still Life, *oil on Masonite, 12" x 24 1/2" (30.5 cm x 62.2 cm), collection of Mr. and Mrs. Bernard Gouss. This pitcher of flowers is a different type of pewter than the mug in the pewter demonstration. It looks shinier and more reflective, but the technique is still basically the same.*

PEWTER

The main problem in this demonstration is to render the color of pewter so that it does not look like silver. The surface of pewter is neither rough nor smooth, but smooth enough to show low-key, muted reflections. Therefore, the surrounding colors must be integrated into the pewter mug without appearing as sharply defined reflections.

Palette
Phthalo blue
Ultramarine blue
Venetian red
Naples yellow
Burnt umber
Raw sienna
Underpainting white
Flake white
Ivory black

Color Mixtures

1. For the white, I mix underpainting white and flake white.

2. Phthalo blue, Venetian red, and Naples yellow are mixed to create a dark pewter tone.

3. Phthalo blue, Venetian red, Naples yellow, and white are blended for a light pewter tone.

4. Small amounts of phthalo blue and white mixed with large amounts of Venetian red and Naples yellow are used for the background and foreground.

5. Raw sienna and ultramarine blue are blended to create part of the background color.

6. Burnt umber and ultramarine blue are combined for the shadow on the foreground.

7. Ivory black and flake white mixed together will make a thin glaze over the pewter; this mixture will also strengthen the mug's shadows.

8. Venetian red and flake white are mixed for the pink reflection on the mug.

Brushes
I select a wide variety of brushes because the surface of pewter is neither rough nor smooth, and I need a lot of latitude to render the surface the way I want. Specifically I use:

 1/8″ (.32 cm) flat sable
 1/4″ (.64 cm) flat sable
 3/8″ (.95 cm) flat sable
 5/8″ (1.6 cm) flat sable
 1/4″ (.64 cm) naturally curved bristle
 3/8″ (.95 cm) naturally curved bristle
 #2 round watercolor brush with fine point

Painting Surface
Since pewter has to be carefully rendered, I think a smooth surface allows me more control than canvas. So I choose a gessoed Masonite board to work on.

Painting Tips
Start out rendering the pewter with the color mixtures, not with black. With the color mixtures you can render nice gradations of tone without having to work with a flat black-and-white gray. I reserve the gray for the end to tone down and evenly distribute the variations that are there.

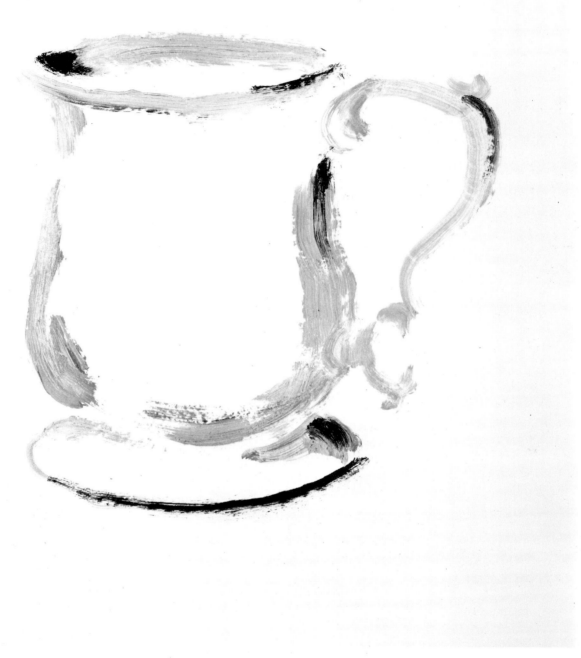

Stage 1. My palette in this stage includes phthalo blue, Naples yellow, Venetian red, flake white, and underpainting white. The only brush I use is a 3/8″ (.95 cm) bristle brush.

The whites are mixed together to create the one I use for this demonstration. I create two tones to work with—one is a dark pewter tone which I will use for the shadowy darker areas, and the other is a light pewter tone with which I do the basic drawing. The dark tone is a combination of phthalo blue, Venetian red, and Naples yellow. I create the lighter tone by adding white to this mixture.

First, with my light tone I outline the mug and handle and make sure the general shape and proportions are correct. After this has been satisfactorily rendered, I add the dark tone into the dark, shadowy portions of the mug and handle. I also use the dark tone to render the bottom edge of the base since this will ultimately be an edge in dark shadow. While the paint is still wet, I move on to Stage 2.

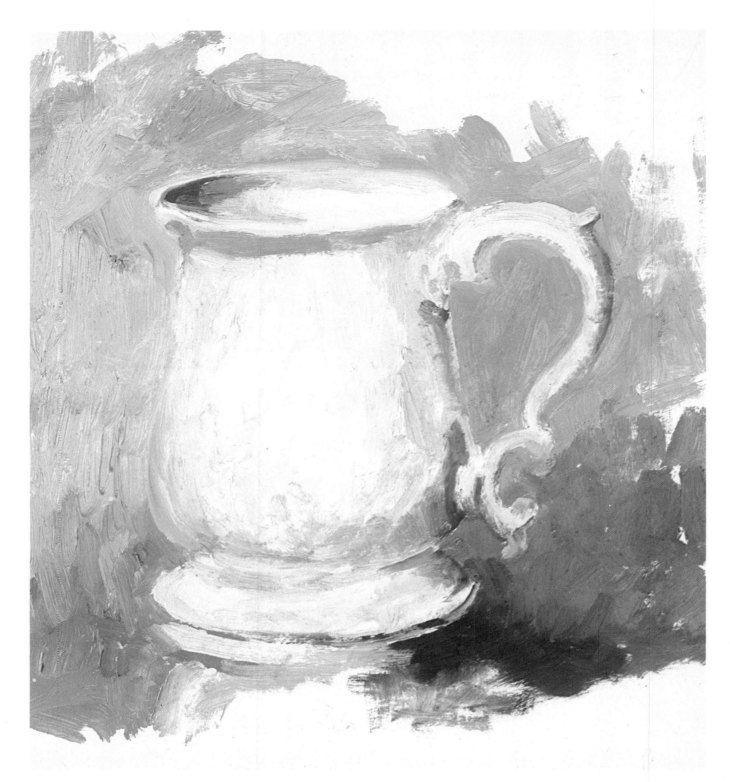

Stage 2. I continue to use the same palette and a 3/8″ (.95 cm) bristle brush.

With these colors, I mix a brownish color for the surface on which the pewter mug sits. This is created by combining small amounts of phthalo blue and white with proportionately large amounts of Venetian red and Naples yellow. I use this mixture in the background and foreground around the mug. I brush this dark shadow tone (phthalo blue, Venetian red, and Naples yellow) on the brown in the lower right portion of the painting where the cast shadow from the mug appears. White is brushed directly under the mug for the reflection. The light tone used in Stage 1 (phthalo blue, Venetian red, Naples yellow, and white) is brushed into the upper portion simply for variation and interest.

To render the mug itself, I use only the two light and dark pewter tones I mixed for Stage 1, and I also use my white mixture. With rough brushstrokes, I paint the entire shape and contour of the mug and handle. I paint many gradations of the two pewter tones between the light and dark areas to achieve the illusion of roundness. The darkest portions are strictly the dark tone, but a great deal of white is added into the lightest areas, such as the rounded center of the mug, the right side of the lip area, and the upper portion of the handle. Working now to achieve the contour of the mug, I do not blend these varying degrees of color together. The essence is what I want; the smoothness will come later.

Now, I brush a little of the same brown that I used for the table onto two areas of the mug where the color is reflected—under the lip of the mug on the left side, and on top of the base of the mug on the right side. This stage is wet as I begin Stage 3.

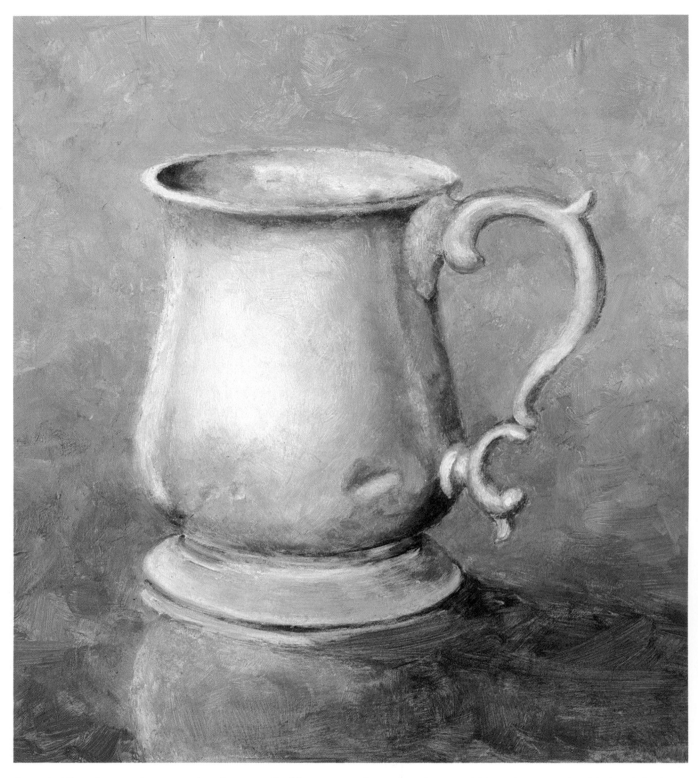

Stage 3. Though my palette remains the same, I add some new brushes: a 1/4″ (.64 cm) curved bristle and a 3/8″ (.95 cm) flat sable for the background and foreground areas, and 1/4″ (.64 cm) and 1/8″ (.32 cm) flat sables for details on the mug and rim.

My concern now is to refine the work I have already done, and to add a few details that are characteristic of pewter, such as the dents in the lower portions of the cup. Even though no deliberate drying has taken place, I notice that by this time the paint in the mug has a definite degree of stickiness. This is because underpainting white has been used in all the mixtures and dries very fast.

I smooth out the gradations between the light and dark tones in the mug, which enhance the roundness of both the mug and the handle. The lightest portions, where the light is directly hitting the mug, are emphasized by blending in

the white mixture. With a 1/8″ (.32 cm) sable brush I add the white along the left and right sides of the lip. Using the same brush, I emphasize the darkest areas, such as the left inside of the cup, under the rim, on both sides and in the details of the handle, under the mug, and under the base.

By using a darker shade of the pewter tone on top and brushing in white in the lower portions, I create the impressions of dents. I brush in the background and foreground more carefully with the same colors I used in Stage 2, filling in all areas of the surrounding space. A little of the background color is brushed under the lip and under the belly of the mug where the reflections occur. I lighten the shadow on the table by brushing more of the table color into it. The white reflection on the table is created by brushing in white very thinly. Before going on to the final stage, I allow Stage 3 to dry.

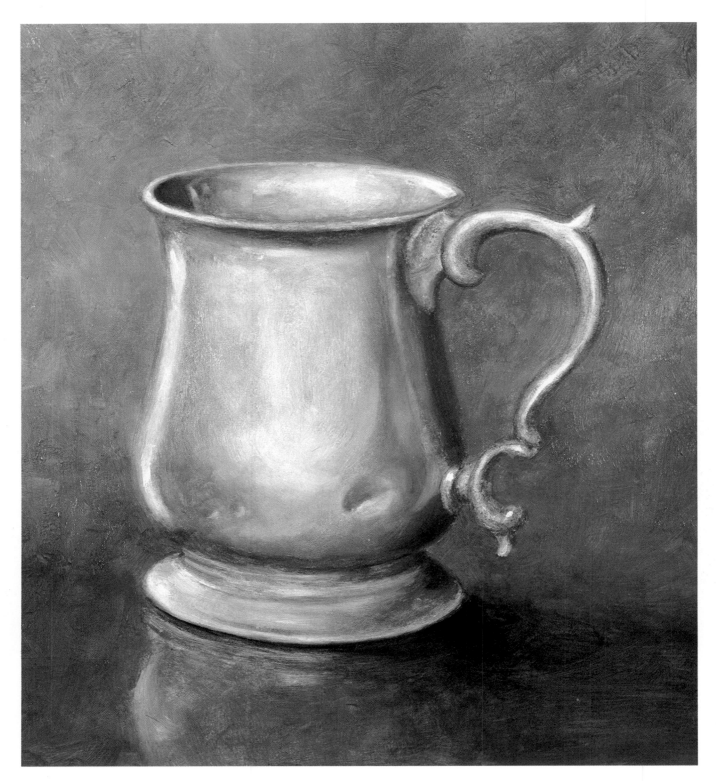

Stage 4. Four new colors are added to the palette: burnt umber, ultramarine blue, raw sienna, and ivory black. The painting medium I use is Winsor and Newton Liquin. My brushes are all sables varying in size from a 5/8″ (1.6 cm), which I use on the background, down to a 1/8″ (.32 cm) for detail. I also work with a #2 watercolor brush for small highlights.

I strengthen the background by brushing in burnt umber at various points, and a combination of raw sienna and ultramarine blue. These colors are brushed in at will to add variety and liveliness to the painting, because I feel colors are a pleasing contrast to the gray pewter. I brush more burnt umber into the bottom portion to add solidity to the form, since the mug rests on this surface. Burnt umber and ultramarine blue are mixed for the shadow directly under the mug and extending to the right. I use flake white to capture the mug's reflection on the surface. To heighten the color and feel of pewter, I thin a combination of ivory black and flake white with Liquin. I brush this mixture lightly over the entire surface, which gives me a somewhat uniform pewter color.

I now have to strengthen the light and dark portions. For the light areas, I use flake white, which I also use to brighten the highlights on the handle, around the lip, and on the far left side of the mug and base. For the dark shadow areas, I brush in a combination of flake white and ivory black, using considerably more black than white. To give an overall softening effect to the painting, I blend all the edges into the background. My final touch is a pink reflection just below the center portion of the lip, which is a mixture of Venetian red and flake white.

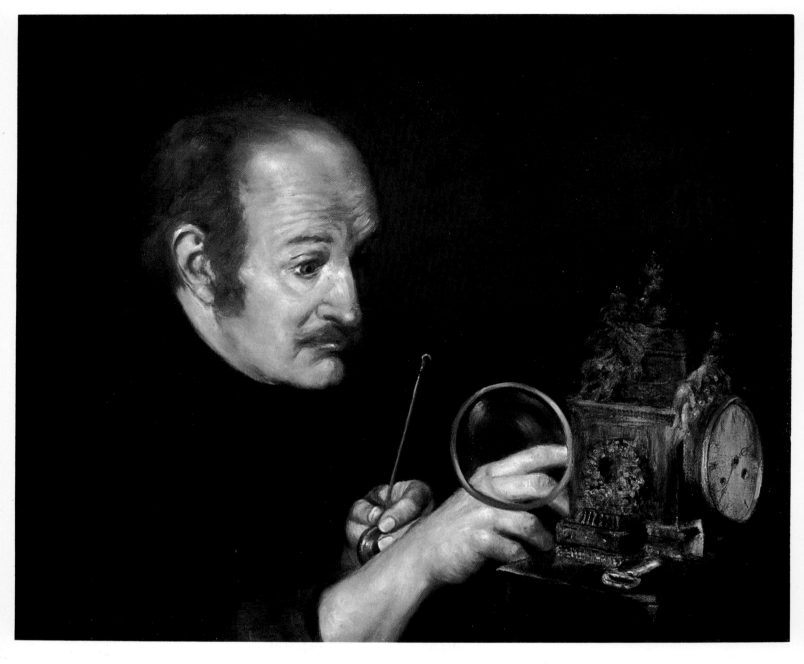

Adjusting the Pendulum, *oil on canvas, 20" x 24" (50.8 cm x 61 cm), private collection. I used the same technique of tinting and glazing on the glass at the back of the clock in this painting as I used on the dusty lantern in the next demonstration. This time, however, I glazed with cremnitz white to render the object shiny rather than dull.*

DEMONSTRATION 4

DUSTY LANTERN

The problem in this painting is to render the layer of dust that covers the entire surface of the lantern without totally obscuring the colors and textures of the glass, metal, and rust. Basically, in the metallic areas I work with a dusty, muddy color. Then I brighten the metal and rust areas which are less heavily coated with dust. I make no effort to render the translucence of the glass bowl in the lantern, since that area is obscured by a coating of dust. I use a lantern for the subject of this painting, but I could just as easily have chosen any other object in order to explore the technical problems of rendering dust.

Palette
Ultramarine blue
Venetian red
Cadmium red deep
Chromium oxide green
Yellow ochre
Underpainting white
Flake white
Ivory black

Color Mixtures
1. I mix ultramarine blue and Venetian red in varying proportions to create three colors that range in hue from one that is more reddish-purple, one more bluish-purple, and one a light violet.

2. Flake white and violet are mixed to create the background color.

3. Yellow ochre and violet are blended to produce a dull gray-green.

4. Chromium oxide green and underpainting white are mixed for the bright green areas.

5. Cadmium red deep and violet combine together to render the glass part of the lantern.

6. Ivory black and flake white are mixed for the gray tones of the dust.

7. Raw umber and ultramarine blue combine for the deep shadow areas.

Brushes
For most of this demonstration I use flat sable brushes of different sizes. To render the few areas of precise detail, I use a #2 watercolor brush.

 1/4″ (.64 cm) flat sable brush
 1/2″ (1.3 cm) flat sable brush
 #2 round watercolor brush with fine point

Painting Surface
I choose to paint on a smooth surface because the textures of the lantern—metal and glass—are basically smooth. A few areas of rust are the only exception and these are just as easily rendered on a smooth surface as they are on a rough one.

Painting Tips
First, I think it is important that the lantern is not mistaken for a gray lantern, but rather, a dusty one. To ensure this, I suggest that the basic colors chosen to render the lantern are strong enough at the end of Stage 3 to show through the glazing in Stage 4.

To help achieve this effect, pretend that you are actually lightly covering the lantern with dust. This will help you apply the gray glaze in a thin, even manner and will help you achieve the desired effect.

Stage 1. My palette colors are ultramarine blue, Venetian red, and flake white.

My primary aim in this stage is to brush in the essential shapes and shadows. For this type of rendering I only use a 1/2″ (1.3 cm) flat sable brush. I indicate the highlights and shadows noting that the light source is chiefly overhead.

First I mix some of the red and blue together to create a muddy, reddish-purple. Next I mix blue and red again, but this time with very little red, to create a purple that is much more violet in hue. Finally, I mix some of the violet with flake white to use as my background color. I use the reddish-purple to render the lantern, thinning it with painting medium in areas where I want a paler color. The very darkest shadows are strengthened with dabs of the violet mixture. The very lightest areas are left unpainted.

The background color surrounding the lantern is painted in, and this color is also used to complete the shapes at the top and base of the lantern. When I am satisfied that I have accurately rendered the shapes and shadows of the lantern, I proceed to Stage 2 before allowing Stage 1 to dry.

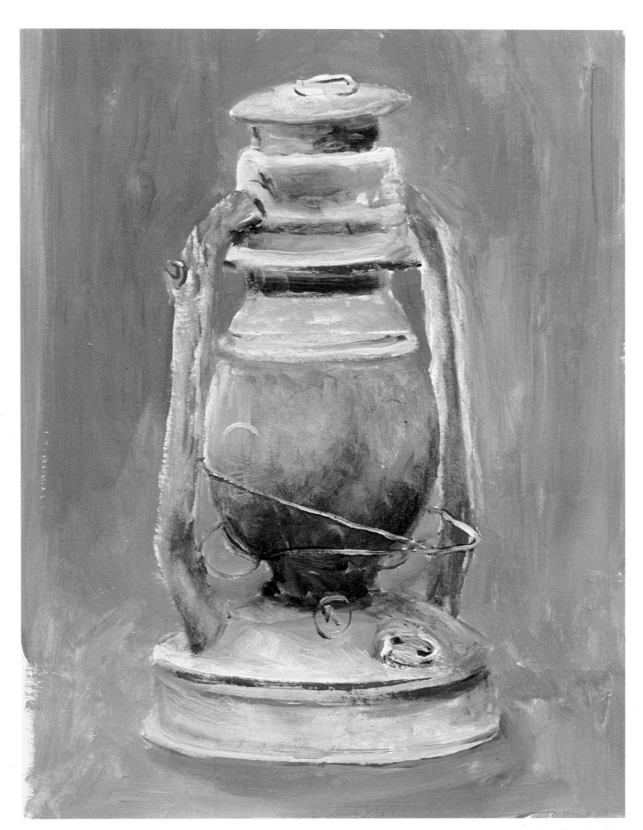

Stage 2. My palette remains the same and I continue to paint with the 1/2″ (1.3 cm) flat sable brush.

In this stage I primarily want to fill in all areas of the lantern and to add the smaller, more intricate details. As I do this, I note that the light source is overhead and slightly from the left.

I continue to use my violet and white mixture for the background, the regular violet mixture for the darkest areas of the lantern, and the reddish mixture for the main parts of the lantern. As I work with the reddish mixture, I blend in flake white to provide the varying shades of color that I need. For the highlights on the many rims of the lantern, and the kerosene hole on the base, I brush in al-

most pure flake white. At this stage blending is not a main concern, except on the shape of the glass bowl. Since I want to convey the roundness of the shape, I blend the reddish mixture with flake white, as the color changes from darker at the base to lighter at the top. Though it is not apparent, this area is glass obscured by dust. That is why I make no effort to render the glass as translucent.

After the roundness of the glass has been created, I add the wires hanging in front of it. To do this I paint a thin streak of the violet mixture alongside a thin streak of flake white, using a #2 watercolor brush. The kerosene hole and the hanging loop are painted in basically the same way. I do not wait for Stage 2 to dry before beginning Stage 3.

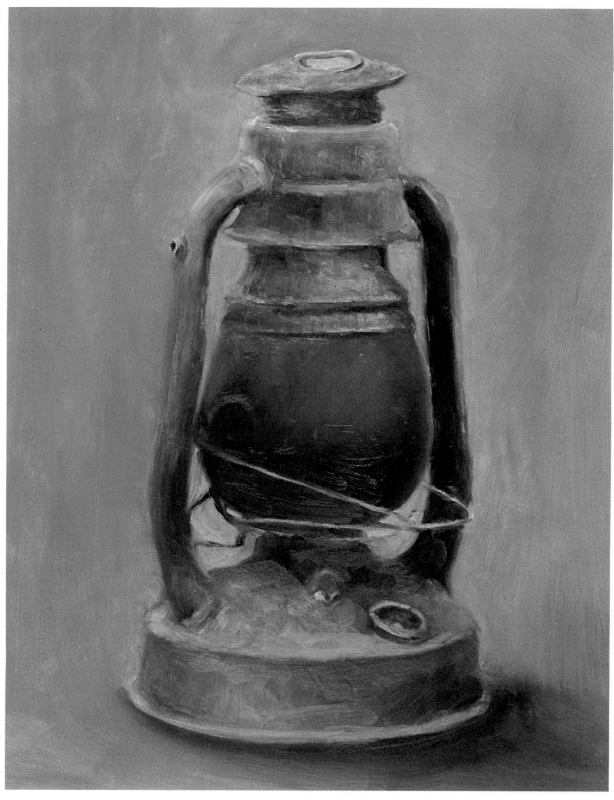

Stage 3. Chromium oxide green, yellow ochre, underpainting white, and cadmium red deep are added to my palette. I continue using flat sable brushes of varying sizes depending upon the need.

I also mix a third batch of ultramarine blue and Venetian red. This mixture is quite reddish having only a slight bluish cast.

On the metal areas I try to capture two things: the very dull gray-green color of the metal and the rust areas. For the dull gray-green, I mix yellow ochre into my violet mixture. I brush this into the metallic areas until they begin to appear almost green. Then I paint chromium oxide green mixed with underpainting white into the brightest green areas, taking care to blend this into the duller green areas.

The reddish color I described in the first paragraph above is the one I use for the rust areas. I paint this color in wherever I see rust, like on the handles and at the top of the lantern. For the shadows I continue to use the dark violet mixture, and for the highlights I use flake white.

The glass part of the lantern is rendered with a mixture of cadmium red deep and violet. At the top of the glass where the color is lighter, I add flake white. When I paint the glass part of the lantern, I am very careful to blend the lighter and darker colors well so that I effectively create a sense of roundness. Next, the wires are accentuated with flake white to capture their thinness and reflective surface. I let this stage dry completely before going on to Stage 4.

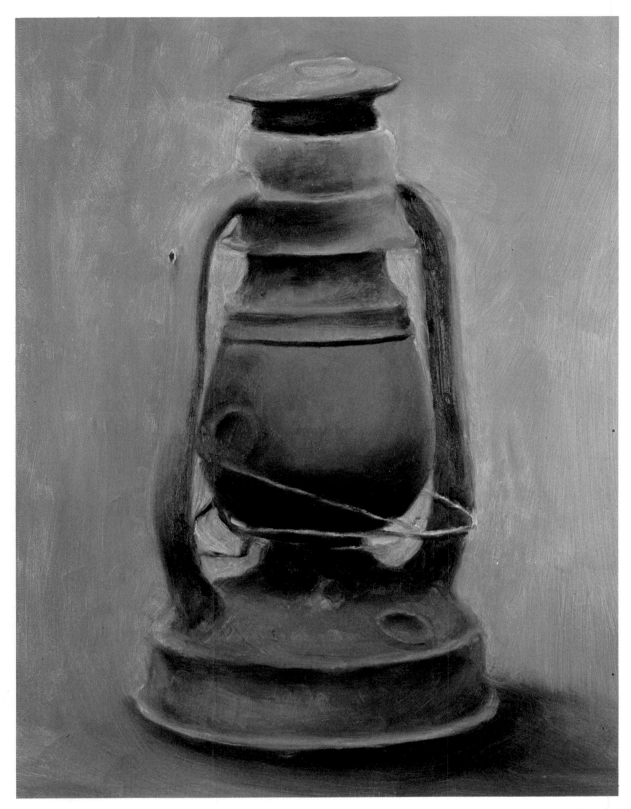

Stage 4. Ivory black is added to my palette, but I do not use it alone since it has a tendency to crack when applied by itself.

Unfortunately, in order to render the dust covering the lantern, it is necessary to obliterate some of the color already painted. In this stage I work only on the lantern. Everything else remains the same.

Working with 1/4″ (.64 cm) and 1/2″ (1.3 cm) flat sable brushes, I thinly glaze a mixture of ivory black and flake white over the entire surface of the lantern. This produces the gray tone I want for the dust. Also, it is thin enough so that the hints of color in the underpainting are still visible. To accentuate the deepest shadow areas, I use a combination of raw umber and ultramarine blue which lends a cool blue cast to the entire area. I blend this well into the dust areas, until I am satisfied that the finished product is a faithful rendering of a dusty lantern.

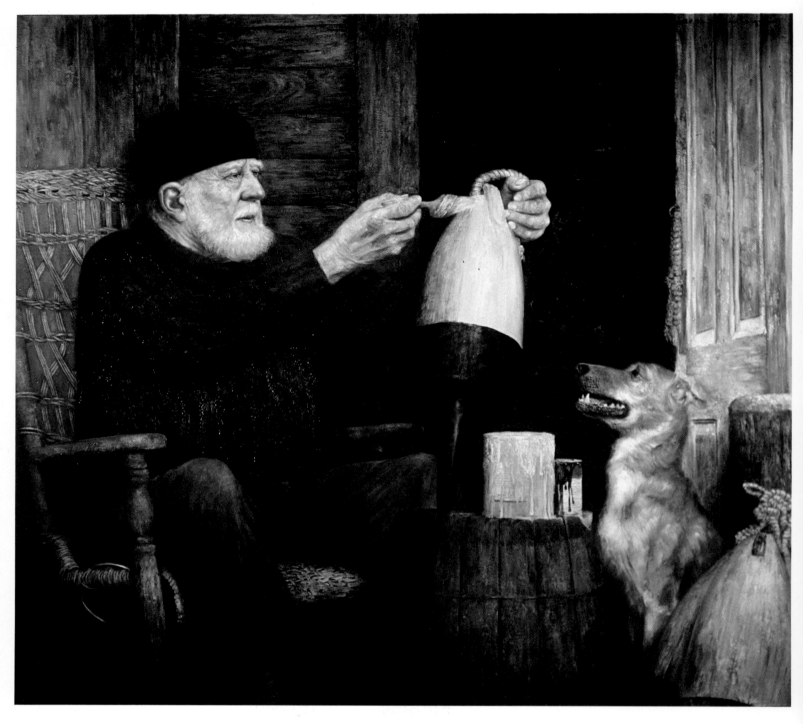

Painting the Buoy, *oil on canvas, 44" x 50" (112 cm x 127 cm), collection of Mr. and Mrs. Jack Weiner. Compare the freshly painted yellow wood on the buoy to the weathered peeling paint on the unpainted portion. This painting presented essentially the same problems as the peeling paint demonstration and was rendered similarly. The best example of peeling paint here is on the chair where the old green paint is slowly peeling away.*

DEMONSTRATION 5

PEELING PAINT

As I see it, the biggest problem in this demonstration is to create a three-dimensional effect of paint peeling away from the shutter. Cracking paint, when it ceases to adhere to a painted surface, presents the same technical problems as peeling paint. The key to creating a realistic painting of peeling or cracking paint is to achieve this three-dimensional effect.

Palette
Ultramarine blue
Phthalo blue
Yellow ochre
Burnt sienna
Raw umber
Underpainting white
Flake white

Color Mixtures

1. Burnt sienna, yellow ochre, phthalo blue, and underpainting white are mixed to create the basic color.

2. The basic color (mixture no. 1) plus more phthalo blue creates a blue-green tone that renders a rough, peeling look to the surface of the shutter.

3. The basic color is altered slightly by adding more burnt sienna and less yellow ochre to create a deep brown that I use for the initial rendering of the shadows.

4. Phthalo blue and yellow ochre are mixed together to create the overall green for the shutter.

5. Raw umber and ultramarine blue are mixed to produce the shadows under the peeling segments and on the green paint.

6. Flake white and underpainting white are combined for the white in Stage 4.

7. The white combination is blended with the green mixture for the light green contrast.

8. Raw umber and white are mixed together to create a grained wood effect.

Brushes

For the detailed work, I use the sables and watercolor brush. I use the bristle brush only once in Stage 4 to remove the green paint with turpentine.

> 1/4″ (.64 cm) flat sable
> 3/8″ (.95 cm) flat sable
> 1/2″ (1.3 cm) flat sable
> 5/8″ (1.6 cm) flat sable
> 3/4″ (1.9 cm) flat sable
> 1/2″ (1.3 cm) naturally curved bristle
> #2 round watercolor brush with fine point

Painting Surface

I work on Masonite that has been thinly coated with gesso. A smooth surface allows me the maximum control I need to render the very important shadows around the peeling paint, and also enables me to control the shaping of the peeled-away areas, so that they are esthetically pleasing shapes as well.

Painting Tips

In order to capture the three-dimensional or sculptural qualities of peeling paint, I carefully render the surrounding shadows cast by the paint. I suggest that you pay careful attention to these shadows, closely observing their shapes, colors, and location. These elements are essential for capturing the effects you wish to portray.

Stage 1. My palette consists of burnt sienna, yellow ochre, phthalo blue, and a little underpainting white.

I mix these colors together to produce a warm brown tone, which is used as my basic color. This tone, thinned with turpentine, is what I use for the initial drawing. Using a 5/8″ (1.6 cm) sable brush, I paint in the general shapes of the horizontal slats and the vertical side panels. Notice that white space is left between the slats; these will become the tops of the slats as they overlap each other, but they need not be painted in at this time.

There are three prominent areas of peeling paint which I begin to indicate by laying in more underpainting white. For this particular job I use a 3/8″ (.95 cm) sable brush. These areas are difficult to spot at this early stage—one is on the side panel at the left; another is on a middle slat to the right; and a third is on the last slat to the right. Before I continue, I allow this stage to dry for a few hours, until the surface is tacky.

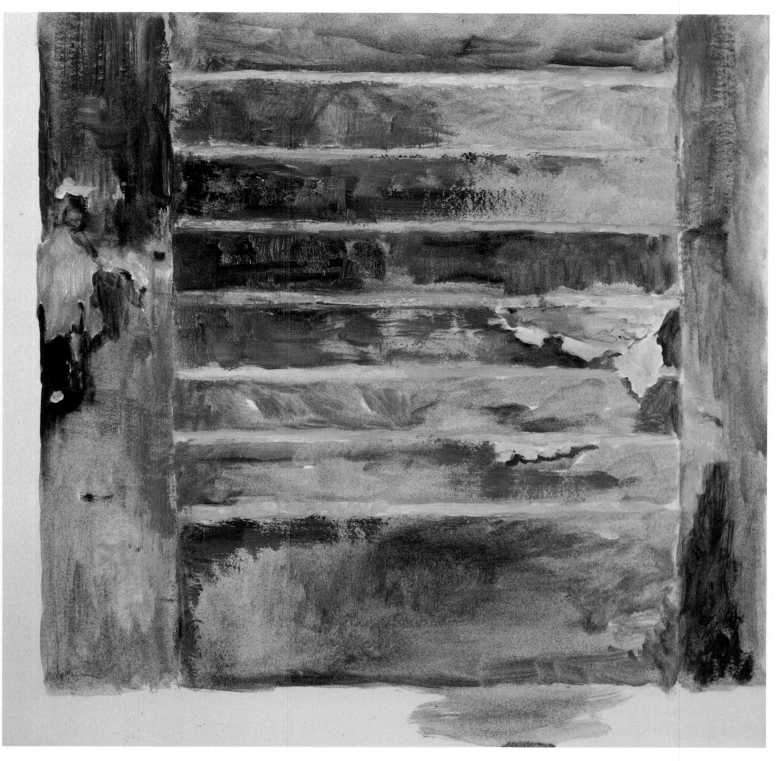

Stage 2. For this stage my palette colors remain the same, but now I mix them in different proportions to create two new colors. I add more phthalo blue to one mixture to create a blue-green tone. For the other mixture, I add more burnt sienna and less yellow ochre to give me a deeper brown tone than my basic mixture. I also keep my initial basic mixture on the palette.

First, remember that it is important to capture the essential problems of a particular subject before tackling the details. For this reason, I have painted over only part of Stage 1 to enable you to see what is happening in this stage, and to help you understand what I am trying to do. Using a 1/2″ (1.3 cm) sable brush I begin by dragging the bluish-greenish tone over the basic color to give the feeling of rough, peeling paint. To fill in the unpainted tops of the horizontal slats, I use underpainting white and a 1/4″ (.64 cm) sable brush.

For the areas of peeling paint, I am only concerned with capturing the essence—not the exact shape. I let so-called accidents happen and improve upon the shapes of these areas as I feel necessary. Also, I note that some areas are primarily cracked or loosened paint, but not yet peeled back. Where the paint is peeled back and the surface underneath exposed, I use my basic tone mixed with underpainting white. The deeper brown mixture of raw umber and ultramarine blue is used to render the shadows cast by the peeled and loosened paint. Before going any further, I let this stage dry completely.

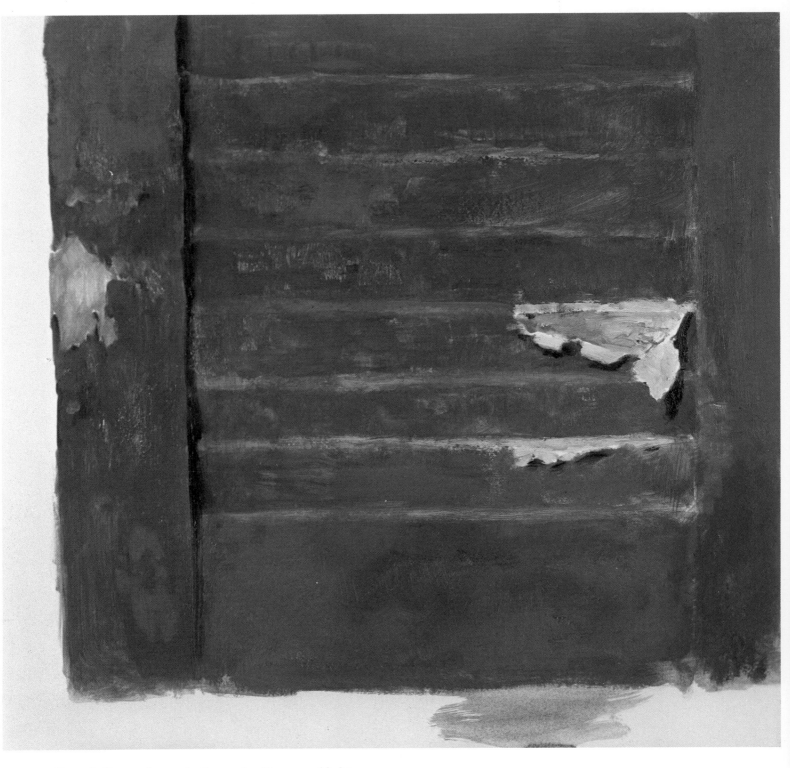

Stage 3. Raw umber and ultramarine blue are added to my palette.

To create the green for the shutter, I mix together phthalo blue and yellow ochre. With a 3/4″ (1.9 cm) sable brush I glaze the green mixture over the entire shutter with one exception—the exposed wood areas.

For the shadow areas underneath the peeling paint and alongside the vertical side panel, I combine raw umber and ultramarine blue. Without waiting for this stage to dry, I move on to Stage 4.

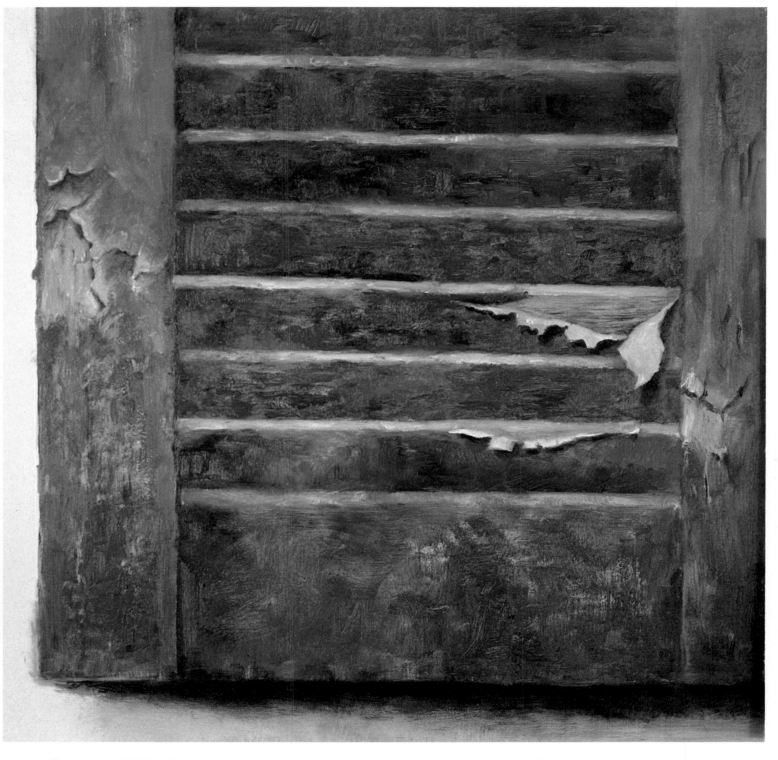

Stage 4. I add flake white to my palette and mix it with underpainting white to create the white for this final stage.

For a more esthetically pleasing composition, I decide to add a fourth peeled-away spot on the right vertical panel. To do this, I remove the green paint with turpentine using a 1/2″ (1.3 cm) bristle brush. Then I follow the procedure described in the previous stages of this demonstration to build the paint back up to the same level as the other peeled areas.

For the rest of this stage, I use 1/4″ (.64 cm) to 5/8″ (1.6 cm) flat sables and a #2 watercolor brush. I scumble my green mixture roughly over all the glazed green areas to

create a rough textured effect. I also lightly scumble on some of the basic color to heighten and emphasize the roughness in certain areas.

To produce the light green I need for the tops of the slats, the back of the peeled paint, and around the loosened cracked paint, I add white to the green mixture. For all the shadows on the green paint I use a combination of raw umber and ultramarine blue. Then, to create a grained wood effect, I brush a combination of raw umber and white across the four areas of exposed wood. Raw umber is used sparingly to capture any shadows that are cast directly onto the unpainted wood.

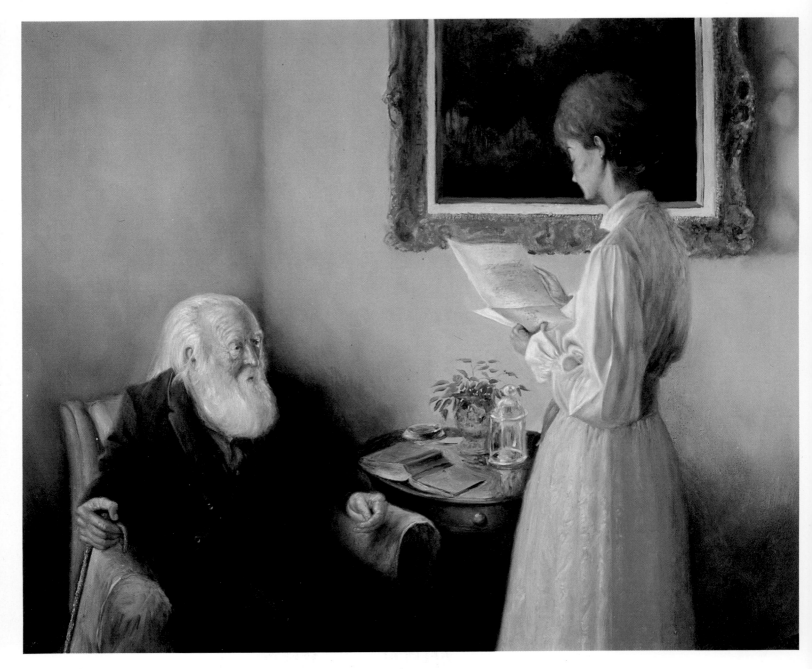

The Letter, *(detail), oil on Masonite, 20" x 24" (51 cm x 61 cm), private collection. The contrast in surfaces of the objects on the table reminds me of the conch shell demonstration. For the conch shell I used a rough technique for the outer surface and a smooth one for the pink interior. A similar problem exists here in rendering all the various surfaces of these objects. I enjoy rendering rough surfaces versus smooth ones—contrasts make an interesting painting.*

CONCH SHELL

The difficulty in rendering a conch shell is that it exhibits two contrasting types of surfaces—a rough exterior and a smooth interior. The problem lies in effectively rendering both kinds of surfaces so that the distinct tactile characteristics of each are visible.

Palette
Ultramarine blue
Venetian red
Cadmium red deep
Rose madder
Yellow ochre
Raw umber
Underpainting white
Flake white

Color Mixtures

1. Raw umber and underpainting white are mixed for my drawing color and for building up texture on the exterior.

2. Flake white and cadmium red deep are mixed for the initial inside of the shell.

3. Flake white and raw umber are the initial background.

4. Yellow ochre and Venetian red are brushed into the outer shell striations.

5. Ultramarine blue and cadmium red deep are mixed for pink variations.

6. Yellow ochre and ultramarine blue are blended for the final background.

7. Raw umber and ultramarine blue are mixed for the shadow under the shell, the final glaze on the shell, and the shadows in the pink interior.

8. Yellow ochre, cadmium red deep, and raw umber blend for the striations on the shell.

Brushes

For the rough exterior of the shell I use bristle brushes. The sables are for the smooth interior of the shell and for the final details.

 1/8″ (.32 cm) flat sable
 1/4″ (.64 cm) flat sable
 3/8″ (.95 cm) flat sable
 1/2″ (1.3 cm) flat sable
 1/4″ (.64 cm) naturally curved bristle
 3/8″ (.95 cm) naturally curved bristle
 #2 round watercolor brush with fine point

Painting Surface

With two distinctly different surfaces involved, I could easily have used either canvas or panel. However, I decided to use a gessoed Masonite panel because it simplified capturing the extremely smooth interior and allowed me to build up the texture for the rough exterior.

Painting Tips

I suggest that you build up the paint for the exterior of the shell in a rough, brushy manner. The rougher and thicker it gets, the easier it is to render the rough texture by glazing. Also, do not forget to change techniques for the pink interior which is always done smoothly.

Stage 1. The two colors on my palette are underpainting white and raw umber. I work with two brushes, a 3/8″ (.95 cm) flat sable and a 3/8″ (.95 cm) bristle. The sable is used for the smooth pink interior portion on the right and the bristle is for building up the texture on the rough outer portions of the shell. Turpentine is my painting medium.

My aims in this stage are twofold. First, I strive to capture the general shape of the shell, and secondly, I simultaneously begin the process of building up texture. This buildup will continue into Stage 2.

With this in mind I mix raw umber and underpainting white into a neutral color and brush in the general shape. I allow the direction of my brushstrokes to help me define the shapes. I leave the lightest areas unpainted and darken my mixture with raw umber for the darker areas. After I feel I have captured the shell to my satisfaction, I begin Stage 2 immediately while the paint is still very wet.

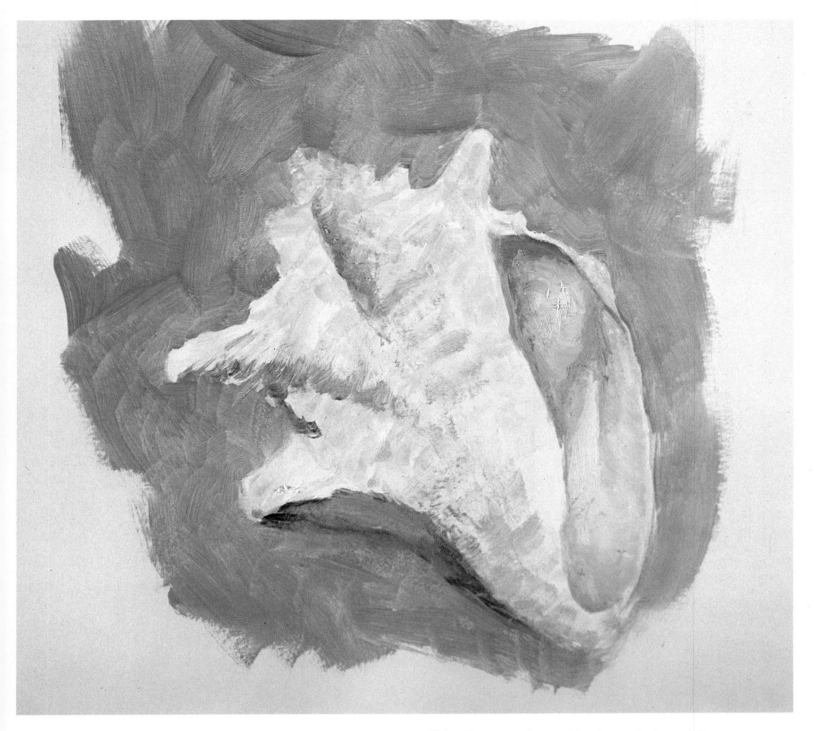

Stage 2. Flake white and cadmium red deep are added to my palette. I continue to use the same bristle brush but I add a 1/4″ (.64) flat sable for the pink interior, and a 1/2″ (1.3 cm) flat sable for the background.

Flake white and cadmium red deep are mixed to create a pink which I brush into the interior with my sable brushes. This pink area is not one solid color, so where it is lighter I add more white, and into the darkest parts I brush a small amount of raw umber. While working in this interior area always keep in mind that it must remain smooth.

Using the same color combinations as in Stage 1, I continue to build up the shell. I add various shades of the raw umber and underpainting white mixture to allow me to capture shape and form. The paint is applied in a very rough manner, dabbing it on whenever possible to help increase the buildup of paint. At no point on the exterior is the paint smoothed out at all. I surround the shell with a background of flake white and raw umber which is very casually brushed on. I allow this to dry for a few hours until it becomes sticky.

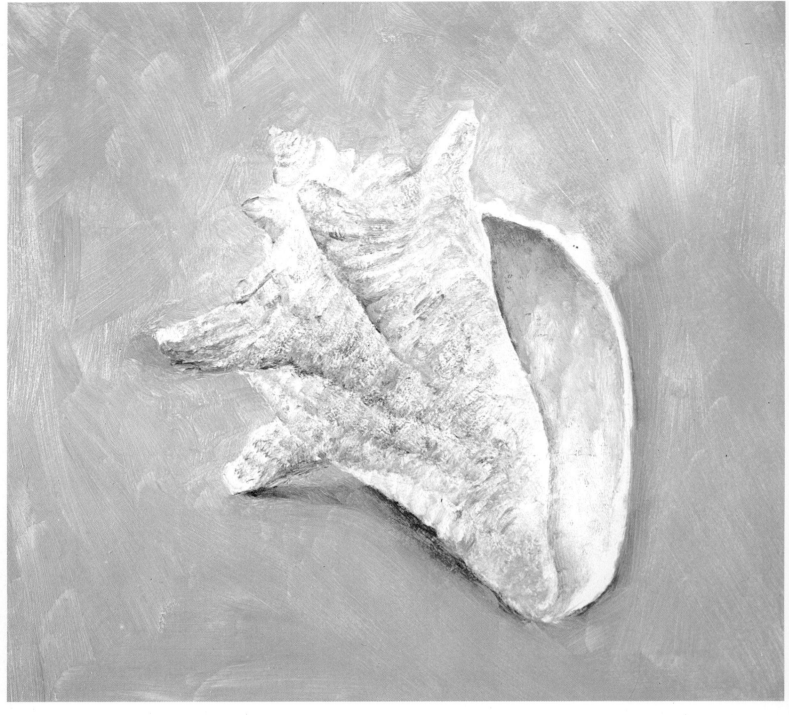

Stage 3. Ultramarine blue, yellow ochre, and Venetian red are added to my palette.

Working with 1/4″ (.64 cm) and 3/8″ (.95) bristle brushes, I scumble a combination of yellow ochre and Venetian red into the reddish brown areas of the exterior shell. I scumble raw umber into the darker areas. Scumbling over the already built up paint helps capture the rough-textured appearance I want to render.

For the variations of pink inside the shell, I mix ultramarine blue and cadmium red deep. With the 1/4″ (.64 cm) sable brush I paint this into the darker upper area and along the right hand edge of the outer shell where it appears next to the pink. I also lighten the lower area by brushing in a bit more flake white and blending it upward toward the pinker top. With the same background color used in Stage 2, I extend the background outward. I render the shadow under the shell with raw umber. Allow this to dry completely before proceeding.

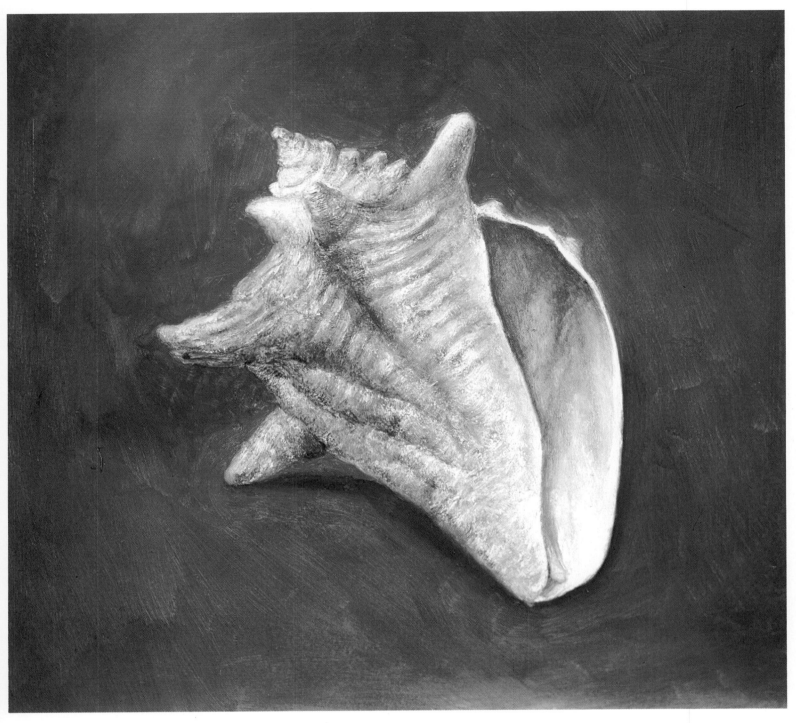

Stage 4. Rose madder is added to my palette, and Liquin is my painting medium. Sable brushes are used exclusively in this stage and I use a variety of sizes; a #2 watercolor brush, 1/8″ (.32 cm), 1/4″ (.64 cm), 3/8″ (.95 cm), and 1/2″ (1.3 cm).

I mix yellow ochre and ultramarine blue together and paint this into the background. For the shadow under the shell I use a combination of raw umber and ultramarine blue. Now that I have all this texture built up on the outer shell I want to let it work for me to the fullest. To do this, I mix raw umber with a little ultramarine blue and then thinning this mixture with Liquin, I glaze it lightly over the top surface of the exterior portion of the shell. This helps to capture the rough-textured feel of this area. Since there is no precision involved in this procedure, I just let things happen naturally. When inconsistencies do occur, they are known as "controlled accidents," and I use them to my advantage.

After the glaze has been applied, I reemphasize the various markings on the shell with a #2 watercolor brush. The lightest parts are emphasized with flake white. The horizontal stripes are a combination of yellow ochre, cadmium red deep, and raw umber. As I rework these markings, I blend them slightly.

For the pink interior, I glaze rose madder over the whole area. The darker shadings and shadows are a combination of raw umber and ultramarine blue. Flake white is added at the bottom and brushed up into the pinker area. Again, this entire area is worked in a very smooth manner to emphasize the even texture.

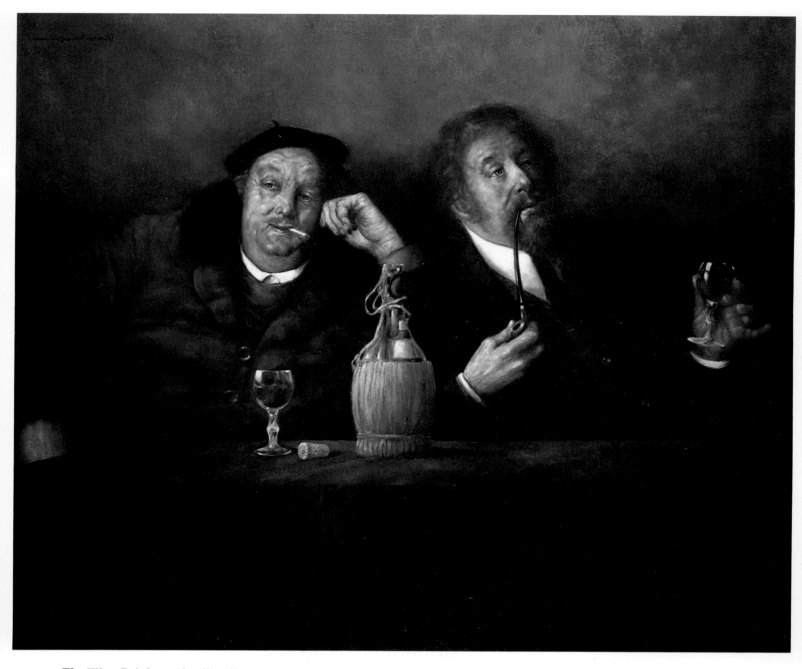

The Wine Drinkers (detail), oil on canvas, 44" x 52" (112 cm x 132 cm), collection of Mr. and Mrs. William Ahern. I used the same technique to paint the wine basket in this demonstration as I did the straw basket in the next demonstration. But I must admit I found the interweaving in the straw basket somewhat more difficult to paint.

STRAW BASKET

The problem in this demonstration is to create the texture and look of straw without attempting to paint each individual strand. Any of the other grass products, such as rattan or wicker, present essentially the same problem.

Palette
Ultramarine blue
Venetian red
Chromium oxide green
Cadmium yellow deep
Raw umber
Raw sienna
Flake white
Underpainting white

Color Mixtures

1. Ultramarine blue, Venetian red, and raw umber are blended for the underpainting color.

2. Underpainting white, chromium oxide green, and a small amount of raw umber are used for the background and the basket sides.

3. Raw umber and ultramarine blue are mixed for the table color.

4. Underpainting white, raw umber, and chromium oxide green are combined to render the leaves.

5. Raw umber and chromium oxide green are for the darker portions of the leaves.

6. Raw umber and white are for the shadows cast by the leaves.

7. Cadmium yellow deep and underpainting white are used for the rose.

8. Cadmium yellow deep, underpainting white, raw umber, and raw sienna make the shadows in the rose.

9. Raw umber, ultramarine blue, and raw sienna are mixed as a glaze for the basket.

10. Ultramarine blue and raw umber are used as a final glaze for the background.

11. Ultramarine blue, flake white, and a little raw umber are used to finish the table top.

12. Raw sienna and flake white are blended for the bottom of the basket.

13. Cadmium yellow deep and flake white are combined for the reflection on the table top.

14. Raw umber, ultramarine blue, and flake white are mixed together to produce the blue-gray color for the final stage.

Brushes
For this demonstration I use naturally rounded (filbert) bristle brushes to render the texture. I use the sables and watercolor brush mostly for details. Specifically they are:

> 1/4″ (.64 cm) flat sable
> 3/8″ (.95 cm) flat sable
> 3/8″ (.95 cm) naturally curved bristle
> 1/2″ (1.3 cm) naturally curved bristle
> #2 round watercolor brush with fine point

Painting Surface
Straw has a brittle, rough feel and its surface is difficult to render. I choose to paint on Belgian linen canvas because its rough texture naturally lends itself to the subject.

Painting Tips
Don't try to paint every strand. The overall effect of straw can be rendered by "fooling the eye" with accurate and imaginative bristle brushwork.

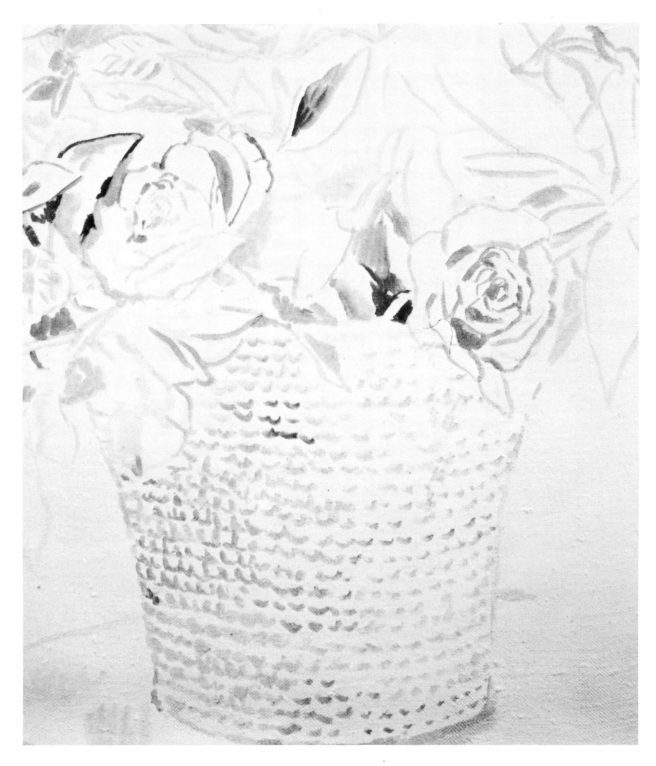

Stage 1. Ultramarine blue, Venetian red, and raw umber make up my palette. A 3/8″ (.95 cm) flat sable is the only brush I use. Turpentine is my painting medium.

The colors on my palette are mixed together to produce a gray that I use for all my drawing in this stage. Since this is a very difficult subject, I use contour drawing to capture the shape and ignore any shadows in this stage. To indicate the rough-woven texture of straw, I lightly draw U-shaped lines in rows on the basket. Remember that at the basket sides these rows of curving individual lines will come closer together. It is important now to accurately render the shapes.

For the leaves and roses in the basket, I use the same color and brush as above. I rough in their shapes and allow them to overlap the basket as they actually do. Before continuing, I allow this stage to dry overnight.

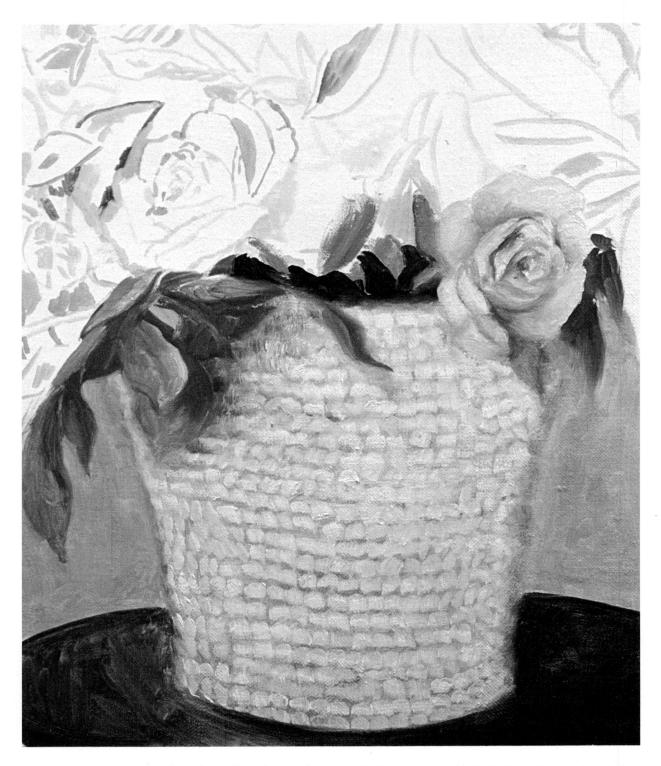

Stage 2. Raw sienna, underpainting white, chromium oxide green, and cadmium yellow deep are added to my palette. The brushes I use in this stage are a 3/8″ (.95 cm) bristle and a 3/8″ (.95 cm) flat sable.

To begin, I glaze raw sienna thinned with Taubes Copal Light painting medium over the entire surface of the basket. Next, into this glaze I paint dabs of underpainting white between the U-shapes rendered in Stage 1.

The background color is a mixture of underpainting white, chromium oxide green, and a small amount of raw umber, which is also lightly brushed into the basket sides. As I paint along the sides of the basket, I am careful to leave the rows as uneven as they naturally are, due to the woven texture. The table is painted with a thinned combination of raw umber and ultramarine blue which is used as an oil wash. I also use this wash for the far right edge of

the basket to create the beginning of the major shadow on that side.

To render the leaves, I use a mixture of underpainting white, raw umber, and chromium oxide green. The darker portions of the leaves are raw umber and chromium oxide green. With a 1/4″ (.64 cm) flat sable brush I blend the light and dark areas together as I work. Since I paint wet into wet, the edges will automatically be somewhat soft-edged, which is what I want. Raw umber and white are used to paint the shadows cast by the leaves on the basket. Cadmium yellow deep and underpainting white are used to block in the rose. To create the shadows in the rose, I mix the cadmium yellow deep and underpainting white with raw umber and raw sienna. I let this stage dry for a day before continuing on to the next stage.

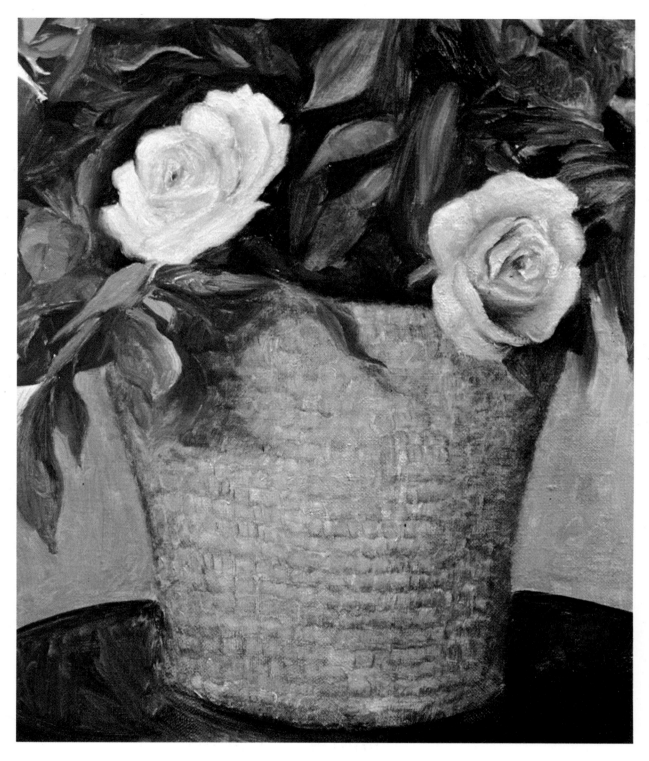

Stage 3. No new colors are added to my palette. The brushes I use for this stage are a 1/4″ (.64 cm) flat sable and a #2 watercolor. My painting medium changes to Taubes Copal Heavy.

To begin, I mix a glaze of raw umber, ultramarine blue, and raw sienna. Using the 1/4″ (.64 cm) sable I glaze this mixture over the entire basket in varying degrees of strength. I paint it very faintly over the lightest portions but much heavier in the shadows. In order to capture the roundness of the basket, the shadow on the right side is gradually and evenly darkened as it approaches the outer edge.

To accentuate the woven texture, I want some spots light and some dark, more or less randomly chosen to provide an overall effect as opposed to an exact rendering. For the light spots I dab away the paint with painting medium, still using the 1/4″ (.64 cm) brush. I accentuate the darks by strengthening some of the vertical and horizontal lines with the same glaze I used in the shadow areas. Since this work required more precise control, I used a #2 watercolor brush.

If the background has dried, I paint over it with the same background color I used in Stage 2, being sure to blend the edges of the basket into it. I continue rendering the leaves and roses by using the same color as described in Stage 2. I allow this stage to dry completely before starting Stage 4.

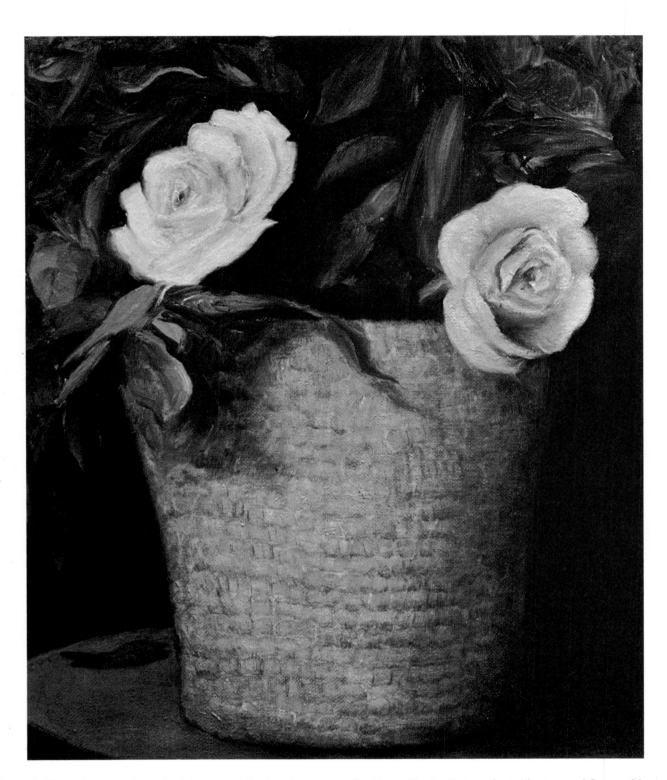

Stage 4. The only new color added to my palette is flake white. I work with two flat sable brushes, a 1/4″ (.64 cm) and a 3/8″ (.95 cm).

I begin by thinly coating the entire surface with Taubes Copal Heavy painting medium. To complete the background, I brush a near-black glaze over it using ultramarine blue and raw umber.

The table top is finished with a mixture of ultramarine blue, flake white, and a little raw umber. With a 1/4″ (.64 cm) sable, I brush this around the bottom of the pot and also lightly up into the lower portion of the pot. To help blend this table color into the bottom of the basket, I work in a little raw sienna and flake white. There is a very faint reflection of the basket on the table top, and I smoothly brush cadmium yellow deep and flake white into what is already there.

For the graduated shadow on the right side of the pot I use a combination of raw umber, ultramarine blue, and flake white, which produces a blue-gray color. With the 3/8″ (.95 cm) brush, I tint the mixture into this area to simulate the roundness of the shadow area. This is a very light tinting job so that the texture of straw is not lost. I use this same color combination to tint over the leaf shadows and to accentuate a few indented areas of the basket. For the darkest portions of the shadow areas, I blend in the black glaze that I used for the background.

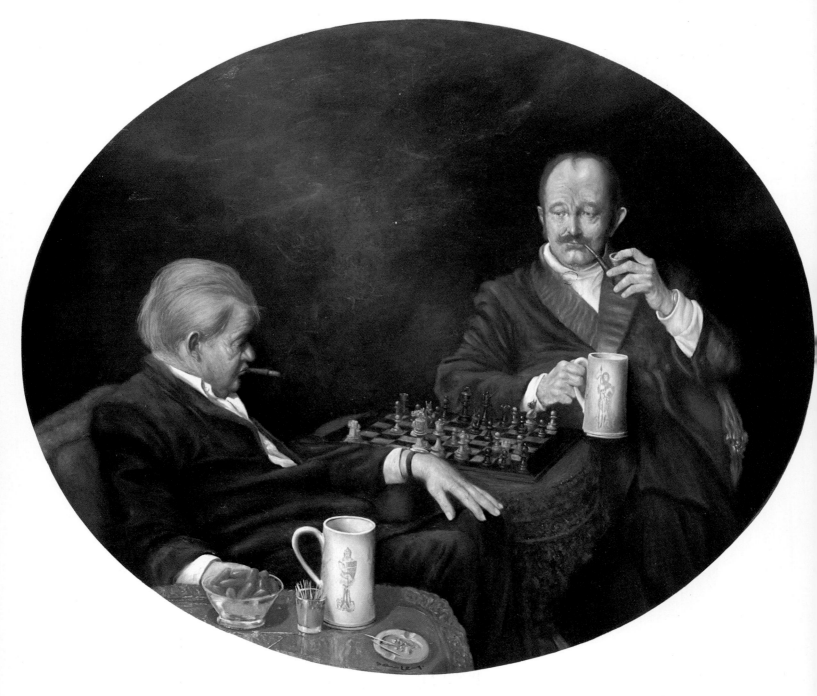

Chess Players, oil on Masonite, 31" x 37" (79 cm x 94 cm), collection of Mrs. Grace Wayman. The knights on the porcelain beer mugs present the same problem as the design on the porcelain bowl. However, because of the varied colors on the porcelain bowl, it seemed more difficult to render.

PORCELAIN BOWL WITH DESIGN

In this demonstration the biggest problem is to capture the scalloped shape and shadows of the bowl, while still painting the design accurately. My solution is to render the bowl first—just as if it had no surface decoration. Then I add the design on top of the plain bowl shape. The various tones which I use to paint the shape of the bowl—the lights and shadows on the form—later come through to lighten or darken the colors I apply for the design.

To provide a sharp contrast in textures, I add three oranges which provide extra color and interest to the still life and accentuate the smoothness of the porcelain.

Palette
Venetian red
Ultramarine blue
Yellow ochre
Cadmium orange
Chromium oxide green
Raw umber
Ivory black
Flake white
Underpainting white

Color Mixtures
1. Flake white and underpainting white are blended together for my basic white.
2. Varying amounts of Venetian red and ultramarine blue are mixed with the white to create three tones—a light, middle, and a dark—tone 1, tone 2, tone 3.
3. Yellow ochre and tone 1 produce the first color I use for the oranges.
4. Cadmium orange and tone 2 are mixed for the background and foreground color.
5. Cadmium orange, yellow ochre, and underpainting white are combined to strengthen the color of the oranges.
6. Venetian red and cadmium orange are mixed for the red in the design.
7. Chromium oxide green, yellow ochre, and flake white are blended for the green in the design.
8. Venetian red, ultramarine blue, and cadmium orange create the brown in the design.
9. Cadmium orange and underpainting white create the rough texture of oranges.
10. Cadmium orange and cadmium yellow provide the final color of the oranges.
11. Ivory black and flake white are used to render the indentations and the roundness of the bowl.
12. Ultramarine blue and raw umber are mixed for the final dark shadows.

Brushes
Since most of the work requires a smooth technique, I rely mainly on two sizes of flat sable brushes and a pointed watercolor brush for details. For the rough texture of the oranges, however, I use a bristle brush.
3/8″ (.95 cm) flat sable
1/2″ (1.3 cm) flat sable
3/8″ (.95 cm) flat bristle
#2 round watercolor brush with fine point

Painting Surface
I feel that it's important to choose a smooth painting surface, since the most distinct characteristic of porcelain is its extremely smooth, glass-like surface. Since an intricate design is also part of the problem, it would be frustrating to use a rough surface. So I use 1/8″ (.32 cm) untempered Masonite, thinly coated with gesso.

Painting Tips
Unlike other ceramics, porcelain has an extremely fine finish which is not only very smooth, but very shiny. Highlights, then, are important in rendering porcelain, and they should be both bright and sharply defined.

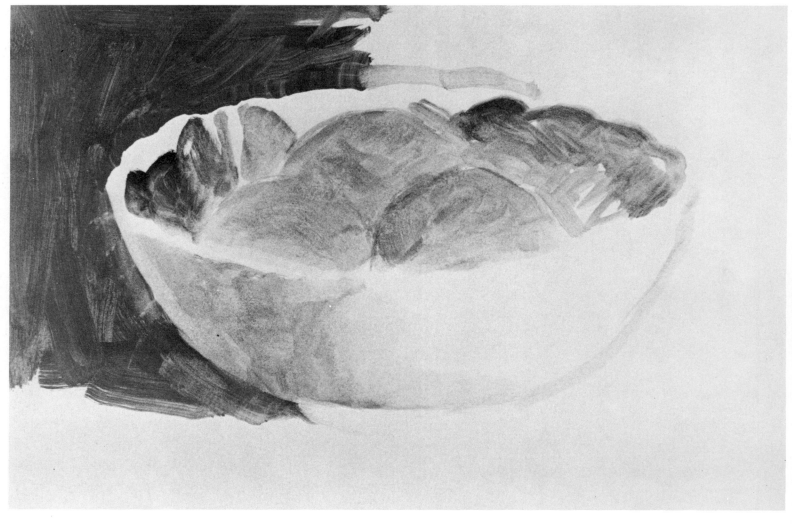

Stage 1. My palette consists of Venetian red, ultramarine blue, yellow ochre, flake white, and underpainting white—the latter two blended together for use as my white. For this stage I use 3/8″ (.95 cm) and 1/2″ (1.3 cm) flat sable brushes.

I mix the red and blue creating a blackish violet, into which I mix the white in varying degrees to give me three different values I call tones 1, 2, and 3. The lightest is tone 1. The violet mixture, with no white added, I refer to as my dark tone 4. The yellowish color needed for the oranges is a mixture of yellow ochre with a small amount of tone 1.

Since my basic goal is to indicate the light and dark areas and to render the general shapes, I don't fill the entire board with paint just yet. I outline the bowl with tone 2, thinned with turpentine. This makes a nice wash to draw with. The shadowed left front of the bowl is thinned tone 2, fading out completely as it rounds into the light on the right. For the deep shadow on the inside of the bowl, I use tone 3, thinned with turpentine. The very light areas of the bowl are left white—bare, unpainted gesso.

The oranges are rendered with the yellowish combination of yellow ochre and tone 1. Then I indicate the separations between the three pieces of fruit with a thin line of thinned tone 1. The background on the left side of the bowl is thinned tone 3. I move right on to Stage 2 while this stage is wet.

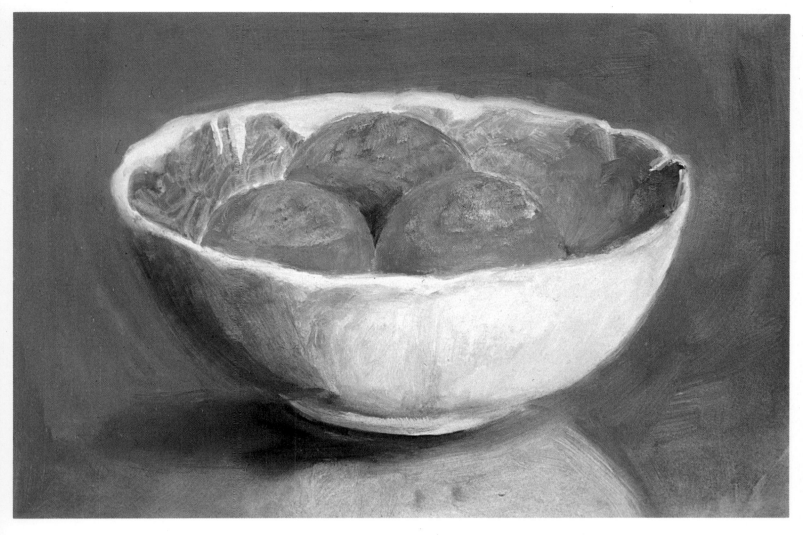

Stage 2. Cadmium orange is the only new color that I add to my palette, and I continue to use the same 3/8″ (.95 cm) and 1/2″ (1.3 cm) flat sable brushes.

Now I work to fill the entire board with paint, making sure that my drawing is accurate by getting the general shapes of all the shadows, the very light areas, and the reflections. To begin, I paint in the background and foreground all around the bowl; this helps me to tighten up and complete the drawing. I use a mixture of cadmium orange and tone 2 in differing proportions to provide variety. The paint in the foreground is kept very thin by mixing it with Taubes Copal Light painting medium. The large reflection in the foreground under the bowl is rendered by removing the paint with a brush moistened with medium.

Starting at the far left exterior of the bowl, I render the deepest portion of the shadow with tone 3. As the bowl rounds into the light, I blend in tones 1, 2, and the white. At the far right, I again blend in tone 1 as the shape rounds off. The shadows on the inside of the bowl are tones 2 and 3 depending on the depth of the shadow. The very light portions are white.

With a combination of cadmium orange, yellow ochre, and underpainting white, I strengthen the color of the oranges. For the shadows on the orange I use tone 3. The shadow under the bowl and extending to the left is tone 4, fading out into the foreground. I move right in to Stage 3 while this stage is still wet.

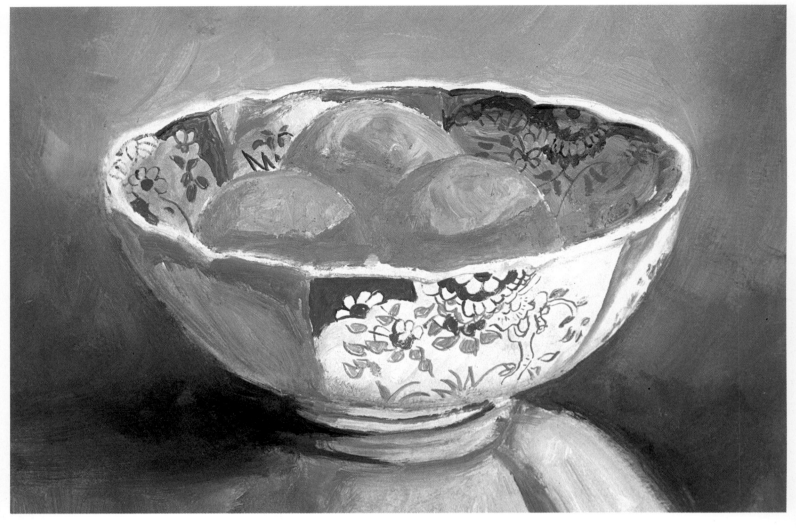

Stage 3. Venetian red, chromium oxide green, raw umber, and more ultramarine blue are now added to my palette. I use the same painting medium.

In this stage the design is added on the surface of the bowl. Before doing this, however, I must smooth out the work I've already done, so that it becomes a good base over which to paint the design. With sable brushes, I smoothly blend the shadows working back and forth, both on the inside and the outside of the bowl, until I achieve a clearly defined roundness.

For the design, I use a #2 round watercolor brush and the following colors: the red is a mixture of Venetian red and cadmium orange; the green is chromium oxide green, yellow ochre, and flake white; the brown is Venetian red, ultramarine blue, and cadmium orange; the blue is ultramarine blue; and the white is a mixture of underpainting

and flake white. As I paint the design onto the bowl, the strokes automatically appear lighter in the highlighted areas and darker in the shadows, influenced by the various base tones over which I'm painting.

Using a 3/8″ (.95 cm) bristle brush, I paint cadmium orange and underpainting white into the oranges. I make no effort to smooth this out, allowing the strokes to create the rough, thick texture of the fruit. Some of the underpainting white and orange combination is also mixed into the shadows of the oranges already painted in Stage 2. Next I blend the background and foreground carefully. I add a line of ultramarine blue directly under the bowl—on the base. Under the base, I use raw umber and ultramarine blue for definition. To render the reflection in the foreground, I use the same colors that were used to paint the design, brushing them loosely over the foreground color. Before starting Stage 4, I let this stage dry completely.

Collection of Calvert Gallery, Washington, D.C.

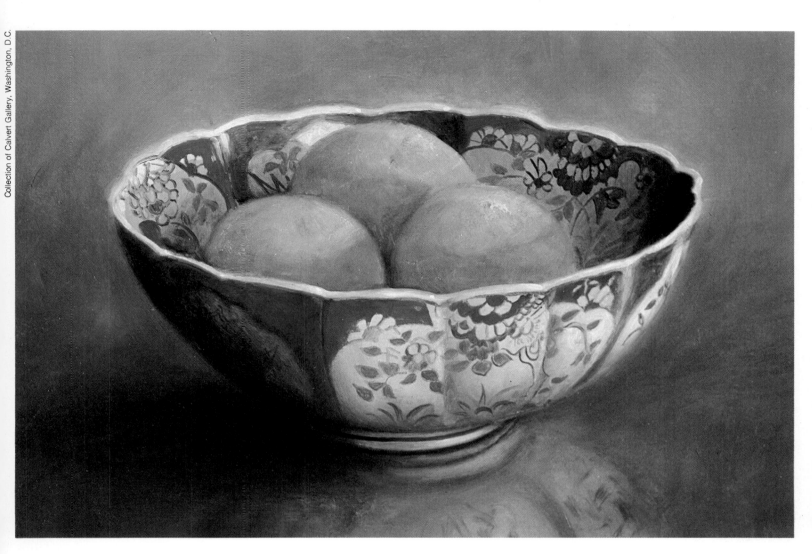

Stage 4. In this final stage, I work only with sable brushes. The only colors I add to my palette are ivory black and cadmium yellow. My painting medium changes to Taubes Copal Heavy.

This particular bowl is a scalloped shape. To render the vertical indentations, I use a mixture of flake white and ivory black. This same color combination is also used to render the roundness at the bottom of the bowl, curving up from the base. To emphasize the very dark shadows—such as the far left exterior and the far right interior—I glaze a mixture of ultramarine blue and raw umber. I do this wherever there is a dark shadow. The bright highlight

areas are touched with flake white, mixed with a little copal concentrate.

After adding these touches, I find that the design needs to be reemphasized in some areas. To do this, I use the same colors as in Stage 3.

A mixture of cadmium orange and cadmium yellow is painted over the tops of the oranges, leaving their shadows much the same. For the finishing touches on the background and foreground, I glaze raw umber over the left side of the table top. I then blend this upward into the gray I've blended across the top.

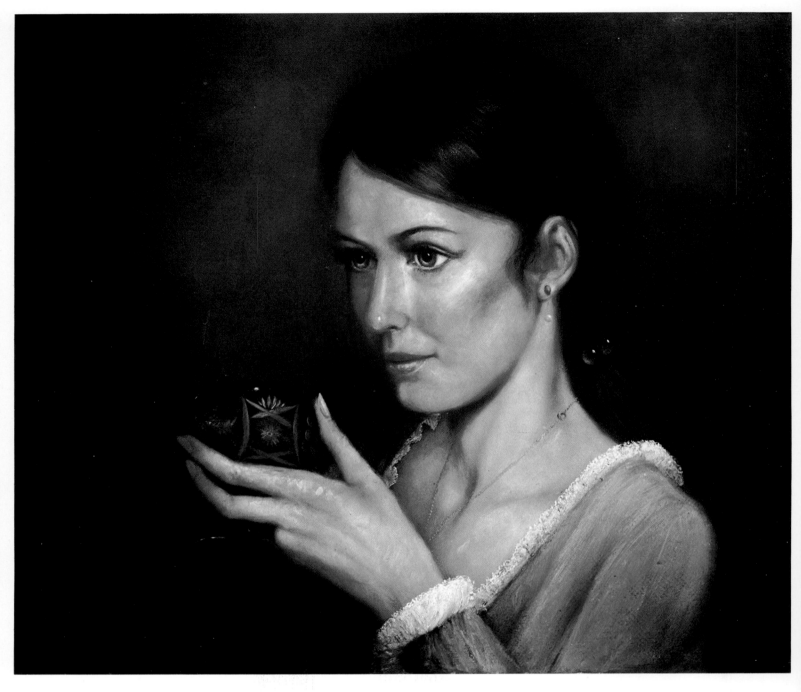

Girl in Blue, *oil on canvas, 16" x 20" (41 cm x 51 cm), collection of Mr. and Mrs. Tom Buck. While this technique is basically the same as the crystal bowl demonstration, cut glass presents different problems. The glass is less transparent than crystal because of its color (I used ultramarine blue here), and the cut glass designs are sharper and more defined. Unlike the crystal bowl, all the reflections of color are not apparent.*

CRYSTAL BOWL WITH FLOWERS

The problem in this demonstration is to simultaneously render the water in the crystal bowl, the flowers submerged in the water, and the texture of the crystal. When you have captured the three separate impressions, it is easier to see the painting as a whole.

Palette
Ultramarine blue
Phthalo blue
Venetian red
Cadmium red deep
Cadmium orange
Yellow ochre
Chromium oxide green
Burnt sienna
Raw umber
Flake white

Color Mixtures
1. Ultramarine blue and Venetian red are combined for my reddish-purple color.
2. Venetian red, ultramarine blue, and flake white are mixed for the violet color I need.
3. Phthalo blue and yellow ochre are blended for my green.
4. Phthalo blue, yellow ochre, and burnt sienna are mixed to create brown.
5. The brown mixture and the violet mixture are blended for the background and the shadow on the table.
6. Raw umber and ultramarine blue create the background color in the final stage.
7. Cadmium orange and ultramarine blue are used for the table.
8. Phthalo blue and flake white create the bluish water color.

Brushes
To render the texture of the carnations, I use a 1/4″ (.64 cm) bristle brush with short strokes to indicate the petals. For the details I use the sables.
3/8″ (.95 cm) flat sable
5/8″ (1.6 cm) flat sable
1/4″ (.64 cm) naturally curved bristle
3/8″ (.95 cm) naturally curved bristle
1/2″ (1.3 cm) naturally curved bristle

Painting Surface
I choose to work on 1/8″ (.32 cm) untempered Masonite coated with acrylic gesso because on this surface it helps me render the extreme smoothness of crystal and water.

Painting Tips
It is far more important to give the impression of water and crystal than it is to paint exactly what you see. In other words, in order to convey the impression of water I add blue, which in reality I do not see. Since the beauty of crystal is its reflectiveness, take liberties to accentuate color wherever you see it, especially at the base of the crystal bowl.

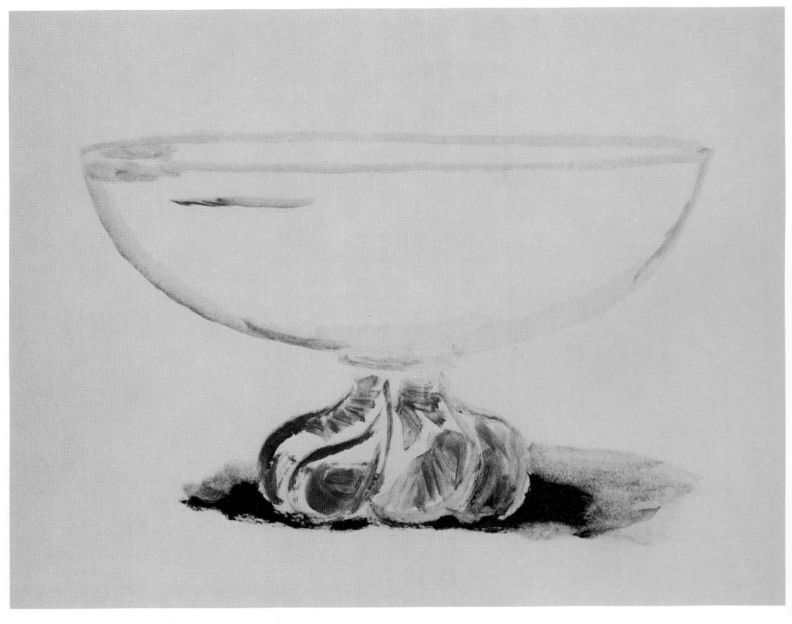

Stage 1. My palette consists of three colors: Venetian red, ultramarine blue, and flake white. My brush is a 3/8″ (.95 cm) sable, and turpentine is my painting medium.

First, I create a reddish-purple mixture by combining the ultramarine blue and Venetian red. For the violet mixture I mix all three colors on the palette together. With the violet mixture I paint a contour drawing of the bowl, and lightly indicate the waterline. Still using the violet mixture, I roughly paint in the most prominent shadows appearing on the base of the bowl.

For the first stages of the table, I use my reddish-purple mixture. Also, I brush this mixture lightly on the right side of the base where the reflection on the table appears. While this stage is wet, I go on to Stage 2.

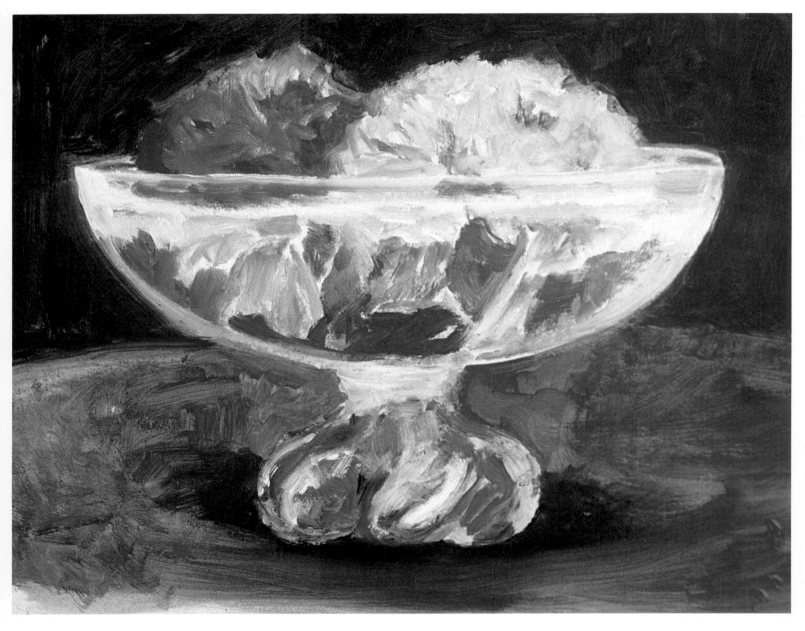

Stage 2. In this stage, phthalo blue, yellow ochre, burnt sienna, and cadmium red deep are added to my palette. My brushes are all bristles: a 1/2″ (1.3 cm), a 1/4″ (.64 cm), and a 3/8″ (.95 cm). Win-Gel is my painting medium.

For green, I mix phthalo blue and yellow ochre together. Then I mix phthalo blue, yellow ochre, and burnt sienna together for a brown. My main concern now is to indicate color and shape. I work in a rough, brushy manner, often just dabbing on color, which is why I use bristle brushes.

To render both the flowers and their individual reflections in the water, I combine cadmium red deep and flake white. For the pink flower a lot more white is added. The blue of the water is the violet mixture from Stage 1 with flake white added.

For the different shades of green, I use the green mixture alone, or I blend the green mixture with yellow ochre, or with both flake white and yellow ochre.

The outline of the bowl is flake white with a little of the violet mixture included in spots, especially on the neck between the bowl and the base. The base is filled in with more violet, a little of the brown mixture, and flake white for the highlights. For the background and for the deep shadow on the table, I mix the brown mixture with the violet mixture. To render the table, I use the brown mixture. I move on to Stage 3 while this is wet.

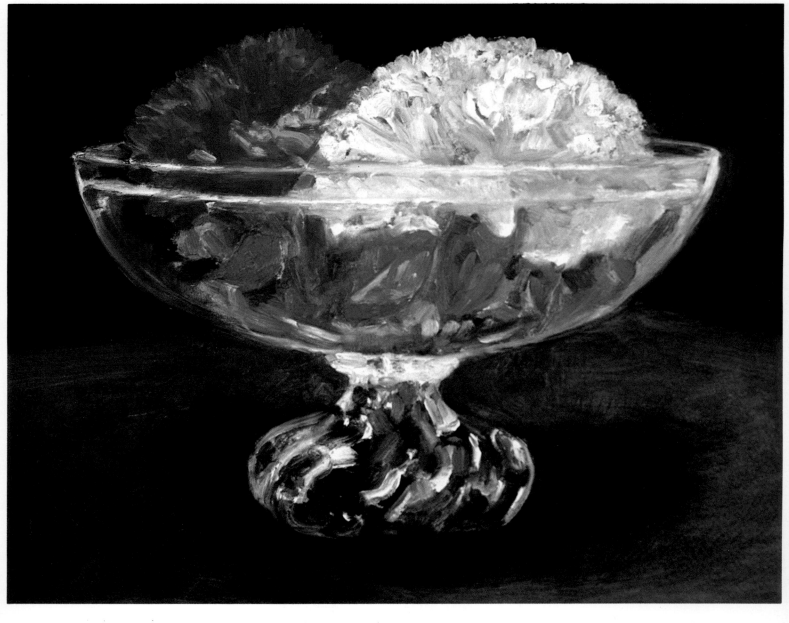

Stage 3. My palette remains the same except for the addition of one new color, chromium oxide green. I mix this sparingly with the green tone, which gives a greener green than before. My painting medium changes to Liquin.

Since I plan to brush the flowers into the background, I paint in the background first with a 5/8″ (1.6 cm) sable brush. I add more of the violet mixture to the background color which makes it darker so that the flowers stand out better. Next I take a 1/2″ (1.3 cm) flat sable brush and smooth out the table to make it a little browner. The shadow cast on the table is the same color as the background and I blend this smoothly into the table color.

For the flowers, the color mixtures remain the same as in Stage 2. I work with a 1/4″ (.64 cm) bristle brush for the flower part only. With short strokes, I flick on various degrees of the colors, allowing these short strokes to illustrate the look of carnations. Around the outer edge of the flowers I flick the color into the background making no attempt at

all to blend it, so the effect will remain sharp and delineated.

The top edge of the bowl and the waterline are basically flake white blended with the various colors directly behind them. In other words, when I paint the glass in front of the red carnation, part of the red is included. The flower petals are not sharply defined as they appear between the top edge of the bowl and the waterline. This is because they are being seen through glass at that point. In the bowl itself, I fill in and define more precisely all that is resting below the waterline. Notice that I use streaks of the flower colors along the far sides of the bowl where they are reflected.

The neck below the bowl is primarily white with a touch of green included to show the reflection of the leaves. The base is a series of dabs and streaks of all the various colors reflected there. I allow this stage to dry completely before beginning Stage 4.

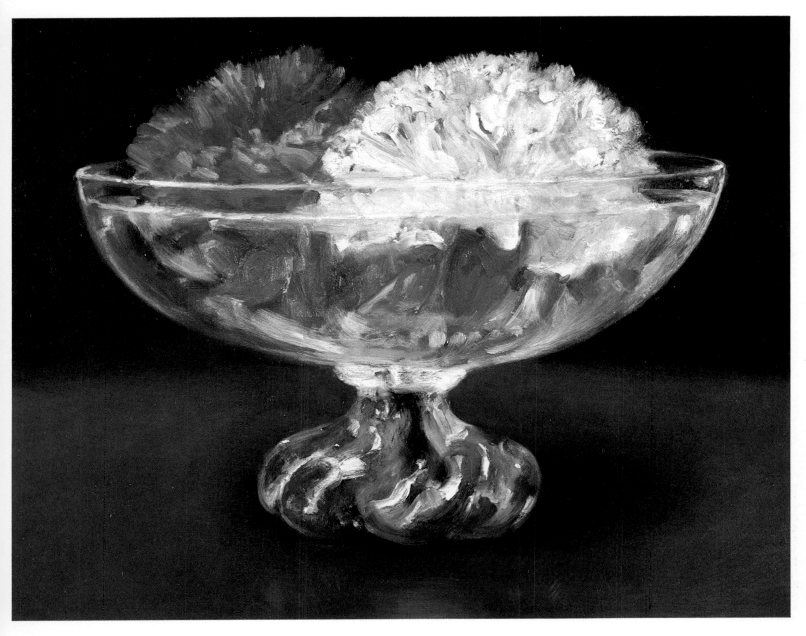

Stage 4. I add cadmium orange and raw umber to my palette in this final stage.

First, with a 5/8″ (1.6 cm) sable brush, I brush Liquin over the entire surface. Then I begin with the background and table for the same reason mentioned in Stage 3. The background color, darker in this stage, is a mixture of raw umber and ultramarine blue. This is painted right up to the edges and slightly into everything it surrounds. The objects the background color touches will be repainted in order to produce soft edges.

The mixture I use to paint over the table surface is cadmium orange and ultramarine blue. Then with a 5/8″ (1.6 cm) sable brush, I blend the table color and the background color together producing a nice soft edge. The violet mixture is used for the reflection in front of the bowl and is blended into the table color.

In the bowl itself, I strengthen the color of the leaves with chromium oxide green. Other than that, my main concern from now on is to render the essence of water in the bowl. Phthalo blue and flake white are mixed to create a bluish water-like color. I chose phthalo blue rather than ultramarine blue because, mixed with white, phthalo blue creates a better impression of water. With a 3/8″ (.95 cm) sable brush, I brush this blue lightly into the waterline, on various spots in the bowl, and on the base as a reflection of the water. I do this until I feel the essence of water in a crystal bowl has been captured.

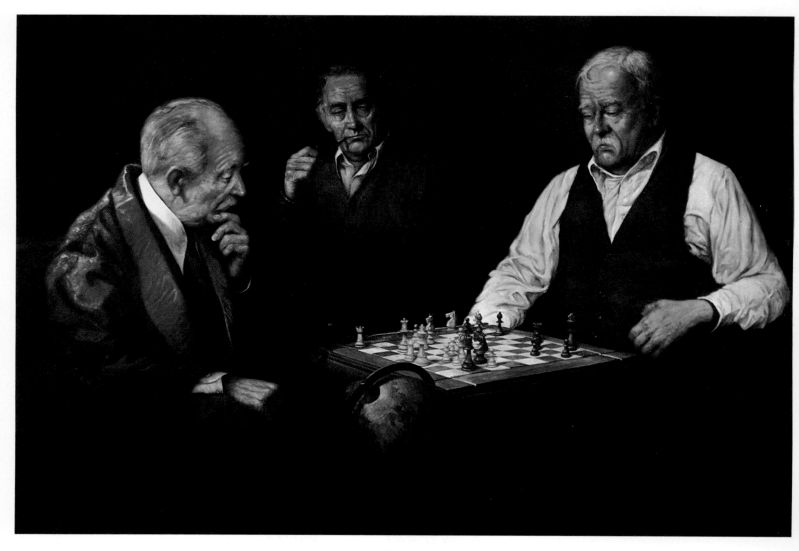

Check, *oil on canvas, 40" x 60" (102 cm x 152.4 cm), collection of Mr. and Mrs. Ira Warner. Patterned after a championship chess match, this painting's wooden chess board and pieces could have been marble. However, the marble striations might have confused an already complicated work. By incorporating changes in striation and color, the shiny wood chess board and pieces can be rendered in the same manner as the marble demonstration.*

MARBLE

The basic problem with painting marble is to render its striations so that they look natural and not contrived. Also, it is important to convey the smooth, cool feeling of a marble surface.

Palette
Ultramarine blue
Venetian red
Cadmium yellow
Yellow ochre
Terre verte
Burnt sienna
Raw sienna
Burnt umber
Raw umber
Flake white
Underpainting white

Color Mixtures
1. Raw umber, ultramarine blue, and underpainting white are mixed for both the initial drawing color and the shadows.
2. The shadow mixture, raw umber, and ultramarine blue are mixed for the beginning background.
3. Yellow ochre, burnt umber, and cadmium yellow are blended to create the gold color.
4. Terre verte and raw sienna are mixed for the greenish striations.
5. Raw umber, ultramarine blue, and flake white are mixed in varying degrees for the final background, shadow areas, and off-white glaze.
6. Venetian red and raw sienna create the red streaks in the lower area.

Brushes
I use sable brushes because the surface is smooth and the streaking is delicate. Specifically they are:
 1/8″ (.32 cm) flat sable
 1/4″ (.64 cm) flat sable
 3/8″ (.95 cm) flat sable
 #1 series fan-shaped sable brush (Winsor and Newton)
 #2 round watercolor brush with fine point

Painting Surface
A smooth gessoed Masonite board is an ideal surface to render the shiny, smooth exterior of marble.

Painting Tips
I suggest that you try to achieve an overall look of marble instead of trying to capture each individual striation. This will lead to a more natural appearance. Allow "controlled accidents" to work for you.

Stage 1. My palette consists of raw umber, ultramarine blue and underpainting white. Using these three colors, I create two mixtures—one is off-white and the other is considerably darker for the shadow areas. I work with a 3/8″ (.95 cm) flat sable brush, and use turpentine as my painting medium.

In this stage I try to accomplish two things: to correctly render the shape of the marble cylinder, and to paint in the shadow areas.

Using the light tone, I brush in the general shape of the cylinder. Then I fill it in completely with this tone, working very smoothly in order not to create a rougher surface than necessary.

With the darker tone I brush in the shadow under the cylinder and along the left side of the object. I do not brush in this vertical shadow directly against the edge of the cylinder. The reason for this is that on a rounded object, there is always a very slight area of reflected light just beyond the shadow as the object rounds out of view. Before continuing, I allow this to dry for a couple of hours until it becomes tacky.

Stage 2. Three new colors are added to my palette: raw sienna, burnt sienna and burnt umber. Besides the 3/8″ (.95 cm) flat sable, I also use a 1/4″ (.64 cm) flat sable and a fan-shaped sable brush, which may be difficult to obtain if you do not already have one. I continue to use turpentine as my painting medium.

What I do now is capture the basic marble striations and clarify the basic shape by adding some background. Using the same dark, shadow mixture as in Stage 1, I surround the cylinder with a beginning background.

For the prominent dark streak across the top of the cylinder, I streak on burnt umber with a 1/4″ (.64 cm) flat sable. (The word *streak* is a brushing technique I use when the paint has been purposefully allowed to become tacky. The chosen color is then streaked or dragged across the surface with a sable brush which causes a slight blending softness.) Below this, smaller striations appear, so I switch to the fan brush to streak the burnt umber on in this portion. Below that, I streak on raw sienna. When using the fan brush, I go across just once each time, in a casual wavy manner. You cannot really make a mistake, so just let the streaks happen and go on from there.

In the lower portion of the cylinder the streaks become bold, and for this I use burnt sienna and a 3/8″ (.95 cm) flat sable brush.

While this stage is still wet, I go on to Stage 3.

Stage 3. I add terre verte, yellow ochre, and cadmium yellow to my palette. My brushes remain the same, but I change my painting medium to Win-Gel.

For the background, I further darken the dark shadow mixture by adding more raw umber and ultramarine blue and paint this over the background. The cast shadow to the left is a still darker version of this same mixture.

As you can now see, this is a container with a lid. To simulate the gold band I use a mixture of yellow ochre, burnt umber, and cadmium yellow. The thin dark line between the two gold bands is burnt umber and the occasional yellow highlights are cadmium yellow. The shadow on the

left side of the cylinder is sticky, so with a 3/8″ (.95 cm) flat sable I brush the paint around toward the center until it is fairly evenly blended. While doing this, be careful not to upset the marble striations already there.

With the fan brush, I continue to streak in burnt sienna, raw sienna, and burnt umber where I see these colors. There are also some greenish striations for which I mix terre verte and raw sienna. I still use the 3/8″ (.95 cm) flat sable to render the large streaks of burnt sienna near the bottom. I continue working in this manner until the entire cylinder is filled with the various marble colors. I allow this stage to dry completely.

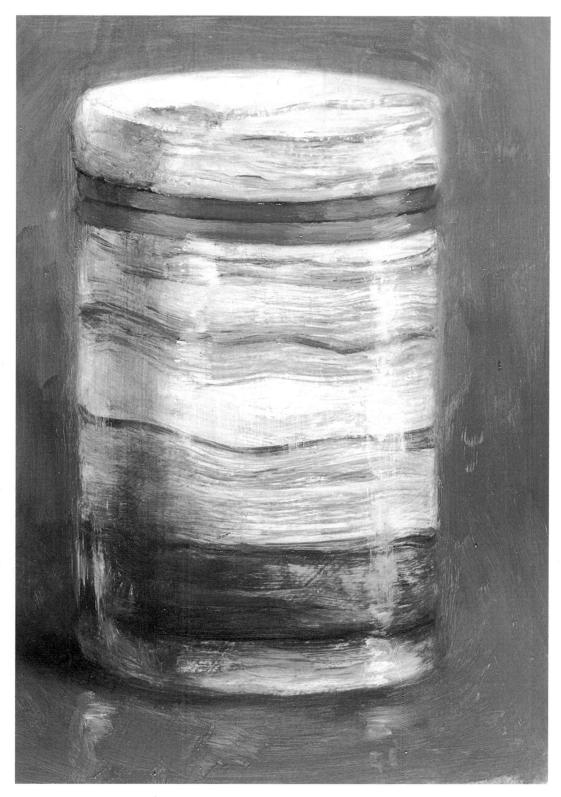

Stage 4. Now I add Venetian red and flake white to my palette. In this stage I am primarily tinting, glazing, or semi-glazing, and for this type of work I use only sable brushes ranging from a #2 watercolor to a 3/8″ (.95 cm) and continue to use the fan brush. My painting medium is Liquin.

With raw umber, ultramarine blue, and flake white, I finish off the background. A darker version of this same mixture is used for the cast shadow on the left and the shadow area directly beneath the cylinder.

To begin work on the cylinder, I create an off-white glaze of flake white adding small amounts of ultramarine blue and raw umber. I then glaze this off-white color over the entire surface of the cylinder. Everything is still visible, but obscured slightly by the thin glaze. The next step is to strengthen the large form shadow on the left side of the cylinder using the background color to do so. I blend this around toward the center of the cylinder, leaving the light area to the far left of the shadow.

Then I reinforce the striations over the glaze and the shadow by using a 1/2″ (1.3 cm) sable brush and sometimes the fan brush for the thin feathery striations. Basically I use the same colors as in Stage 3 except for the bolder lines which now appear. The lower red streaks are Venetian red and raw sienna brushed into the red area and then smoothed out with a 3/8″ (.95 cm) flat sable. The horizontal streak in the middle of the cylinder is burnt umber, and the streak in the middle of the orange area is also burnt umber. Flake white is used for the white highlights. The gold band is smoothed, blended, and strengthened where necessary.

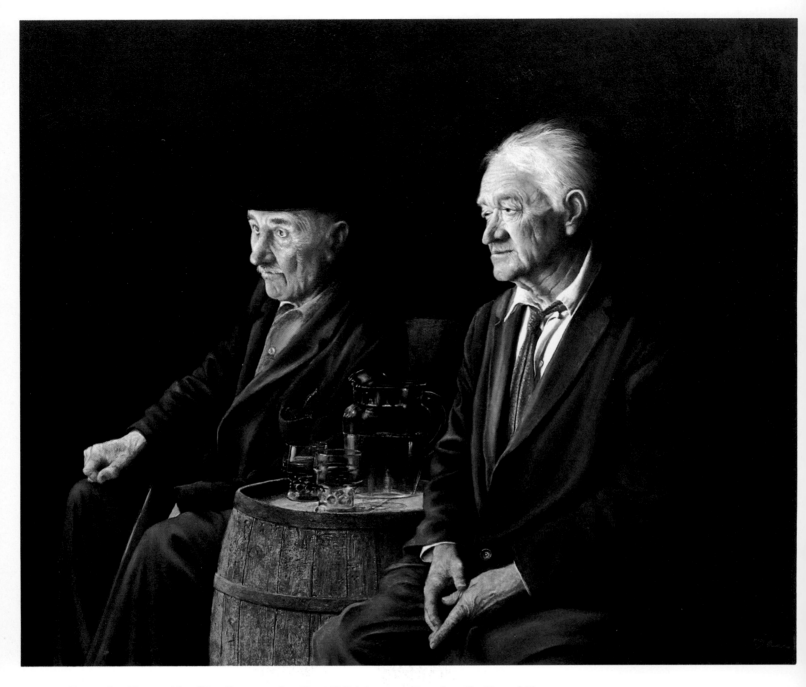

December Years, *(detail), oil on panel, 30" x 40" (76.2 cm x 102 cm), collection of Mr. and Mrs. Robert Sklar. Because there is no ice in the glasses, this was easier to render than the glass of water with ice demonstration. Though the cut glass adds a new point of interest, the main difference between this and the glass of water with ice is the lack of frost.*

GLASS OF WATER WITH ICE

The main problem here is to render two objects that look similar but are physically different—glass and ice. Because they are both colorless, transparent, solid, and have shiny surfaces, they reflect the colors around them. By bringing in the colors seen in the reflections and through the glass, it is easier to create a more accurate rendering of glass and ice. The water in the glass does not present a problem because it can easily be captured with the use of the waterline.

Palette
Ultramarine blue
Phthalo blue
Cadmium orange
Sap green
Yellow ochre
Raw umber
Underpainting white
Flake white

Color Mixtures

1. Raw umber and ultramarine blue are mixed and used as my darkest drawing color in Stage 1, and in Stages 2 and 4 in place of black.

2. In Stage 1, I add underpainting white to the raw umber and ultramarine blue mixture to create a basic middletone which I use to work on the ice and water.

3. For the white in Stages 2 and 3, I mix flake white and underpainting white.

4. Yellow ochre, cadmium orange, and ultramarine blue are combined for the table color.

5. Cadmium orange and the white mixture are blended to render the chair.

6. Raw umber, ultramarine blue, and yellow ochre are mixed for the background.

7. Ultramarine blue and raw umber are mixed for the base and rim of the glass, and for the water in Stage 4.

8. Ultramarine blue, raw umber, and the white mixture are blended for the ice and water in Stages 2 and 3.

9. Both the table color (mixture no. 4) and background color (mixture no. 6) are combined for the cast shadow on the table.

10. Ultramarine blue, sap green, and cadmium orange are mixed for use as a final glaze over the background.

11. Phthalo blue and flake white are combined for the final blue of the water.

Brushes

I use bristle brushes when I need strong brushstrokes, such as in the ice, water, and the bold reflections. The sables are reserved for the glazing, the more refined work, and the small details.

> 1/4" (.64 cm) flat sable
> 3/8" (.95 cm) flat sable
> 1/2" (1.3 cm) flat sable
> 1/4" (.64 cm) naturally curved bristle
> 3/8" (.95 cm) naturally curved bristle
> #2 round watercolor brush with fine point

Painting Surface

I choose a smooth surface to paint on because it will help convey the feeling of the shiny, smooth surfaces of the ice, water, and glass.

Painting Tips

First, water is not blue though everyone associates blue with it. So in order to help identify the water, I add blue. Second, the waterline helps immeasurably to convey the impression of water. And it is more effective to raise the waterline where it flows over the ice.

 As far as painting reflections go, remember that reflections appear on the glass on the opposite side from where they originate. For example, the orange chair is to the left of the glass, but is reflected on its right side. Also, the reflections in the glass offer a good opportunity to bring color into the painting.

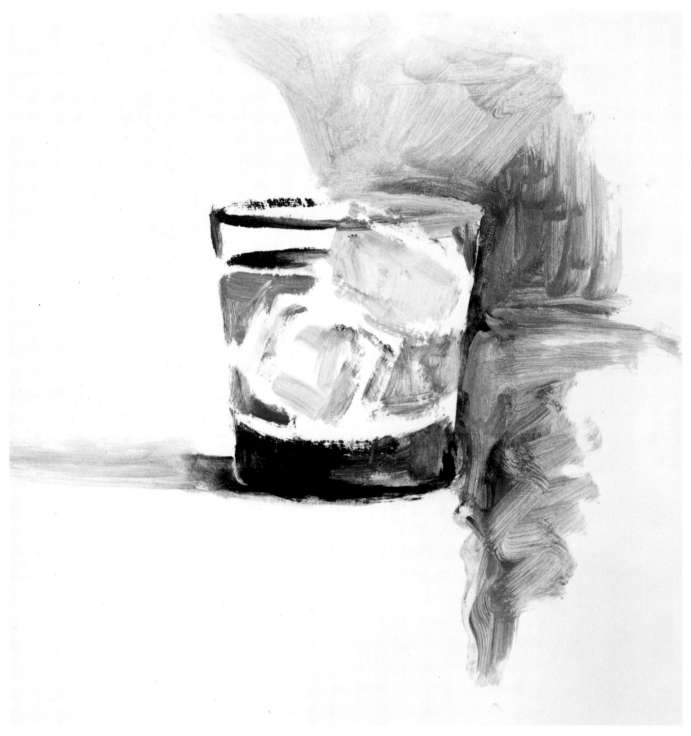

Stage 1. Raw umber, ultramarine blue, and underpainting white make up my palette. In the initial stage my brushes include a 3/8″ (.95 cm) bristle to sketch the glass, water, and ice, and a 1/2″ (1.3 cm) sable for the background and the long shadow cast by the glass.

The raw umber and ultramarine blue are mixed together for the darkest tone which I use around the left part of the rim, for the surface of the water on the left, and for the base of the glass. Now, I add underpainting white to this

mixture to create a middletone which I use to roughly fill in the ice cubes, the background on the right, and the long cast shadow on the left.

For the water, I take ultramarine blue and add a little raw umber and underpainting white. In this stage, I'm basically just roughing in the shapes and proportions. However, I also brush the water mixture into areas that will reflect it later on, such as the ice cubes, the base of the glass, and the right-hand side of the rim. While the paint is still wet, I move on to Stage 2.

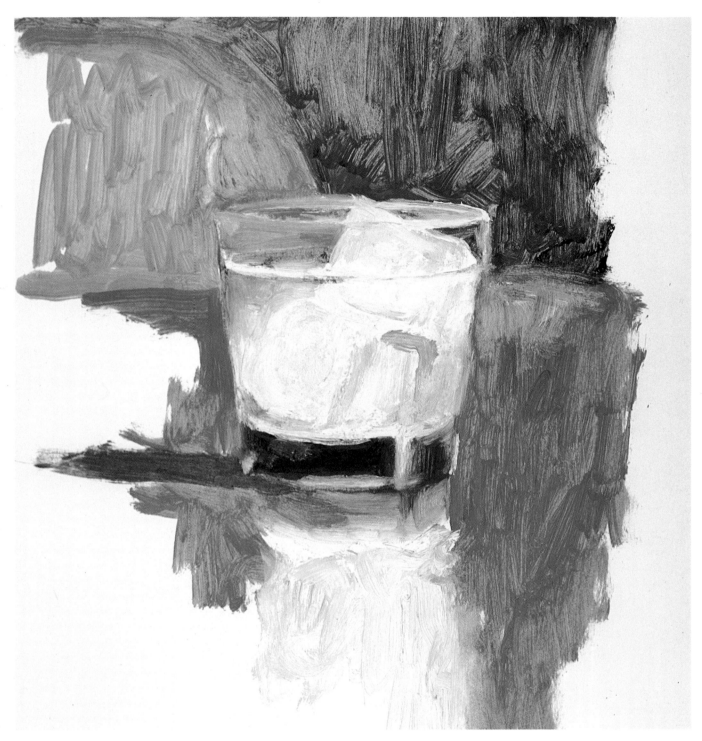

Stage 2. I add cadmium orange, flake white, and yellow ochre to my palette. Two bristles, 3/8″ (.95 cm) and a 1/4″ (.64 cm) are the only brushes I use.

First, I mix flake white and underpainting white together, and use this mixture whenever I need white in this stage and in Stage 3. At this point I am not only interested in developing the glass and its contents, but also in roughing-in the table, the orange chair at the table, and the background.

For me it is easiest to begin by brushing in the table. To do this I mix together yellow ochre, cadmium orange, and ultramarine blue. Next, I brush in the chair by blending a little of the white mixture with cadmium orange. Also, I brush this into the upper left-hand part of the glass so that the color can be seen through it.

Now, I fill in the background with a mixture of raw umber, ultramarine blue, and yellow ochre, which I also use to fill in the glass on the upper right-hand side. For the glass itself, I mix a black made of ultramarine blue and raw

umber which I use to paint in the base and under the upper left rim of the glass. Also, a little black is brushed into the top surface of the water. White is used to accentuate the right side of the rim, and is brushed into the base where you can see a long vertical reflection.

The water and the ice are both mixtures of ultramarine blue, raw umber, and white, with the water having more blue added and the ice more white. The differing amounts of blue and white in the mixture provide all the variations I need to paint both the water and the ice.

For the cast shadow on the left side of the table, I mix both the table color (yellow ochre, cadmium orange, and ultramarine blue) and the background color (raw umber, ultramarine blue, and yellow ochre).

I brush my water and ice color mixture into the table in the foreground to render the large reflection there. Finally, I add a stroke of cadmium orange on the right side of the glass where a reflection of the chair appears. I move on to Stage 3 while this one is wet.

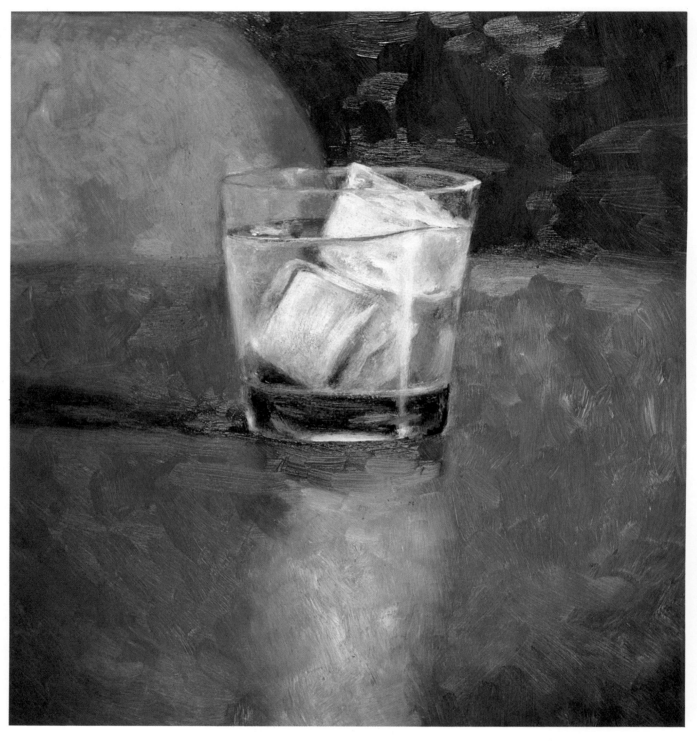

Stage 3. I do not add any new colors to the palette. I use two bristles, a 3/8″ (.95 cm) and a 1/4″ (.64 cm) sable; and a #2 watercolor brush.

Basically, the chair, background, and table are worked in the same manner and with the colors that I used in Stage 2. The dark shadows on the table are rendered by brushing the background color onto the table in the foreground. I continue to use the ultramarine blue, raw umber, and white mixture for both the water and the ice, using various combinations of it to render the shapes of the cubes and to fill in the water more completely. In addition, I use this color to render the left side of the glass and the portion of the rim which appears in front of the orange chair. With a #2

watercolor brush and a dark shade of this combination, I paint in the waterline. Note that the waterline rises as it passes the ice—this always happens when ice touches the glass.

I carefully go over the entire rim with the white just to emphasize it. While doing this, I also blend it slightly into the background and into the chair. The same thing is done with the waterline where the water itself is behind it.

Next, cadmium orange is blended into the glass, the ice, under the rim, and into the base where the reflection of the chair appears. The last thing to add is the slight reflections with the white—the vertical reflection on the right side of the glass and the horizontal one at the base. Before moving to Stage 4, I allow this stage to dry completely.

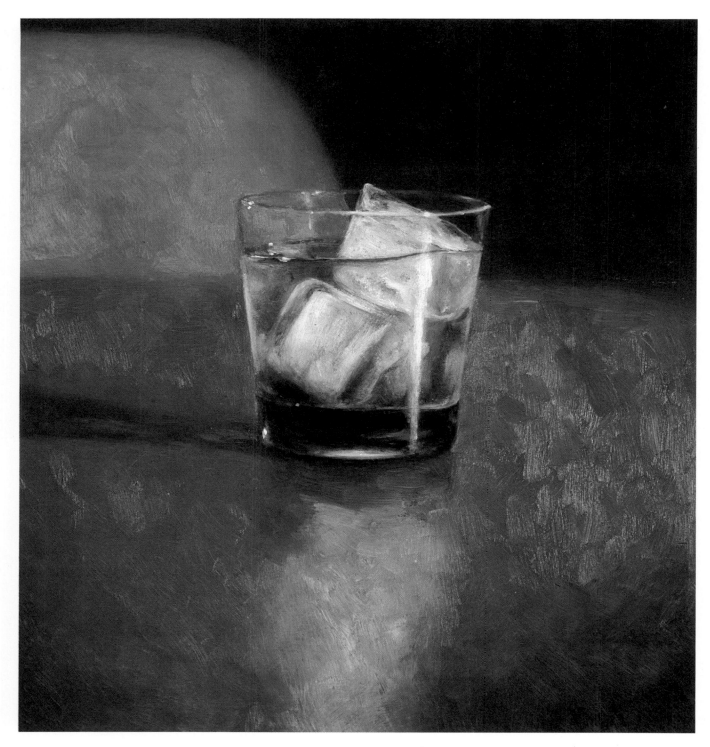

Stage 4. I add sap green and phthalo blue to my palette, and use Winsor and Newton Win-Gel as my painting medium.

At this point, the painting is basically complete, though I still want to strengthen some areas and add a few finishing touches. The table remains the same, as does the chair, except that I blend the edge of the chair into the background with a mixture of cadmium orange and flake white. Then with a 3/8″ (.95 cm) sable brush, I glaze a mixture of ultramarine blue, sap green, and cadmium orange over the background and lightly into the upper ice cube where the color shows through.

To strengthen the blue of the water, I mix phthalo blue and flake white, which I also lightly brush into the rim and into the ice in various spots. For the darker, lower portion of the water, I glaze on a mixture of ultramarine blue and raw umber. This is also glazed on the ice in a few places and into the base of the glass. Wherever I see reflections of cadmium orange, I add them.

With flake white and a #2 watercolor brush, I put the finishing touches on this painting by brushing on the brilliant highlights around the rim, waterline, and base of the glass.

First One Today, *(detail), oil on Masonite, 18" x 27" (46 cm x 69 cm), private collection.*
This mug of beer is quite a contrast to the condensation droplets on glass demonstration.
Few water droplets appear on this mug and the sparkling highlights overpower most
of what is there. In comparison, the glass of iced tea was more carefully done, but if I
rendered the mug in the same manner it would have looked out of place.

CONDENSATION DROPLETS ON GLASS

The problem in this demonstration is to recognize and to render the various forms of condensation, such as dripping, beading, and fogging. It is important to observe all these effects in order to produce an accurate rendering of condensation.

Palette
Ultramarine blue
Venetian red
Yellow ochre
Raw sienna
Raw umber
Chromium oxide green
Flake white
Underpainting white

Color Mixtures
1. Flake white and underpainting white are mixed together for my white.
2. Yellow ochre, ultramarine blue, Venetian red, and white are combined for the gray in the initial drawing.
3. Yellow ochre, ultramarine blue, and Venetian red are mixed for the background and later for the dark tea color.
4. Ultramarine blue, Venetian red, and white are blended for the glass table top.
5. Yellow ochre and white are mixed for the light tea color.
6. The gray mixture (mixture no. 2) and ultramarine blue are used for the cast shadow on the table top.
7. Flake white, raw umber, and ultramarine blue create the frosty glaze.
8. Raw umber and ultramarine blue are mixed for the droplets.
9. Raw umber, ultramarine blue, and flake white are used for the base and stem.
10. Raw umber, ultramarine blue, and raw sienna are mixed for the final glaze on the tabletop.

Brushes
I use bristle brushes to build up the necessary rough-textured undercoating of paint. Then I use sables for the details and other areas.

 1/16" (.16 cm) flat sable
 1/8" (.32 cm) flat sable
 1/4" (.64 cm) flat sable
 3/8" (.95 cm) flat sable
 1/2" (1.3 cm) flat sable
 1/4" (.64 cm) naturally curved bristle
 3/8" (.95 cm) naturally curved bristle
 1/2" (1.3 cm) naturally curved bristle
 #2 round watercolor brush with fine point

Painting Surface
Due to the smooth surface of the glass, I choose a gessoed Masonite board to paint on.

Painting Tip
The key here is to carefully observe the effects of condensation on a glass and to note the various changes that take place. This provides a more accurate idea of what normally transpires and allows you to analyze the forms that can develop. Good brushwork is important here. I have chosen to build up the paint in Stage 3 before adding the finishing details. This seemed the more artistic approach to me, but you may choose to remain more precise throughout. It is strictly a matter of personal preference.

Stage 1. The colors on my palette are yellow ochre, ultramarine blue, Venetian red, flake white, and underpainting white. Turpentine is used as my painting medium, and my brush is a 3/8″ (.95 cm) naturally curved bristle.

Both whites are mixed together to create the one I use. The basic drawing color is created by mixing all the colors on my palette together which produces a medium-toned gray. With this, I brush in the general shapes of the goblet, ice, and waterline.

My main concern now is to accurately render the four ovals appearing in this subject. I am referring to the rim, the waterline, an oval on the stem, and the oval-shaped base. If these ovals are not rendered accurately at this point, I will have difficulties later on with the perspective and it will be quite difficult to correct. I go right on to Stage 2 while this is wet.

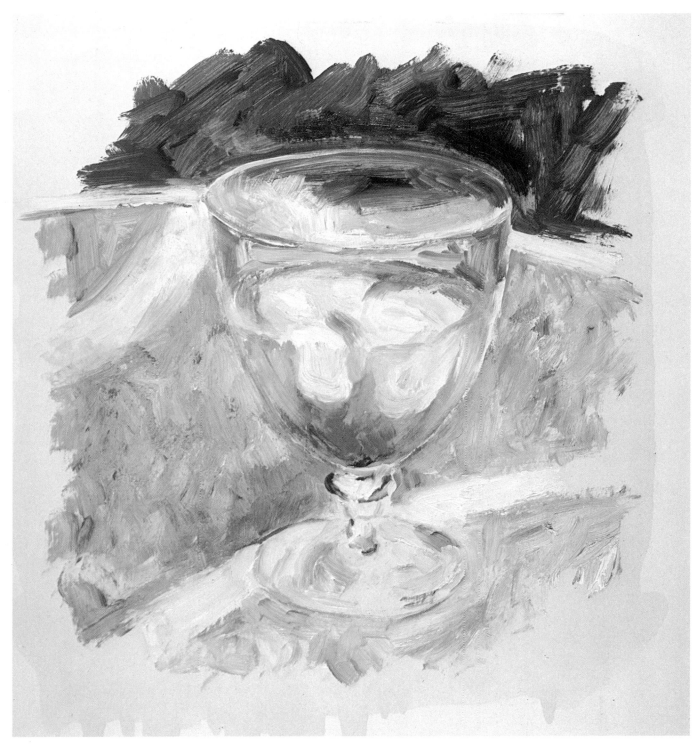

Stage 2. My palette remains the same. The brushes I use are all naturally curved bristles, a 1/4″ (.64 cm), a 3/8″ (.95 cm), and a 1/2″ (1.3 cm). I continue to use turpentine as my painting medium.

This glass of iced tea is resting on a patio table which is a rough-textured glass table top on the white metal frame of a table. In this stage I will render the table, and as I do so the colors I use will be reflected in the glass itself. To provide a rough background color, I mix yellow ochre, ultramarine blue, and Venetian red together.

Using the 1/2″ (1.3 cm) bristle I brush white in the metal part of the table. I then fill in the glass table top with mixtures of ultramarine blue, Venetian red, white, and a little of the gray drawing color in places. These colors are roughly brushed on since this particular table top has a rough frosty surface as opposed to the usual smoothness of glass. For the lightest portions of the tea I use yellow ochre and white, and the darker areas are mostly yellow ochre mixed with a little Venetian red, and ultramarine blue which gives me just the brown I want. The ice cubes are basically white with a little of the tea color blended in.

Inside the rim, I brush in the background color in the upper portion and a gray-white in the lower half. I keep the paint rather thick as I work on the glass because I need to build up texture for the next stage. Between the rim and the tea, I brush in the table top colors since they are reflected there. The stem and base of the glass are basically white but also have the table top colors worked in. I let this stage become sticky which will take a couple of hours.

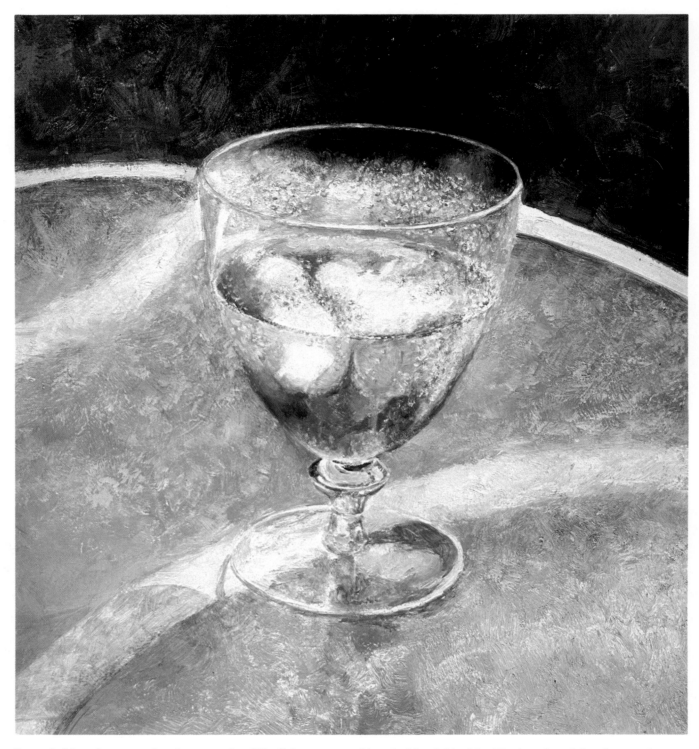

Stage 3. My palette remains the same, but Win-Gel replaces turpentine as my painting medium. For my brushes, I add 1/16″ (.16 cm), 1/8″ (.32 cm), 1/4″ (.64 cm), and 3/8″ (.95 cm) flat sables and continue with the 1/4″ (.64 cm), 3/8″ (.95 cm), and 1/2″ (1.3 cm) naturally curved bristles.

With a 3/8″ (.95 cm) naturally curved bristle, I brush a mixture of yellow ochre, Venetian red, and ultramarine blue onto the background. Using the gray and white, I brush in the rim of the table. I continue to use the same table top colors as in Stage 2, brushing and scumbling them together until the table has a more finished appearance. The shadow cast on the table top to the lower left of the glass is the gray mixture with a little ultramarine blue. With a 3/8″ (.95 cm) flat sable, I brush this mixture on smoothly and thinly in a manner similar to glazing.

The tea and ice are more highly defined using the same colors as in Stage 2. The waterline is a dark brown with

bits of white dabbed in. The interior of the rim area is smoothed and refined by using both the background colors and the table top colors wherever they appear. Around this, the rim itself is defined by brushing on white with 1/8″ (.32 cm) and 1/16″ (.16 cm) flat sables.

With sable brushes and using a pulling-brushing technique, I simulate the frosty sides of the glass where the droplets of condensation will next be brushed in. The pulling-brushing method is a light scumbling technique that is applied with little pressure to a half-wet (sticky) surface. I don't use a specific color for this—whatever the existing color is at that point is what I use.

For the droplets of moisture, I brush on small dabs of white. To emphasize the shape and density of the drops, I add thin U-shaped lines of ultramarine blue directly underneath many of the droplets. Finally, the stem and the base are smoothed out, incorporating the surrounding colors that are reflected. I now allow this to dry completely.

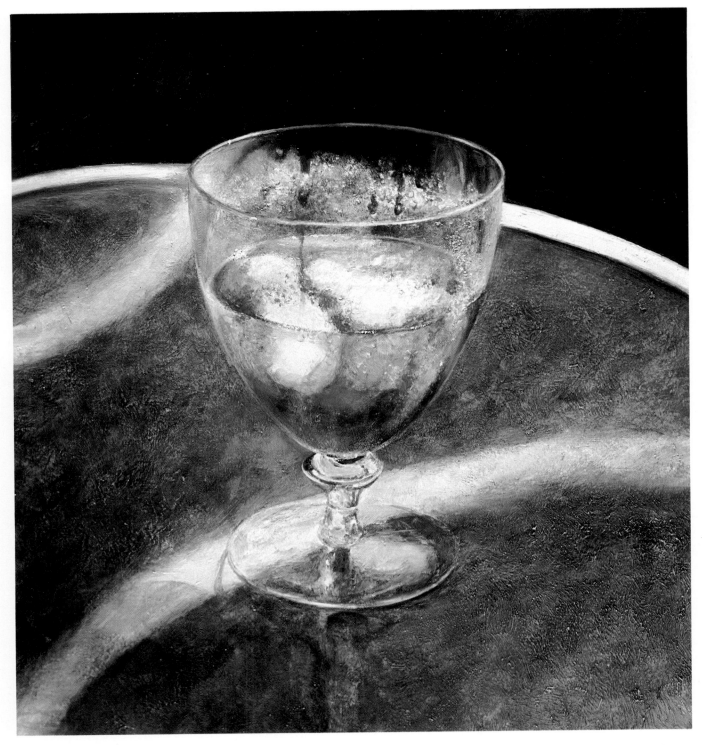

Stage 4. I add raw umber, raw sienna, and chromium oxide green to my palette. Two painting mediums are used in this stage, Liquin and Win-Gel. I use sable brushes exclusively, varying from a #2 watercolor brush to flat sables 1/8″ (.32 cm) to 1/2″ (1.3 cm) in width.

With raw umber, I glaze over the background and the top of the glass through which the background is seen. Into the background area I dab in chromium oxide green to help convey the feeling of being outside.

To capture the frosty appearance of the glass, I mix flake white with a little raw umber and ultramarine blue which creates an off-white blue-gray. I then glaze this over most of the bowl of the glass, except in the areas that will appear cloudy and frosted. On the upper part, where the droplets are trickling down and for similar dark effects of this type, I brush on a combination of raw umber and ultramarine blue. With a #2 watercolor brush, I dab on flecks of flake white for the glistening highlights on the condensation.

The color of the tea is reinforced with raw sienna wherever necessary.

I more clearly define the base and the stem with raw umber, ultramarine blue, and flake white. For the table top, I first glaze over it with a combination of raw umber, ultramarine blue, and raw sienna. After letting this become sticky for a couple of hours, I then drag flake white over the surface.

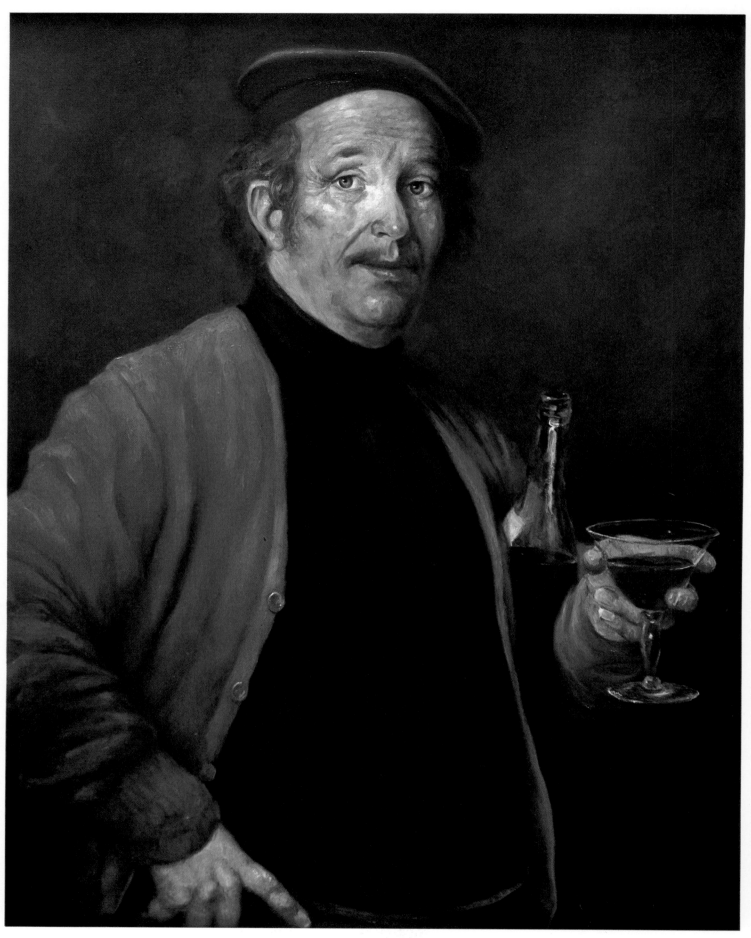

Man with a Bottle of Wine, oil on canvas, 24" x 30" (61 cm x 76.2 cm), private collection.
The velvet beret is of course the same as the one in the next demonstration. Compare the
differences in highlights of the beret—the way the light lays softly on top. Note the
way the highlights lay softly on top of the beret.

VELVET BERET

The main problem with velvet is in rendering its highlights—they should appear on top of the velvet and they should look soft. When a highlight does not blend into the surrounding area, it usually indicates a hard surface. Highlights fall sharply on velvet and stay relatively confined, much as they do on a hard surface. The trick is not to let this phenomenon trick your eye into thinking the surface is hard instead of soft.

Palette
Ultramarine blue
Cadmium red deep
Chromium oxide green
Yellow ochre
Raw umber
Flake white
Ivory black

Color Mixtures
1. Cadmium red deep and ultramarine blue are mixed for the purple.
2. Chromium oxide green and yellow ochre are combined for the beginning stages of the background.
3. Cadmium red deep and ultramarine blue are blended for the red in the beret.
4. Cadmium red deep, ultramarine blue, and raw umber create a dark shadow zone.
5. Flake white is mixed with the red mixture for the highlights.
6. Raw umber, ultramarine blue, and flake white are mixed for the final background.

Brushes
To capture the elements of the beret, I begin by using a bristle brush. To finish, I use only sable brushes which help create a final, very soft effect. Specifically they are:

 1/4″ (.64 cm) flat sable
 3/8″ (.95 cm) flat sable
 3/8″ (.95 cm) naturally curved bristle

Painting Surface
If a subject has a smooth, slick surface, a panel is an ideal surface to work on. However, even though velvet is smooth, its underneath texture is not so smooth, so I decided to render it on canvas in order to help capture this elusive quality.

Painting Tips
The problem is to soften the highlights just enough but not too much. I find it helpful to use my finger to soften highlights. To the best of my knowledge, fingers have been used as painting tools for many years, and it is certainly permissible in this situation to do so.

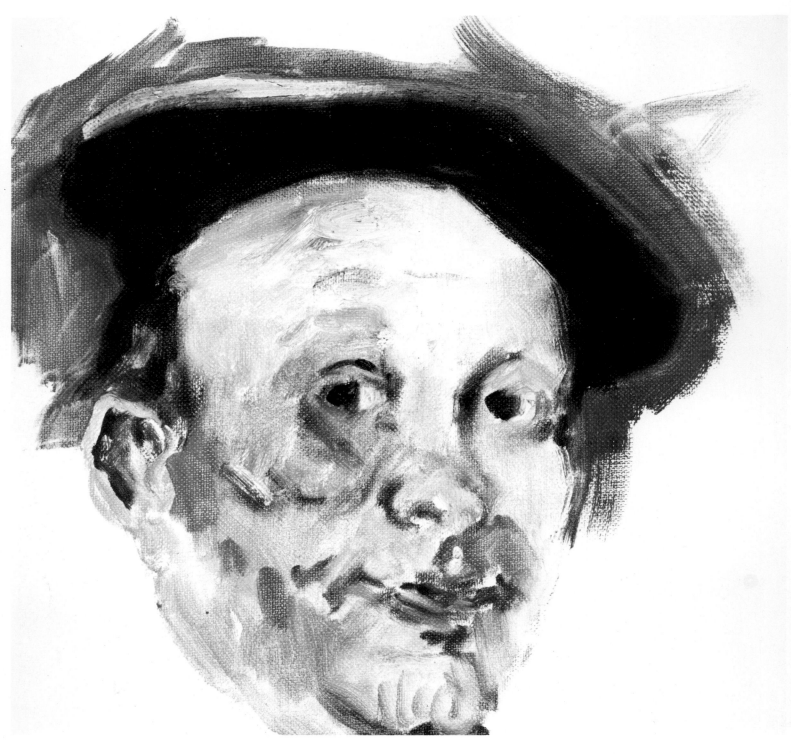

Stage 1. My palette consists of chromium oxide green, yellow ochre, cadmium red deep, ultramarine blue, and flake white. Turpentine is my medium, and I work exclusively with a 3/8″ (.95 cm) naturally curved bristle brush.

To properly render a velvet beret, it needs a head to rest on. Since face and skin tones are very complicated, I shall not attempt to provide detailed procedures on the rendering of this portion. If you need information about how to paint a head, it is available in one of my earlier books, *Character Studies in Oil*.

My primary aim in this stage is to brush in the general shape of the beret. To do this I mix cadmium red deep and ultramarine blue which creates a deep purple. I also make sure the beret is positioned properly on the man's head. Then, I rough in the highlight on the upper left side with flake white.

To provide a background, I mix chromium oxide green and yellow ochre, and brush this around the beret. While this stage is wet, I move right on to Stage 2.

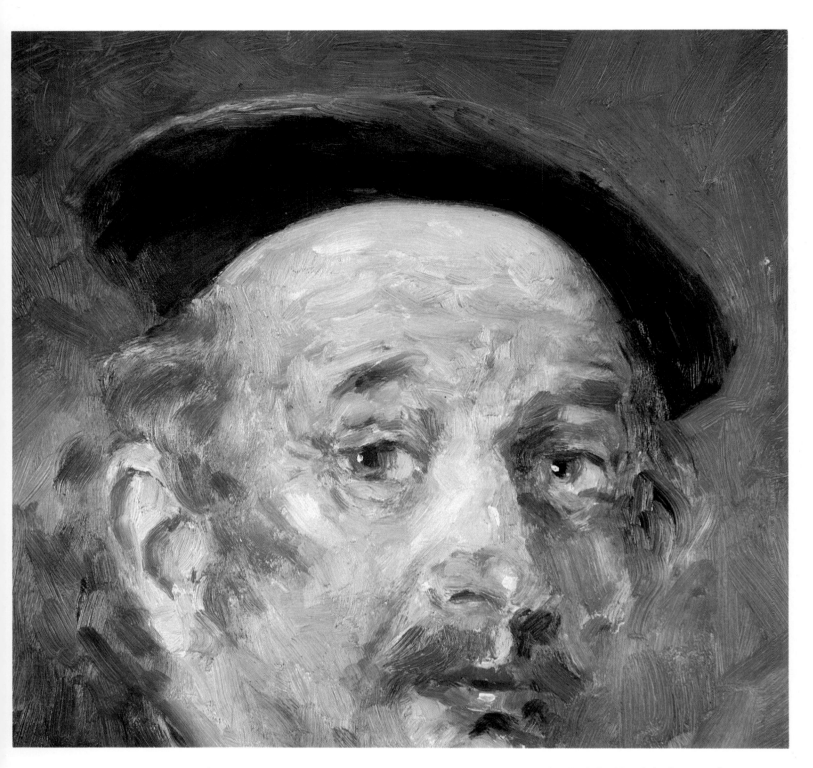

Stage 2. I continue to use the same 3/8″ (.95 cm) naturally curved bristle brush, and turpentine remains my medium. Raw umber is the only new color I add to the palette.

Three color mixtures are used to render the beret. One is the purple mixture which was used in Stage 1. Next with the same cadmium red deep and ultramarine blue, I create a red mixture, but add considerably more red. Finally, to create a very dark mixture, I mix cadmium red deep, ultramarine blue, and raw umber with the emphasis on the ultramarine blue and raw umber. These three mixtures give me the various tones and subtleties I need to give texture and shape to the beret.

I use the red mixture on the left side of the beret and blend it gradually into the purple. The very dark mixture is for the deepest shadows, such as around the band and under the crown on the right side. I use the purple mixture in any of the other areas where needed. For the highlight, I mix flake white with the red mixture and brush it into the top of the beret. I blend the mixture into the beret and slightly into the background.

The background color is the same mixture used in Stage 1, with a bit more of the chromium oxide green added. I go right on to Stage 3 while this is wet.

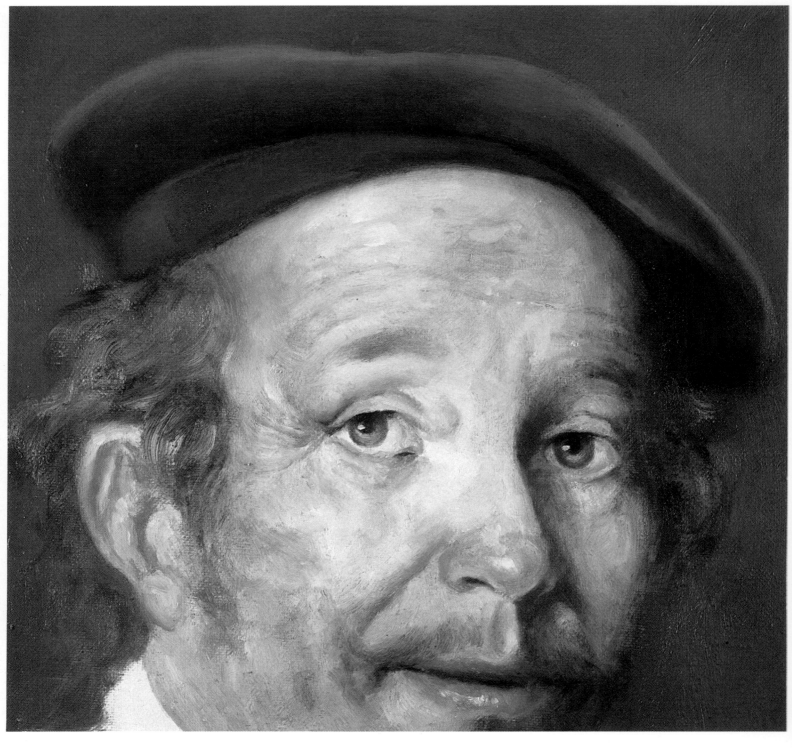

Stage 3. I continue to work with the same brush and still use turpentine.

In this stage I primarily blend, smooth, and soften everything to help render the essence of velvet. As I work the existing colors into a soft blend, I paint over most of the brushstrokes done in Stages 1 and 2. This is purposely done—to help capture the extreme softness of the fabric.

After the entire beret has been softened and all colors, even the highlights, are blended together I put some detail back in. Where the beret dips on the right side, I brush in a long highlight with the same highlight color (flake white

and the red mixture) used in Stage 2. Also I add a little on the left side of the band and blend it thoroughly. Using thin streaks of the dark mixture, I accentuate both the upper and the lower edges of the band. Just below this dark streak at the top of the band, I lightly brush in a thin streak of flake white and blend it downward, but not up into the dark crease.

For a softening effect, I softly brush the outer edges of the beret into the background and the forehead. To smooth out the background, I add a little raw umber and flake white into the color that is already there. This stage is allowed to dry completely before proceeding.

Collection of Mr. and Mrs. P. J. Mullaney (velvet)

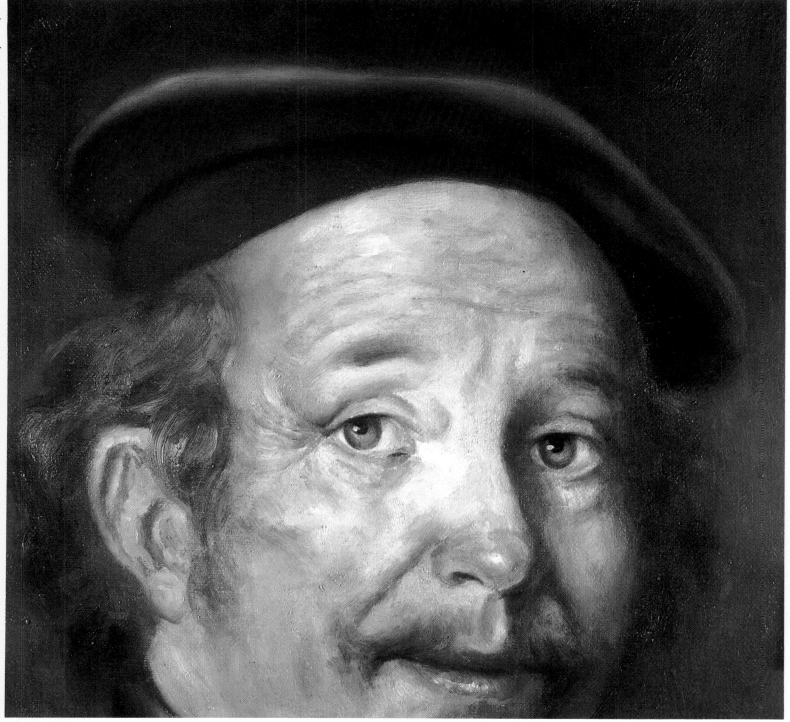

Stage 4. My painting medium changes to Winsor and Newton Liquin. Since capturing softness is the goal here, I only use two sable brushes in this stage—a 1/4″ (.64 cm) and a 3/8″ (.95 cm). The only new color added to my palette is ivory black.

This demonstration could easily have been called complete at the end of Stage 3. The differences between this stage and Stage 3 are very subtle, and all I really do in this stage is to advance the subject to a higher degree of softness.

For the background, I blend raw umber, ultramarine blue, and flake white. To begin, I lightly glaze a combination of cadmium red deep and ultramarine blue over the beret area. I add flake white to lighten this red and blue mixture and brush this into the highlighted areas, highly blending it into the purple. Where I brushed this into the top of the beret, I also blend it into the background to soften the effect.

I deepen the basic purple mixture with more ultramarine blue and work it in carefully where the darker purple appears, again making sure to blend it into surrounding areas. Finally, a little black is brushed into the very darkest areas—the deep shadow on the right and the crease at the top of the headband.

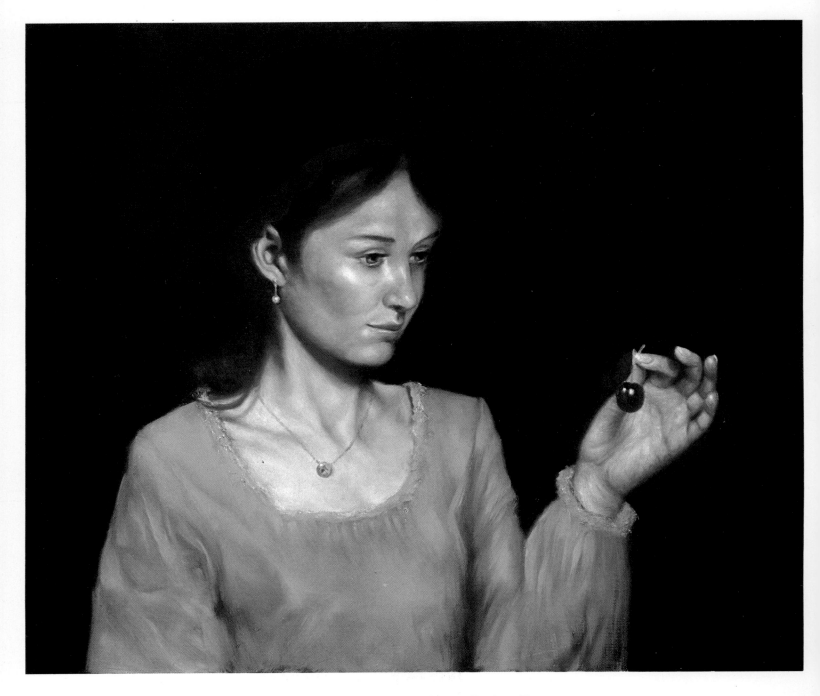

Girl with a Cherry, *oil on canvas, 20" x 24" (51 cm x 61 cm), private collection. The carefully rendered yellow fabric in this painting was as difficult to paint as the heavy fabric with design in the next demonstration. Here the problem was to render the soft wrinkles and nuances of this smooth fabric, and show the form beneath the dress. There was no buildup of paint as in the heavy fabric demonstration, but rather a thinner and smoother application of paint.*

HEAVY FABRIC WITH DESIGN

As I see it, the main problem is to simultaneously render the pattern and the heavy texture of the fabric. This becomes especially challenging as the pattern rounds in and out of the heavy folds. It is more important to convey the heavy feeling of the fabric than to capture the details of the pattern.

Palette
Ultramarine blue
Venetian red
Cadmium red deep
Chromium oxide green
Yellow ochre
Raw umber
Underpainting white
Flake white

Color Mixtures
1. Ultramarine blue and Venetian red are mixed to create a violet that is used as my basic color and for accents.

2. Yellow ochre, cadmium red deep, underpainting white, and the violet mixture are combined for the skin tone.

3. Chromium oxide green and underpainting white are mixed for the light areas of the fabric.

4. Chromium oxide green and the violet mixture are used for the shadows and folds of the fabric.

5. Flake white and underpainting white are mixed for the white in Stage 4.

6. Ultramarine blue and raw umber are blended for the final background.

Brushes
I use the bristle brush for the texture of the fabric. To capture details I usually rely on the watercolor and sable brushes. Specifically they are:
 1/4″ (.64 cm) flat sable
 3/8″ (.95 cm) flat sable
 1/2″ (1.3 cm) flat sable
 1/4″ (.64) naturally curved bristle
 #2 round watercolor brush with fine point

Painting Surface
Since the texture of the subject is basically rough, I feel it isn't necessary to capture exact details. Therefore, I choose to work on canvas.

Painting Tips
First, try to capture the feel and folds of the heavy fabric before attempting to paint on the design. Second, strive to capture the essence of the pattern rather than duplicating it exactly. No one will be aware that it is not exact, and it certainly makes the painting more "painterly."

Stage 1. The two colors on my palette are ultramarine blue and Venetian red. I use 3/8″ (.95 cm) and 1/2″ (1.27 cm) sable brushes.

In this stage, my main concern is to establish the major folds and shadows and to capture the general shape of the fabric. To help create interest and purpose for the fabric, I drape it on a model.

I blend my two colors together to create a mixture I use exclusively in this stage, and thin the mixture with turpentine to the consistency of a wash. This mixture creates a violet undertone that will give subtle contrast to the green fabric later on. While this stage is still wet, I move on to Stage 2.

Stage 2. In addition to the violet mixture on my palette I add yellow ochre, cadmium red deep, underpainting white, and chromium oxide green. I work with the same 3/8″ (.95 cm) and 1/2″ (1.3 cm) sables as in Stage 1 and add a 1/4″ (.64 cm). Damar resin is my painting medium.

The skin tone is a mixture of yellow ochre, cadmium red deep, underpainting white, and the violet mixture. For the fingernails, I use only cadmium red deep. To render the fabric I fill in the entire area with chromium oxide green, paying close attention to capturing the large folds, shadows, and indentations which denote the heavy texture of the fab-

ric. The palest, highlighted areas are also very important to help emphasize the feeling of heaviness, so I'm careful not to overlook them.

For the lightest areas I use chromium oxide green mixed with underpainting white. The shadows and folds are chromium oxide green mixed with the violet mixture, and chromium oxide green is used alone for the overall green of the fabric. The violet mixture and a small amount of chromium oxide green are used to fill in the background. I start working on Stage 3 before Stage 2 has time to dry.

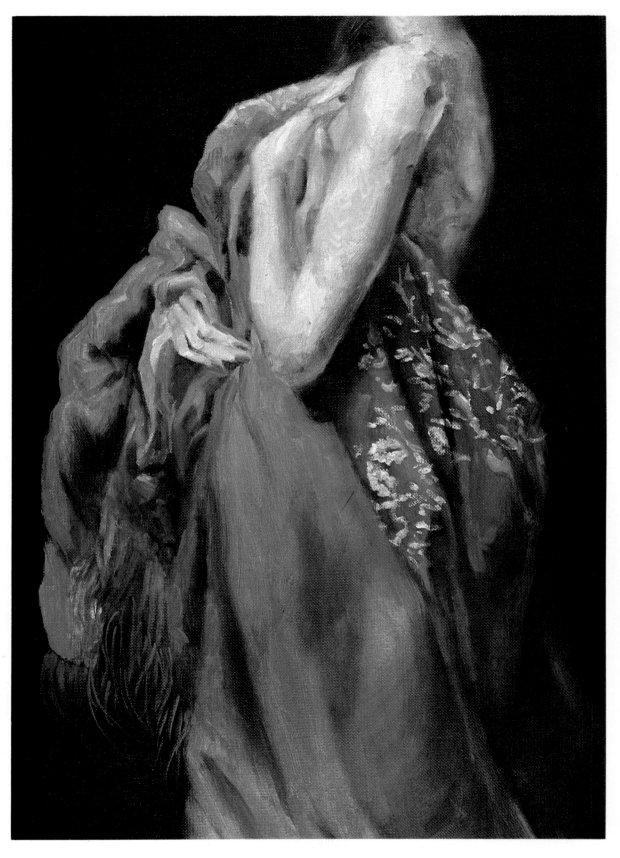

Stage 3. This stage is different from the others in that I only work on one part of the drape to enable you to see more clearly what I am doing and how I am doing it.

I begin using a 1/4″ (.64 cm) bristle brush, a #2 watercolor brush, and underpainting white. The pattern is roughly painted onto the green fabric rather thickly. As I work, I blend a little so the design doesn't look stuck on. Actually, since I work wet into wet (which prevents hard edges from developing in the design), this happens almost naturally anyway. The particular thing I have to watch out for is to render the design with equal intensity throughout and not to allow myself to become lazy.

Where the design is added over a dark fold area, I come back in with the violet mixture to reemphasize the fold. I continue in this manner until the entire fabric is covered with the pattern. In addition, I use the violet mixture to darken the background. While this stage is wet, I go on to Stage 4.

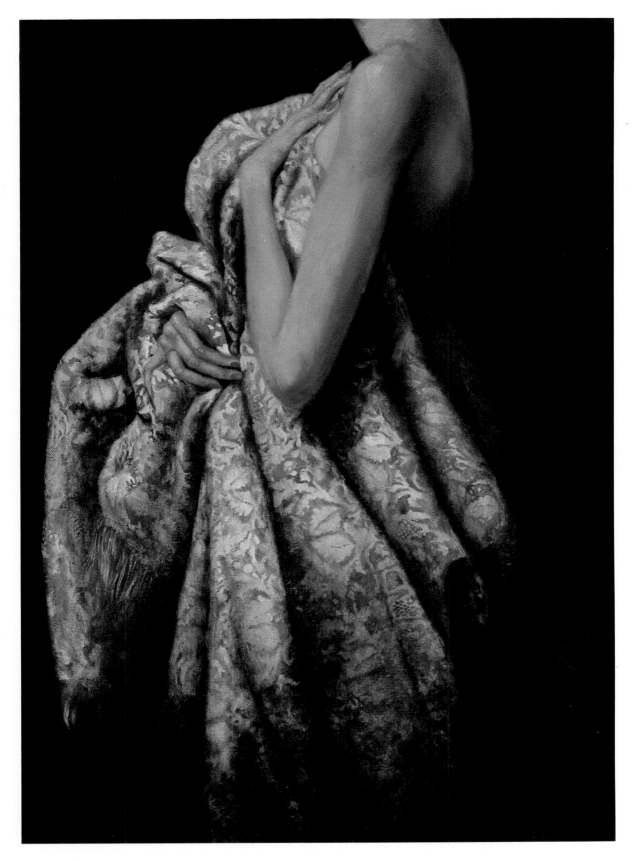

Stage 4. Raw umber and flake white are added to my palette.

Flake white is mixed with the underpainting white for this stage. Using a #2 watercolor brush and the white mixture, I go back over the design to strengthen it and render it more precisely—but not too precisely. I take many liberties with the design. Only the essence of the pattern is necessary, so the more intricate the pattern the less exacting I have to be—especially where folds are involved. In other words, a simple stripe would require more precise rendering than a complex design.

As the pattern falls into the shadowy folds I add chromium oxide green or violet to the white, blending it well, to maintain the rounded depth of the folds. The background is finished with a mixture of ultramarine blue and raw umber, and the skin tones of the model are smoothed out and rendered until I feel satisfied they are complete.

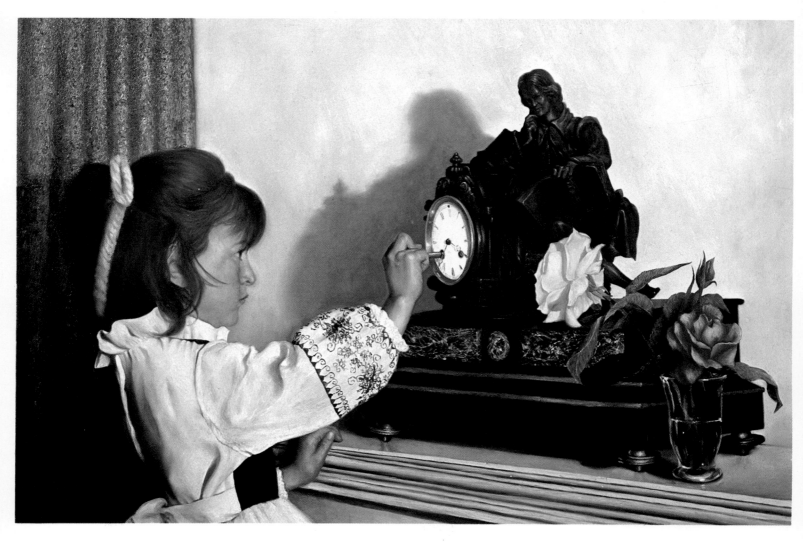

Girl Winding the Clock, *oil on Masonite, 20" x 28" (51 cm x 71.1 cm), private collection. I used the same technique here as in the roses demonstration. When I painted this piece several years ago, the new alkyd painting mediums (Liquin, Win-Gel) were not on the market. Therefore, the only difference is that I used Damar painting medium, which I did not like as well.*

ROSES

The chief problem in this demonstration is to simultaneously capture the soft gradations of color and the delicate texture of the petals. Because of the various colors in a rose, it is difficult to create the impression of one color, keep it vibrant, and integrate all the other subtle colors found in the highlights and shadows.

Palette
Ultramarine blue
Cerulean blue
Cadmium red deep
Cadmium red light
Rose madder deep
Lemon yellow
Cadmium yellow deep
Yellow ochre
Sap green
Raw umber
Ivory black
Flake white

Color Mixtures
1. Flake white and cadmium yellow deep are mixed for the yellow rose.
2. Flake white and cadmium red light are blended for the pink rose.
3. Flake white and cadmium red deep are combined for the red rose.
4. Yellow ochre and ultramarine blue are combined for the dark separation between the roses and the other leaves.
5. Cadmium red deep, ultramarine blue, and flake white are combined for the early shadows in the pink rose.
6. Cadmium red deep and ultramarine blue are mixed for the early shadows of the red rose.
7. Raw umber and flake white form the initial background.
8. Ultramarine blue, cadmium red deep, and flake white are mixed for the deep shadows in the red rose.
9. Yellow ochre and ultramarine blue are mixed for the leaves.
10. Raw umber, cerulean blue, and flake white create the final background.
11. Yellow ochre and lemon yellow mix to strengthen the yellow rose.
12. Rose madder deep and ultramarine blue create the final shadows of the red rose.
13. Sap green and ivory black are used for the final dark leaves.
14. Lemon yellow, yellow ochre, and sap green combine for the light portions of the leaves.

Brushes
Because of the delicate tinting and glazing involved, I work exclusively with sables. Also I use sables because I do not want any rough brushstrokes to disturb the soft texture of the petals.

 1/16" (.16 cm) flat sable
 1/8" (.32 cm) flat sable
 1/4" (.64 cm) flat sable
 3/8" (.95 cm) flat sable
 1/2" (1.3 cm) flat sable
 #2 round watercolor brush with fine point

Painting Surface
In order to give myself every advantage in rendering the soft texture of the petals, I use the smoothly gessoed surface of a Masonite panel.

Painting Tips
In order to produce the best results, it is important to use the right brushes. I advise using sables to ensure the smooth brushstrokes necessary for conveying the delicate character of the rose.

Stage 1. Initially, I select cadmium red light, cadmium red deep, cadmium yellow deep, flake white, yellow ochre, and ultramarine blue for my palette. I use turpentine as my painting medium and two flat sables, a 3/8″ and a 1/4″.

Even though this stage of the demonstration is reproduced in black and white, I do not actually begin with neutral colors. My main concern is to capture the general shape and relative positions of the flowers, and I use colors similar to the actual rose colors to do this.

The rose at the top is yellow and I brush in its general shape with a mixture of flake white and cadmium yellow deep. For the pink rose to the left I use flake white and cadmium red light. The red rose on the right is cadmium red deep mixed with a little flake white. For the dark area separating the three roses, I use a combination of yellow ochre and ultramarine blue. While this stage is still wet, I move on to Stage 2.

Stage 2. Raw umber is the only color I add to my palette. I continue working with the same brushes, but my painting medium changes to Win-Gel.

Into the basic rose colors I have painted, I brush dark tones of each rose color to begin delineating the various petals. To indicate the petals in the yellow rose I use yellow ochre; for the pink rose I mix cadmium red deep, ultramarine blue, and flake white; and for the red rose I use cadmium red deep and ultramarine blue, not always mixed.

The darks in the red rose vary in depth more than in the other two, so I use the two colors separately and mixed to provide the variations I need.

The dark separation between the flowers remains the same as in Stage 1, though it is extended a little lower in this stage. I brush in an elementary background of raw umber and flake white. While this stage is wet, I move on to Stage 3.

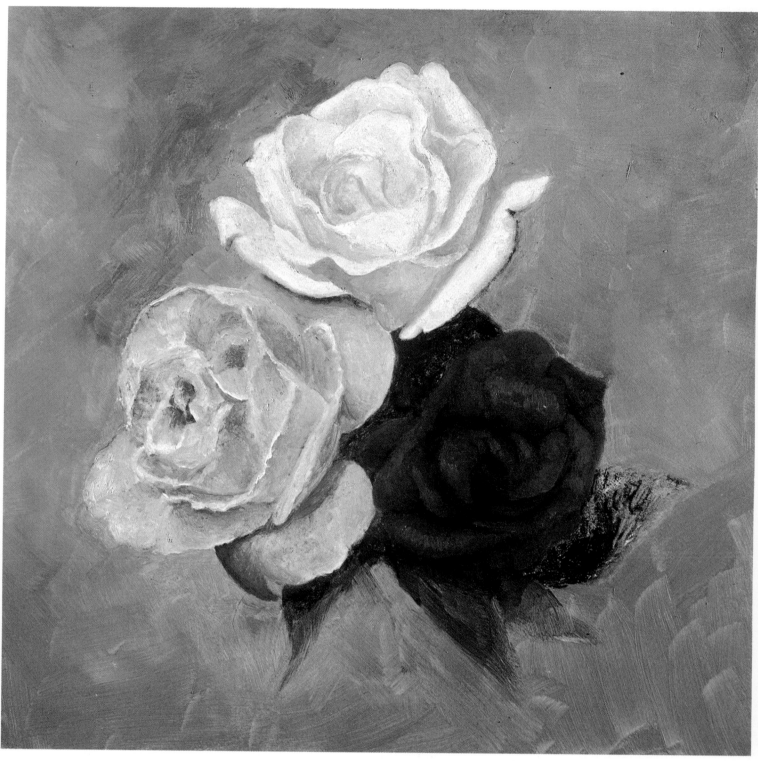

Stage 3. My palette remains the same. The painting medium I now use is Liquin. My brushes include the two I have been using and a #2 watercolor brush, 1/16″ (.16 cm), 1/8″ (.32 cm), and 1/2″ (1.3 cm) flat sables.

The same background color in Stage 2 is now used to fill in the background fully. Small amounts of the background color are brushed into both the yellow and pink roses to help define the petals and shadows. Everything is carefully blended in these two flowers to clearly define the petals and their shapes. Where necessary, flake white is added for def-

inition and accent along the petal tops, especially in the pink rose.

For the red rose, I carefully blend colors and define shapes. A combination of ultramarine blue, cadmium red deep, and flake white is used for the very dark shadows. I continue blending and refining the three roses until I am satisfied that I have captured the various delicate shapes of the petals.

The green leaves are a combination of yellow ochre and ultramarine blue with streaks of flake white for highlights on the leaf on the far right. I now allow this stage to dry completely.

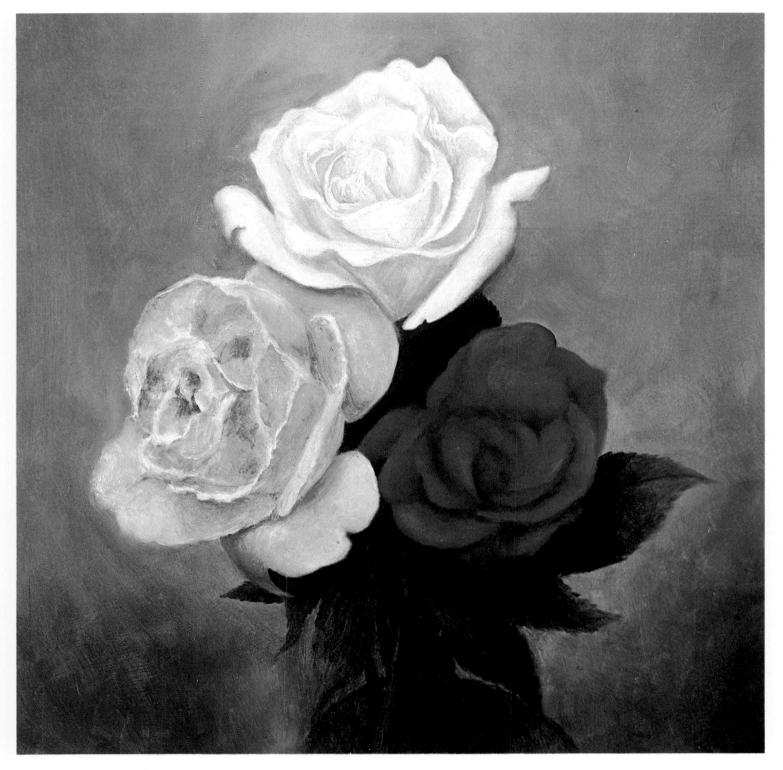

Stage 4. The following colors are added to my palette— lemon yellow, rose madder deep, sap green, ivory black, and cerulean blue. I use the same brushes, and Liquin remains my painting medium.

The background is finished off with a combination of raw umber, cerulean blue, and flake white. To complete the yellow flower, I begin by brushing on a thin glaze of lemon yellow mixed with Liquin. I then mix yellow ochre and lemon yellow and use this to strengthen the shadow areas. Into the deepest portions of the shadows I also brush in a little of the background color using small sables. For the lighter portions of the petals I brush small amounts of flake white into the glaze that is already there. To render the white highlights I brush on flake white with a #2 water-color brush, primarily along the edges of the petals.

For the pink flower, I brush over the top with Liquin.

Then, I strengthen the pinkest parts with rose madder blended carefully into the rest of the rose. To capture the shadows, I carefully blend in the background color. As with the yellow, I use flake white for the white highlights, brushed on with a #2 watercolor brush.

To begin the red rose I brush on a thin glaze of rose madder deep mixed with Liquin. The dark shadows are brushed in with rose madder deep and ultramarine blue. Flake white is brushed into the lighter areas of the petals.

The dark leaves in the middle of the roses are sap green and ivory black. This combination is used for other dark areas of the leaves and the lighter portions are lemon yellow, yellow ochre, and sap green. The little points along the edges of the leaves are rendered with a #2 watercolor brush.

Man with an Orange, oil on Masonite, 16 1/2" x 16 1/2" (42 cm x 42 cm), collection of Mr. and Mrs. Milton Gelman. "You can't make an apple out of an orange." I don't know who said this, but it holds true in art. Look at the next apple demonstration and compare the difference in textures–the roughness of the orange peel and its glistening interior as opposed to the apple's slick peel and the more solid off-white interior color.

DEMONSTRATION 16

APPLES

The main problem is not with the red skin of the apple but with its interior. Almost as soon as it is exposed to the air, the interior begins to take on a brownish effect. The difficulty lies in rendering this subtle color change without overdoing it.

Palette
Ultramarine blue
Venetian red
Cadmium red
Cadmium red light
Cadmium yellow light
Yellow ochre
Raw sienna
Burnt umber
Raw umber
Flake white
Underpainting white

Color Mixtures
1. Venetian red, cadmium red, and ultramarine blue are mixed for the initial red peel.
2. Venetian red, cadmium red, ultramarine blue, yellow ochre, and flake white combine for the initial background and for the seeds.
3. Ultramarine blue and flake white are mixed for the edge of the plate and in Stage 3 for the long highlight near the stem.
4. Ultramarine blue, Venetian red, and flake white are mixed for the cast shadows on the plate.
5. Yellow ochre, Venetian red, ultramarine blue, and flake white are all mixed in various degrees and used for the advanced background, the table, the shadow under the plate, and the plate's reflection on the table.
6. Ultramarine blue and flake white with a small amount of Venetian red are used for rendering the plate.
7. Yellow ochre, Venetian red, and ultramarine blue are mixed for the yellowish-brown interior of the apple.
8. Ultramarine blue, Venetian red, and yellow ochre are mixed for both the seeds and the stem.
9. Ultramarine blue and raw umber are mixed for the final background, the shadow under the plate, and the dark areas of the peels in Stage 4.
10. Cadmium yellow and ultramarine blue create the green for the apples.
11. Cadmium red light, yellow ochre, and cadmium yellow are blended for the bright red on the peels.

Brushes
Apples are basically smooth, so I use sable brushes most of the time. I also incorporate a bristle brush.
 1/8″ (.32 cm) flat sable
 1/4″ (.64 cm) flat sable
 3/8″ (.95 cm) flat sable
 1/2″ (1.3 cm) flat sable
 3/8″ (.95 cm) naturally curved bristle
 #2 round watercolor brush with fine point

Painting Surface
I select a gessoed Masonite panel since it will help me best convey the shiny smooth surface of the apple peel.

Painting Tips
In order to render the brownish color of the exposed interior, allow the white underpainting to become sticky before scumbling brown over it. The tackiness of the white allows the brown to mix lightly into it as the brown is pulled across the top surface during scumbling. What actually results is a technique that combines both wet into wet and glazing. In painting apples, the final subtleties are the most important part because they unify and enhance the composition.

Stage 1. My palette consists of Venetian red, cadmium red deep, ultramarine blue, yellow ochre, and flake white. In this stage I work exclusively with a 3/8″ (.95 cm) naturally curved bristle brush and use turpentine for my painting medium.

First, I brush in the correct shapes in relation to each other. To do this, I leave the interior of the apples unpainted, and paint in the red peels. Also, to round off the general shapes, I brush in the beginning of the background.

For the red peel, I mix together Venetian red and cadmium red deep and then add a slight bit of ultramarine blue. The brown of the background is a mixture of all the colors on the palette. While this is wet, I go on to Stage 2.

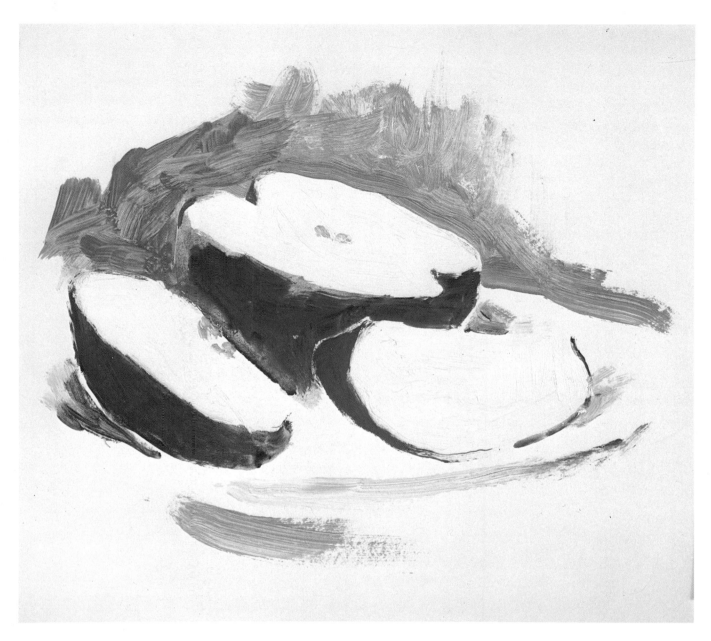

Stage 2. Underpainting white is added to my palette. My brush remains the same, and I continue using turpentine as my painting medium.

To begin, I brush underpainting white thickly into the inside portions of the apples. I work carefully within the peels so none of the red accidentally blends into the white. The background color is the same as Stage 1, and I use this to dab in the apple seeds. I also brush more of the background in.

The edge of the plate is indicated by using ultramarine blue and flake white. The white surface of the plate remains unpainted. A streak of background color is brushed in below the plate to indicate the bottom of it. The apples cast shadows on the plate, which I roughly indicate by combining ultramarine blue, Venetian red and flake white.

Before proceeding any further, I let the white of the apples become sticky, but not dry. I allow this stage to sit two or three hours before continuing.

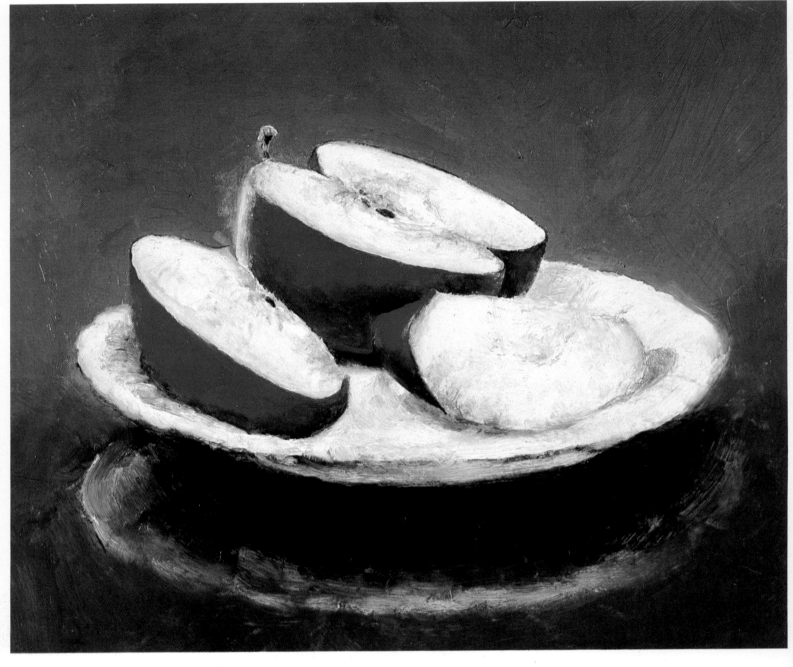

Stage 3. Cadmium red light is added to my palette, and my painting medium changes to Win-Gel.

The first thing I do is render the background, the table, the shadow under the plate, and the light reflection of the plate on the table. To do this I combine yellow ochre, Venetian red, ultramarine blue, and flake white in various tonal values. Then, I brush in the plate using a mixture of ultramarine blue and flake white with a slight amount of Venetian red added where the red peel is reflected on the plate.

As you know, when the inside of an apple is exposed to air even briefly, it takes on a yellow-brown cast. This never occurs evenly, so instead of glazing, I use the sticky underpainting white as a workable base over which to scumble this color and give the effect of a browning apple in various stages. Using flat sable brushes, a 1/4" (.64 cm) and a 3/8" (.95 cm), I brush on a combination of yellow ochre, with

very little amounts of both Venetian red and ultramarine blue, which provides me with the yellowish-brown I am after. The brownest parts appear to be near the peel and the seeds. To darken these parts, I lightly brush in some of the background color with a 1/8" (.32 cm) flat sable. If it appears too pronounced, I soften it by brushing in flake white.

For the bright red parts of the apple peels, I use cadmium red light blending it well to avoid any sharp edges. For the darker, shadowy parts of the peel, I blend in ultramarine blue. The largest piece of apple has a long bright highlight near the stem. For this I use flake white and a slight amount of ultramarine blue.

The seeds and stem are a mixture of ultramarine blue, Venetian red, and yellow ochre. I accentuate the stem with flake white, both to indicate highlights and to make it stand out. I allow this stage to dry completely.

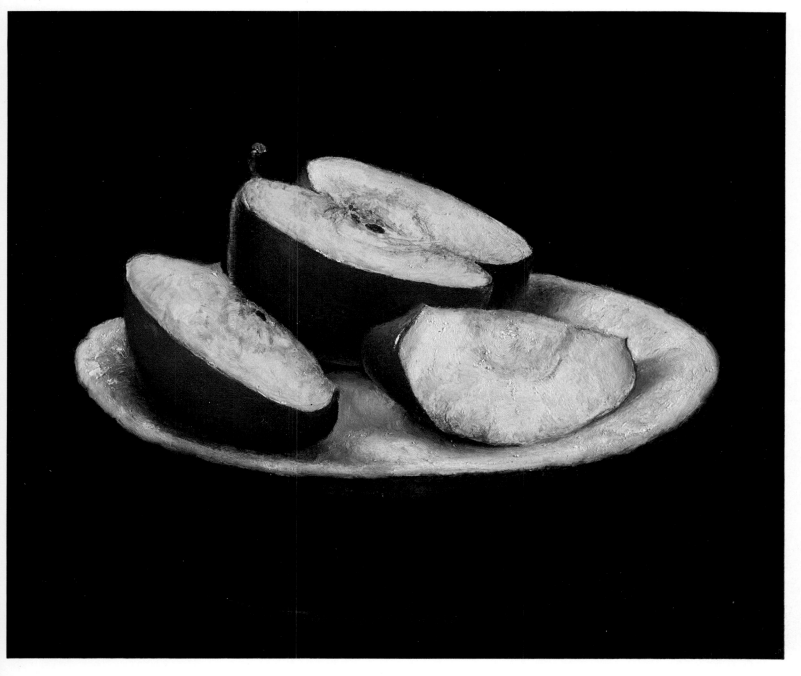

Stage 4. Raw umber, burnt umber cadmium yellow light, and raw sienna are added to my palette. I use two painting mediums—Win-Gel and Liquin. In this entire stage I only use sable brushes of various sizes, a #2 watercolor, a 1/8″ (.32 cm), a 1/4″ (.64 cm), a 3/8″ (.95 cm), and a 1/2″ (1.3 cm).

This is one of those demonstrations where only subtle changes appear in the final stage. Even though they may seem minor, these subtleties add the finishing touches that will render a more realistic painting of apples.

I brush in the background and the shadow under the plate using a combination of ultramarine blue and raw umber. Burnt umber is then glazed into the foreground, allowing a bit of the plate reflection to show through. The plate is finished off with flake white blended with small amounts of ultramarine blue and raw umber.

For the interior, I strengthen the brown portions with raw sienna. Also, tinges of green appear in the apple interior and for this I mix cadmium yellow light and ultramarine blue. The addition of the green is most easily seen in the two slices in the foreground.

The basic colors of the peels should be strengthened. I blend everything together thoroughly and add the final subtle touches. In the medium red areas I use cadmium red light, and the large bright red areas are cadmium red light mixed with a little yellow ochre and cadmium yellow. All the darkest areas are raw umber and ultramarine blue brushed back and forth into the cadmium red light. Sometimes a greenish cast appears on parts of the peel. Where this happens, such as on the upper peel of the right slice, I dab on the green mixture I used in the interior. Finally, I use flake white to dab on the brightest highlights and for the long vertical highlight on the apple half.

Boy Eating Grapes, *oil on canvas, 15 1/2" x 19" (39.4 cm x 48.3 cm), collection of Mr. and Mrs. Phil Dunklin. The grapes here are a little pinker than the red ones in the next demonstration. While red grapes seem to vary in color, green ones remain pretty much the same. The red grapes (which are not red but more of a purple) allowed me a little more poetic license in altering their color to harmonize with their surroundings.*

DEMONSTRATION 17

GRAPES

The main difficulty in painting grapes is to render their semi-translucent coating, which gives them the appearance of being moist when they are not. When rendering fruit it is important to achieve a natural look as opposed to a plastic or artificial appearance.

Palette
Ultramarine blue
Venetian red
Alizarin crimson
Cadmium red deep
Sap green
Lemon yellow
Yellow ochre
Burnt sienna
Burnt umber
Raw umber
Paynes gray
Flake white

Color mixtures
1. Ultramarine blue and lemon yellow are mixed to draw the outline of and fill in the green grapes.
2. Ultramarine blue and alizarin crimson are blended to draw the outline of the purple grapes.
3. The green mixture and the purple mixture combine to create a brownish cast for the purple grapes.
4. Paynes gray, yellow ochre, and Venetian red are combined for the table color.
5. Flake white, Paynes gray, and the table color (mixture no. 4) are used for the plate.
6. Cadmium red deep, ultramarine blue, and flake white create the basic purple grape color.
7. Flake white and the basic green color are combined for the lighter portions of the green grapes.
8. Raw umber and ultramarine blue are mixed for the background.
9. Raw umber, ultramarine blue, and burnt umber are combined for the foreground.
10. The background color, foreground color, and flake white are mixed for the plate.
11. Sap green and flake white form the glaze over the green grapes.
12. Cadmium red deep and ultramarine blue create the purple reflections and are used as a glaze over the purple grapes.
13. Sap green, flake white, and burnt umber are mixed for the stem of the green grapes.

Brushes
This entire demonstration is rendered with sable brushes due to the smooth surface and small details of the grapes.

 1/16″ (.16 cm) flat sable
 1/8″ (.32 cm) flat sable
 1/4″ (.64 cm) flat sable
 3/8″ (.95 cm) flat sable
 1/2″ (1.3 cm) flat sable
 #2 round watercolor brush with fine point

Painting Surface
I work on a gessoed Masonite panel because it will help me best convey the smooth texture of the grapes.

Painting Tips
Since the shapes of most grapes look very similar, I strongly advise that you select and set up the grapes so that the bunches form esthetically attractive designs. A pleasing and interesting composition is a necessity for a still life; you can then concentrate on the rendering of the individual grapes.

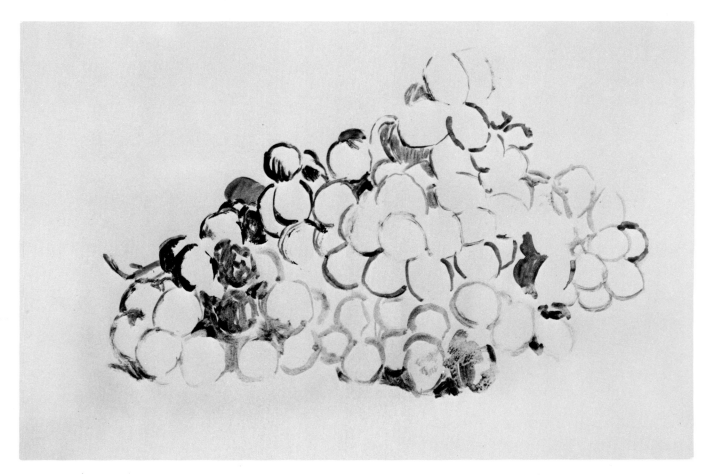

Stage 1. My palette is ultramarine blue, alizarin crimson, and lemon yellow. I use two flat sable brushes, a 1/4″ (.64 cm) and a 1/8″ (.32 cm). Turpentine is my painting medium.

In this stage I draw the outlines of the grapes and their respective colors. Also, I brush in the stem which extends to the left of the purple grapes and place a few of the major shadows under the grapes.

To render the shapes of the green grapes I mix ultramarine blue and lemon yellow together. For the purple grapes, I blend ultramarine blue and alizarin crimson. I add a little more blue for the areas of shadow and deeper purple. This shadow mixture is used for those areas within the two bunches where some grapes appear to be in deep shadow. I brush in the shape of the stem to the left with both my green and purple mixtures. I immediately move on to Stage 2 while this is wet.

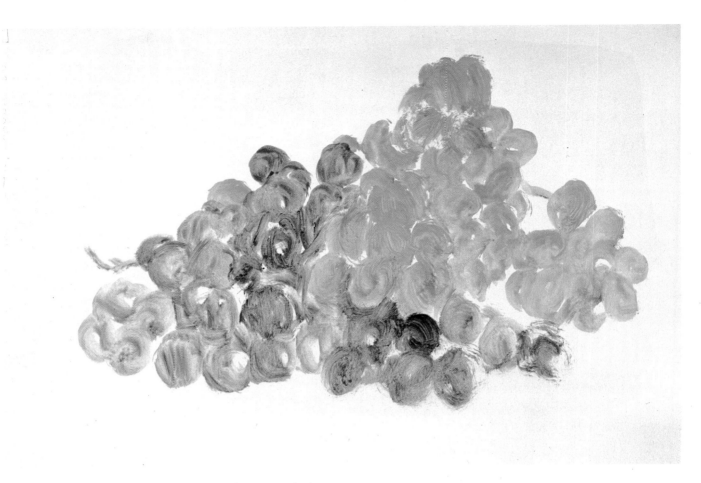

Stage 2. My palette remains the same as does my painting medium. I work with a 1/4″ (.64 cm) flat sable brush.

Basically all I do in this stage is fill in the grapes I have already outlined. Since the color of the green grapes remains fairly constant, I simply brush in the same green mixture created in Stage 1.

The tones of the purple grapes vary slightly so I have to render them a little differently. For some of the purple grapes I use the original mixture adding more red or blue to create subtle variations. Some of the grapes appear to be somewhat brownish, and for this effect I combine a little of the green mixture into the purple mixture. I begin Stage 3 immediately while this is still wet.

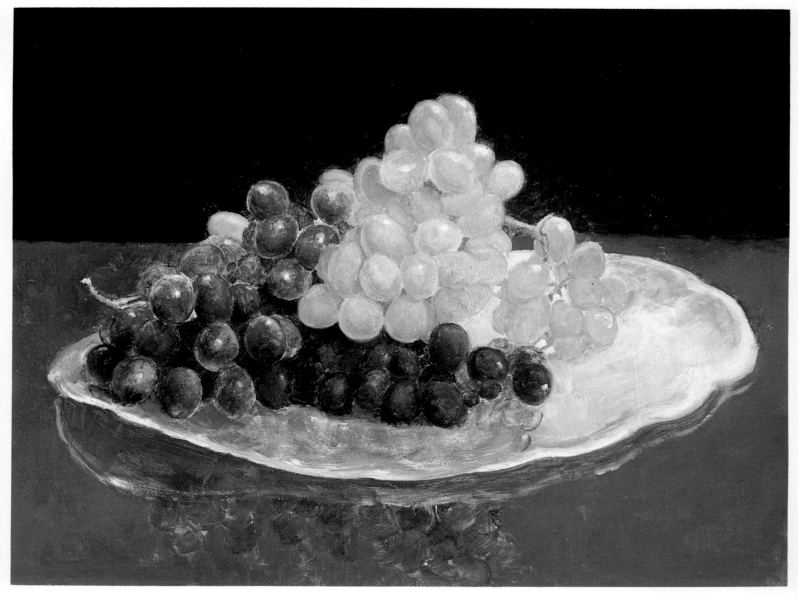

Stage 3. I now add Paynes gray, Venetian red, yellow ochre, cadmium red deep, and flake white to my palette. I work with the same brushes but my painting medium changes to Win-Gel.

The background surrounding the grapes is Paynes gray. To render the table, I mix Paynes gray, yellow ochre, and Venetian red, varying this combination slightly for interest. A little Paynes gray is used for the shadow of the plate and grapes on the table. The grape reflections on the plate are rendered with a little of the purple and green grape color where it applies. The plate is a mixture of flake white with a little Paynes gray and the table color mixed in.

For the basic purple grape color I mix cadmium red deep, ultramarine blue, and flake white. I vary the degrees of this mixture to give me the lighter and darker values needed. On some of the grapes, I dot on highlights with flake white and lightly brush in some of the green color to create the brownish cast sometimes displayed. The basic green grape color is what I use for the deeper green and shadowy areas of the green grapes. For the lighter portions I lighten this mixture with flake white and blend the lights and darks together to create roundness.

Some of the green grapes are highlighted with flake white. Also I brush the purple grape color where it is reflected in a few lower portions of the green grapes. Both the purple and green grape colors are blended and used to render the stems. I now allow this stage to dry completely.

Collection of Mr. and Mrs. R. Pinto

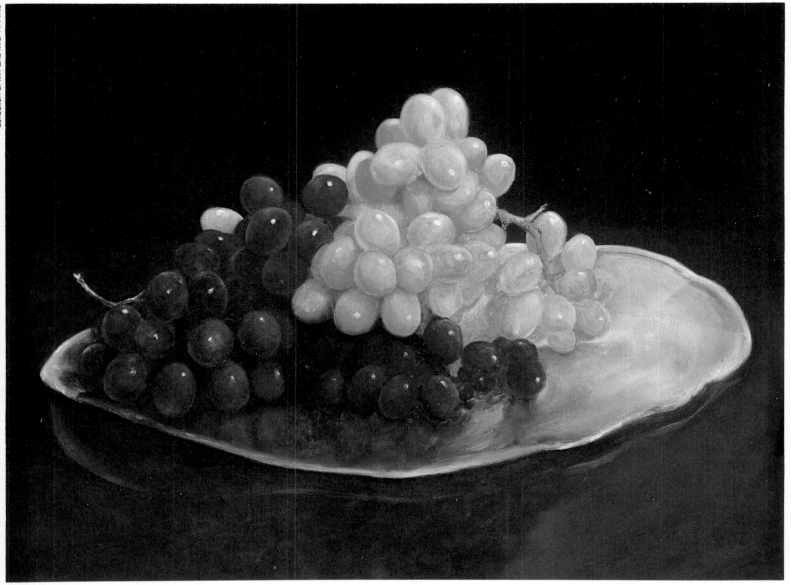

Stage 4. Burnt sienna, sap green, raw umber, and burnt umber are added to my palette. The brushes I use are a #2 watercolor and flat sables ranging in size from 1/16″ (.16) to 1/2″ (1.3) in width. The painting medium changes to Liquin.

The background is a combination of raw umber and ultramarine blue. The foreground is a mixture of burnt umber combined with a little of the background color which is then glazed over what is already there. This enables the plate and grape reflections to show through. For the plate itself, I mix several variations of the background color, the foreground color, and flake white.

To render the green grapes, I glaze sap green and flake white thinly over all the green grapes. I add more sap green in the darker areas and more flake white in the lighter areas and then blend all this together to create the form and roundness of the grapes. Some of the underpainting shows through and this helps capture more tonal variations. Cadmium red deep and ultramarine blue are mixed and added very lightly to the areas where a reflected purple cast appears. Finally, I add highlights of flake white. For the stem of the green grapes on the right, I use sap green, flake white, and burnt umber.

For the purple grapes, I thinly glaze over these grapes with cadmium red deep and ultramarine blue occasionally adding burnt sienna. Here again, this allows the underpainting to show through which enhances the variations of tone. I also add more variations so that some of the grapes are redder and some a deeper purple. To help capture the roundness, I brush on flake white. The darkest areas where the grapes disappear into shadow are the background color. Finally, I dot on highlights of flake white. Burnt umber and flake white are used for the final rendering of the stem on the left.

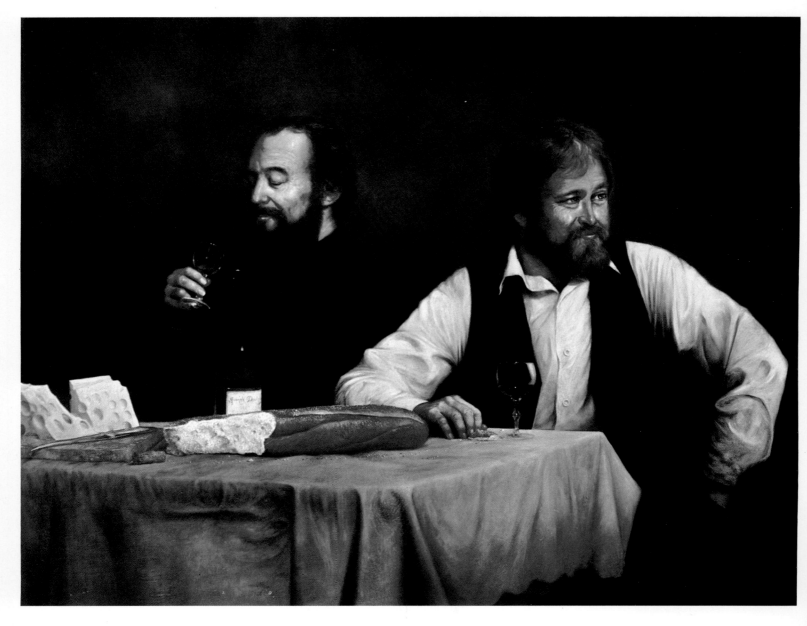

Happy Days, *oil on canvas, 45" x 60" (114.3 cm x 152.4 cm), collection of Mr. Roy Thorpe. The interior of bread is rendered similarly to that of the watermelon; I use a stippling effect to show the texture of both foods. I painted the smooth texture of the Swiss cheese in the same manner as the green rind of the watermelon.*

DEMONSTRATION 18

WATERMELON

Like the apple, the biggest problem with the watermelon is not its skin but its interior. It is pithy and full of glistening moisture, and both of these characteristics need to be fully rendered.

Palette
Ultramarine blue
Venetian red
Rose madder
Chromium oxide green
Terre verte
Raw umber
Raw sienna
Underpainting white
Flake white

Color Mixtures
1. For the white in the early stages, I mix flake white and underpainting white.
2. Venetian red and the white mixture are mixed for the initial pink-red interior color.
3. Ultramarine blue, raw umber, and white are mixed for the initial gray shadow under the melon for the rendering of the plate.
4. Raw umber and ultramarine blue are mixed for the beginning and later stages of the background, the shadow under the plate, and for the seeds' shadows on the plate in Stage 4.
5. Rose madder and the white mixture are used for the interior color.
6. Raw sienna and ultramarine blue are mixed for the brown table color.

Brushes
I use the bristle brushes for the rougher textured portions of the melon, and rely on the sables for the smoother sections and the detail areas.

 1/16″ (.16 cm) flat sable
 1/8″ (.32 cm) flat sable
 1/4″ (.64 cm) flat sable
 3/8″ (.95 cm) flat sable
 1/2″ (1.3 cm) flat sable
 1/4″ (.64 cm) naturally curved bristle
 3/8″ (.95 cm) naturally curved bristle
 #2 round watercolor brush with fine point

Painting Surface
Since the watermelon has a variety of textures, I select a canvas rather than a smooth gessoed Masonite panel to work on.

Painting Tips
I suggest that you render the watermelon first and save adding the seeds and the final glistening effects for last.

Stage 1. My palette consists of underpainting white, flake white (both of which are mixed and used for my white in this stage), Venetian red, raw umber, ultramarine blue, and terre verte. For this entire stage I use a 3/8″ (.95 cm) bristle brush and turpentine as my painting medium.

Since this is basically an underpainting stage, I intend to paint in everything very thinly. I begin by brushing in the general shapes and shadows, using approximate colors to do so. To render the large front section of watermelon, I mix Venetian red and my white mixture for the pink-red inte-

rior. I then brush in the white mixture for the white, and use the side of the brush to streak in terre verte for the green outer rind. The gray shadow under the melon is a mixture of ultramarine blue raw umber and white.

On the shadowy right side of the melon, a considerably darker combination of Venetian red and white is used. For the white rind I brush in the shadow mixture and then place a stroke of terre verte under that, letting the gray and green mix a bit since it is all in shadow. This stage is left wet as the painting progresses to the next stage.

Stage 2. Rose madder is added to my palette. I continue to use the same brush but change my painting medium to Win-Gel.

I add the plate on which the melon is sitting by brushing in several shades of the raw umber, ultramarine blue, and white mixture which is also used for the shadow beneath the melon. For the background and the shadow under the plate, I use a mixture of raw umber and ultramarine blue.

First, I concentrate on the front section of the melon. Rose madder and the white mixture are mixed and brushed in over much of the interior, simulating a more nearly accurate color of pink. I allow this to blend into the white somewhat since in reality the color change is not sharply defined.

Using terre verte, I reinforce the green outside rind, again blending softly into the white to avoid harshness. On the dark right side I leave the rind as is, but add rose madder to the interior. Before going on, I allow this stage to become tacky which requires it to sit for a couple of hours.

Stage 3. Raw sienna is the only color added to my palette. I continue to use Win-Gel as my painting medium and now use a variety of brushes which I will identify as I go along.

For the background and foreground, I use a 1/2″ (1.3 cm) flat sable brush. The black at the top of the painting and under the plate is a mixture of raw umber and ultramarine blue that is gradually blended downward into the raw sienna and ultramarine blue combination forming the table color. To smooth out the plate and shadow under the melon, I brush in flake white with a 3/8″ (.95 cm) flat sable. Since the paint is sticky, I work the white into what is already there.

Again I start with the front section of the melon. Using 3/8″ (.95 cm) and 1/4″ (.64 cm) naturally rounded bristles, I scumble pure rose madder into the pink interior. Then with the same brushes I scumble on the white mixture simulat-

ing moisture that reflects light. I work with these two colors until I feel I have captured the color variations and texture of watermelon. To maintain softness, I scumble rose madder lightly into the white rind. Using a 1/4″ (.64 cm) flat sable, I add more terre verte to the rind, blending it still further into the white than it already is. With the white mixture I paint in the white seeds. The dark seeds are painted in with raw umber using a 1/16″ (.16 cm) flat sable brush. As I paint in these seeds I am careful to get rose madder around their perimeters. This helps create the impression that they are imbedded in the interior instead of being stuck on the surface.

On the dark right side, I brush the gray shadow mixture into the interior leaving much of the red exposed. To capture the light reflections along the tops of both sides as well as on the shadowed rind, I brush in pure flake white. This stage is now left to dry completely.

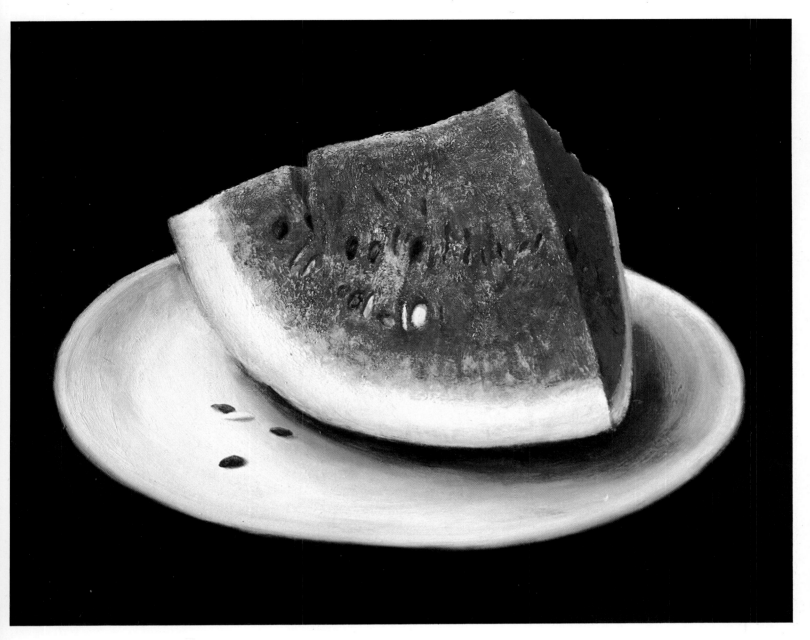

Stage 4. The only addition to my palette is chromium oxide green. Liquin is my painting medium. I use flat sable brushes exclusively in this stage, a 1/2″ (1.3 cm), a 1/4″ (.64 cm), a 3/8″ (.95 cm), and a 1/8″ (.32 cm) and a #2 watercolor brush.

To complete the background I thinly glaze raw umber over the entire area including the foreground. The plate is finished with various mixtures of raw umber, ultramarine blue, and flake white. The shadow under the melon is rendered with raw umber. I add four seeds on the plate for effect. The dark ones are rendered with raw umber and the white one is flake white. For the shadows under the seeds I use a mixture of raw umber and ultramarine blue.

To render the large interior area I begin by brushing on a thin glaze of rose madder and I cover the entire front interior area with this glaze except for the seeds. In doing so I blend the interior color into the white rind. I accentuate the empty seed holes and the shadows around the seeds with rose madder. The seeds themselves are refined with various applications of raw umber and flake white.

A lot of white appeared on the interior at the end of Stage 3. Most of this shows through the rose madder glaze I have just applied and produces the glistening effect I want. However, I accentuate this effect by adding additional flake white at the top of the slice. Along the very bottom of the rind I brush in chromium oxide green and then blend this upward into the white portion. On the shadowed right hand of the interior I also add a thin glaze of rose madder, leaving the highlighted top to glisten.

Boy with a Pear, *oil on Masonite, 25" x 30" (63 cm x 76.2 cm) collection of Mr. and Mrs. William Ahern. Here is another study in textures. In the next demonstration compare the fuzzy exterior of the peach to the pear's slick smooth surface. Notice that although the pear skin is shiny, it is not as shiny as the apple's in Demonstration 16. The interior color of the pear is a soft white and lacks the brightness of the peach.*

PEACHES

In this demonstration, both the peach skin and the peach interior present problems. The fuzz on the peach skin must be rendered while blending many bright colors together. The peach interior is moist but its texture is somewhat coarse. Also the pit has a unique bumpy surface that must be rendered accurately.

Palette

Ultramarine blue
Venetian red
Cadmium red deep
Rose madder
Yellow ochre
Cadmium yellow
Naples yellow
Raw umber
Paynes gray
Flake white
Underpainting white

Color Mixtures

1. Underpainting and flake white are mixed together for the white.
2. Yellow ochre and white are mixed for the initial peach interior and the left side of the whole peach skin.
3. Paynes gray and white are blended to use for the first shadow under the plate, peach, and background.
4. Naples yellow and white are later brushed over the peach interior.
5. Venetian red and white are blended for the pit.
6. Cadmium yellow and white is the third mixture brushed over the peach interior.
7. Cadmium red deep and white mixed together give the bumpy effect to the peach pit.
8. Venetian red and raw umber are combined for the foreground color in Stage 4.
9. Flake white, raw umber, and ultramarine blue are mixed for the plate and the peach shadows.
10. Cadmium yellow, yellow ochre, and rose madder are the final glaze over the interior.
11. Rose madder and flake white are mixed for the final glazing over the skin.

Brushes

For the smooth plate, finishing details, and background I use the sable brushes. The texture of the peaches requires the use of the bristle for the necessary underpainting.

1/8″ (.32 cm) flat sable
1/4″ (.64 cm) flat sable
3/8″ (.95 cm) flat sable
1/2″ (1.3 cm) flat sable
3/8″ (.95 cm) naturally curved bristle
#2 round watercolor brush with fine point

Surface

I select a gessoed Masonite panel for this demonstration, because its smoothness allows me absolute control in executing the subtle details of the peach.

Painting Tips

There is quite a bit of texture buildup which transpires here, so I suggest that you let the colors fall where they may, within reason, of course. This helps create and maintain a more natural appearance. Also, peaches are extremely beautiful and colorful. Select choice fruit originally, and then render the colors bold and strong.

Stage 1. My palette consists of yellow ochre, underpainting white, flake white, and cadmium red deep. I work exclusively with a 3/8″ (.95 cm) bristle brush, and turpentine is my painting medium.

In this stage I position the fruit correctly and brush in the basic colors. For the sake of clarity until everything becomes visually apparent in the final stage, the peach pit remains in the upper right half and the pitless half is on the left. Unless otherwise specified, when I refer to the interior of the peach, I am referring to both halves simultaneously. Also, when I refer to the skin, I am speaking about both the whole peach and the peach half on the left.

For my white, I mix together the underpainting white and the flake white.

To outline the peaches, I mainly use yellow ochre. Yellow ochre and white are mixed together for the interior as well as for the pale left side of the whole peach skin. The dark right side of the whole peach is yellow ochre which is roughly blended into the pale left side. The skin of the peach half on the left is also rendered with yellow ochre.

Into the center of the interior where the pit and hole are, I brush in cadmium red deep. Short strokes of cadmium red deep are also brushed into the peach skins on the lower left and right. While this stage is wet, I advance to Stage 2.

Stage 2. The colors added to my palette are Paynes gray, Naples yellow, and Venetian red. I continue to use the 3/8" (.95 cm) bristle brush, but change my painting medium to Win-Gel.

To begin, I brush in the shape of the plate and fill in the surface with the white mixture. The shadow under the plate, the peach shadows on its surface, and the background are all a mixture of Paynes gray and white. Naples yellow and white are mixed and brushed over the peach interior.

The pitless half on the left remains as is, but the pit on the right is brushed in with a mixture of Venetian red and white.

I brush cadmium red deep into the skin on the right and lower left blending it slightly where necessary. On the whole peach skin, I add pure Paynes gray on the right tip where there is a very dark area. This is blended lightly into the red. Before going further I allow this to dry a couple of hours until it becomes tacky.

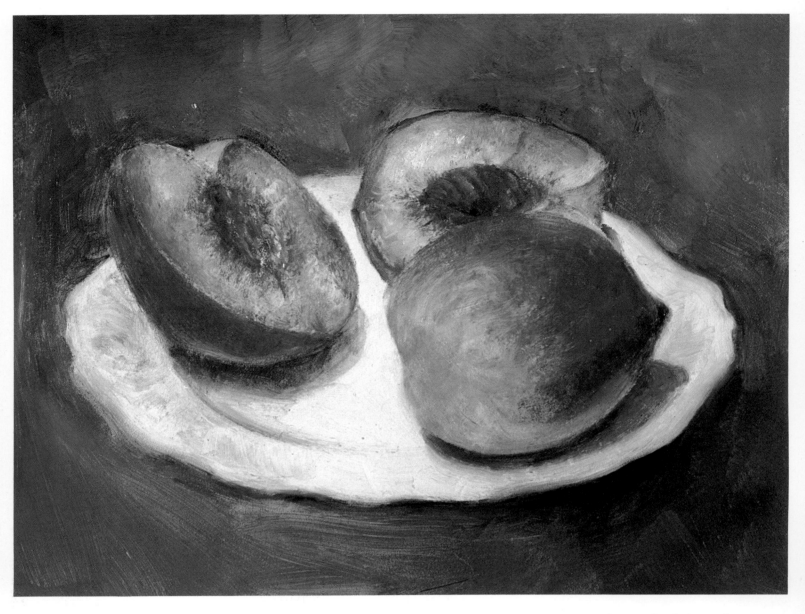

Stage 3. I add cadmium yellow and rose madder to my palette. Win-Gel continues to be my painting medium. In addition to the bristle brush, I also use flat sables ranging in size from 1/2″ (1.3 cm) to 1/8″ (.32 cm) for the purpose of smoothing out the background, plate, and shadows. The bristle brush is used to help build up the texture on the peaches.

Paynes gray and white are mixed to complete the background, to render the shadows under the fruit, and to give form to the plate. Pure Paynes gray is used under the plate for the shadow cast there. I mix cadmium yellow and white together and brush this over the surface of the interior. The peach interior has a tendency to be brownish in areas, so for these brown areas I add yellow ochre.

For the peach pit I render the shape more carefully with Venetian red and then streak in a mixture of cadmium red and white to indicate the bumpy surface. The shape of the hole on the left half is more accurately captured with rose madder and white on the right side. On the far left side where it is shadowed, I work in a little of the gray shadow color. Most peaches have little red striations around the pit, and with a 1/8″ (.32 cm) brush, I streak rose madder into the interior area surrounding the pit on both halves.

On the skin, I use all the colors on my palette. As I apply them I smooth out the surface and blend the colors so they flow into each other. Because of the tacky underpainting I am able to give the skin a textured appearance. To help maintain this texture I find it helpful to lightly streak some of the red color into the lighter portions of the skin in much the same manner as I rendered the striations around the hole and the pit. I allow this stage to dry completely.

Collection of Mr. and Mrs. I. Warner

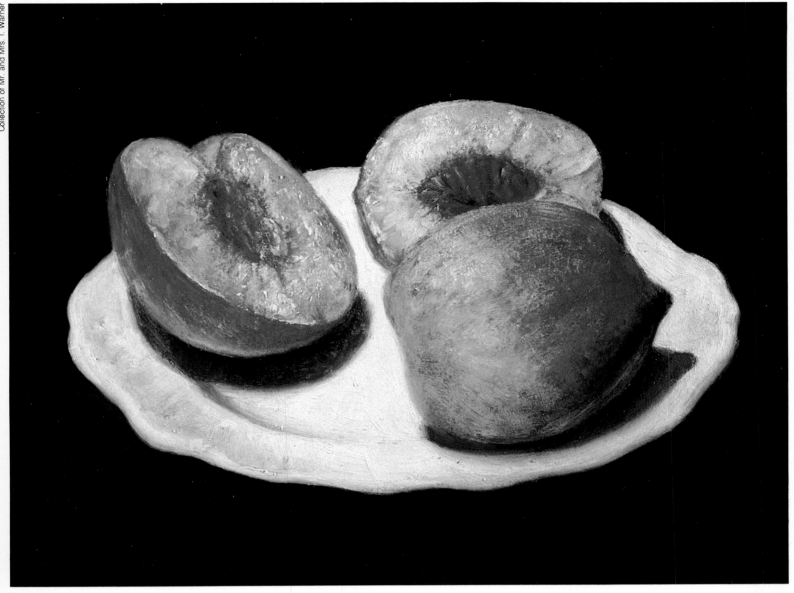

Stage 4. Raw umber, ultramarine blue, rose madder, and cadmium yellow are all added to my palette. Liquin is my painting medium. I use flat sable brushes, a 1/8″ (.32 cm), a 1/4″ (.64 cm), a 3/8″ (.95 cm) and a 1/2″ (1.3 cm) as well as a #2 watercolor brush.

To complete the background I brush on raw umber. The foreground is a combination of Venetian red and raw umber. These two areas are carefully blended into each other so that the change in color appears very gradually. The final rendering of the plate is done with flake white, raw umber, and ultramarine blue. Use less white for the darker versions of these three colors which are used on the plate for the shadows being cast by the peaches.

For the peaches, I basically emphasize what has already been done in Stage 3 and add subtle touches. I mix cadmium yellow, yellow ochre, and rose madder to create an orange-yellow color which I glaze over the interior. Where necessary I reemphasize the brown portions with yellow ochre. The pink striations radiating out from the peach pit and hole are strengthened with rose madder. Flake white is lightly dabbed over the interior and brushed thinly along the edge of the skin in order to render the glistening moisture and highlights.

The red in the skins was a little too intense, so I tone this down by glazing over it with rose madder and flake white. Also, I brush this glaze into the other areas of the interior to tie together the color variations more accurately to produce a truer rendition of peach skin.

Old Man with a Book of Etchings, *oil on canvas, 22" x 27" (56 cm x 69 cm), collection of Mr. and Mrs. Morton Goldman. A study in light, this painting contrasts with the next demonstration because it shows natural light as opposed to light from a fireplace. None of the fire's brilliant orange or yellow highlights appear, but a more gradual light to dark pattern is evident. The face and hands, the book, the curtains, and window sill are all flooded with light; the chair is darker because it's farther from the light. The objects on the bookcase pick up highlights only where the light hits them.*

FIREPLACE

The main problem in this demonstration is to simultaneously render the fire as an actual part of the logs and to make it appear to glow. Also, it is important to capture the constant free movement of the roaring fire so that it contrasts with the solid stone fireplace surrounding it.

Palette
Ultramarine blue
Venetian red
Rose madder genuine
Cadmium orange
Cadmium yellow
Raw umber
Underpainting white
Cremnitz white
Ivory black

Color Mixtures
1. Raw umber, ultramarine blue, and underpainting white are mixed for use as my basic drawing color.

2. Raw umber and ultramarine blue are blended for the darkest tone.

3. I mix Venetian red and ultramarine blue for the basic color of the bricks and stones.

4. Cadmium orange and ultramarine blue mixed together create the tonal variations in the bricks and stones.

5. Ivory black and cremnitz white are combined to render the ashes on the logs.

Brushes
Bristle brushes are excellent for creating the rough-hewn texture of the fireplace. I like to use the sable brushes for the smoother flames of the fire and the watercolor brush for the fine details. Specifically they are:

1/4″ (.64 cm) flat sable
1/4″ (.64 cm) naturally curved bristle
3/8″ (.95 cm) naturally curved bristle
#2 round watercolor brush with fine point

Painting Surface
I select a smooth, untextured gesso-covered board as my painting surface, since fire has no texture or form and I ultimately want to capture its fluidity.

Painting Tips
I strongly suggest that the fire be surrounded in semi-darkness. Then accent these dark surroundings with brilliant touches of the fire's reflections. These contrasts emphasize and accentuate the brightness of a fire. If you paint a fire against pale surroundings you lose an amazing amount of its intensity and brilliance.

Stage 1. Raw umber, ultramarine blue, and underpainting white make up my palette. I use one brush—a 3/8″ (.95 cm) bristle, and turpentine is my painting medium.

In this stage, my main concern is to position the fireplace, logs, and cinder blocks so that their proportions are accurate in relation to each other. For my darkest tone, I mix raw umber and ultramarine blue. I add underpainting white to this mixture for the lighter tone which I use basically for drawing and which I refer to as my basic color.

First with the basic color I brush in the arc of the fireplace and the two sides, and use the dark color to indicate the shadowy depth of the far corners. Next, with the dark color, I paint in the bottom log with shadows, and use this as the base for establishing the relationships to the cinder blocks and upper two logs in the lower part of the painting. Then with the basic color I brush in the cinder blocks on which all the logs are resting, and also outline the upper two logs. I move on to Stage 2 while this one is wet.

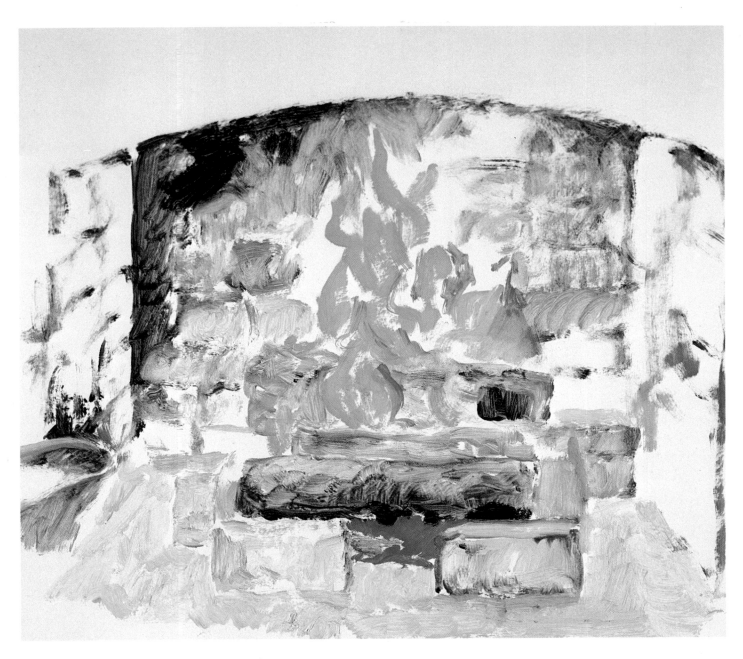

Stage 2. In this stage I continue to use the same 3/8″ (.95 cm) bristle brush, and add cadmium yellow and cadmium orange to my palette.

Using the same mixture that I used as my basic color in Stage 1, I fill in major areas of the rear brick wall and the cinder blocks under the logs. To this mixture I add more raw umber and roughly fill in the logs. The dark mixture on my palette is used for the shadowy areas such as under the logs and in the far rear recesses of the wall. I now add some more underpainting white to the basic color to brush in the ash-covered fireplace floor and lighten the cinder blocks.

Finally, I paint in the fire and its reflections by using both the cadmium orange and cadmium yellow. For the glow under the logs, I use cadmium orange alone. To render the fire, use short brushstrokes that capture the leaping free motion of the flames. Move on to the next stage while this is still wet.

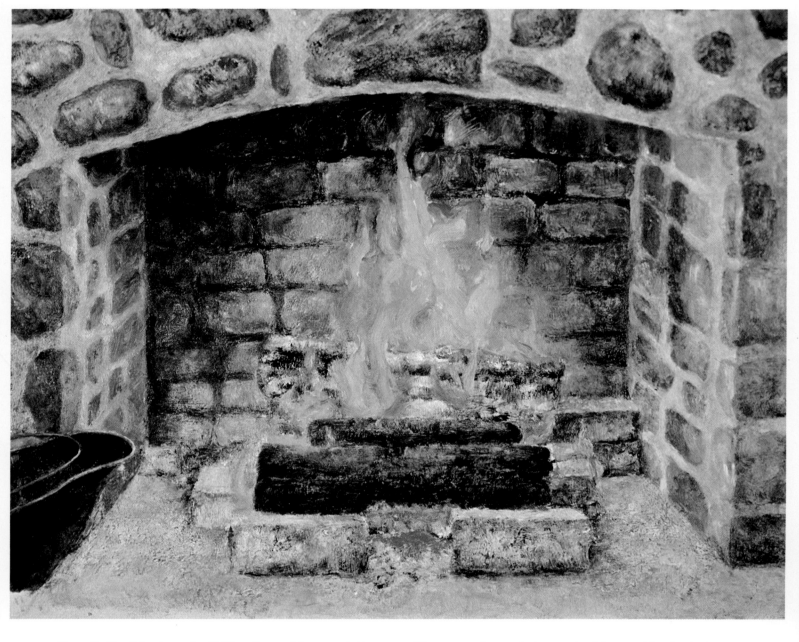

Stage 3. For this stage, I add Venetian red to my palette and include these brushes, a 1/4″ (.64 cm) sable, a 1/4″ (.64 cm) bristle, and a #2 watercolor.

Now that all the proportions and relationships have been established, I render the exterior of the fireplace. To render the bricks and stones, I use a combination of Venetian red and ultramarine blue, and then mix cadmium orange and ultramarine blue for variations in tonal values. The basic color is used to scumble in the mortar between the stones and bricks. I now let the stones on the fireplace facade become sticky and then scumble on underpainting white in some places.

The raw umber and ultramarine blue combination is for the charred rear of the fireplace and the charred portions of the cinder blocks. This mixture is also scumbled on the logs and underpainting white is used to scumble onto the portions of the logs that are turning to ash.

More cadmium yellow and cadmium orange is worked into the fire, which I render much more precisely than in the previous stage, but I am still careful to retain a loose flowing feeling. After partial drying takes place, I scumble cadmium orange on for the glowing effect under the logs, and scumble lightly onto the rear bricks and sides to represent the fire's reflection. I allow this stage to dry completely.

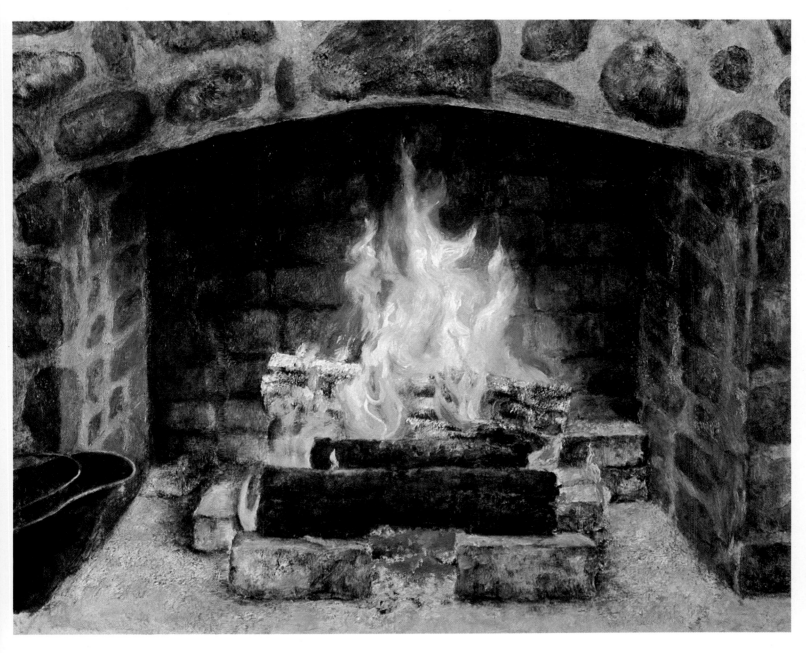

Stage 4. Cremnitz white, rose madder genuine, and ivory black are added to my palette.

The raw umber and ultramarine blue mixture is lightly glazed over the stone facade of the fireplace as well as over the bricks inside. I paint this mixture on quite heavily in the far rear behind the fire, where the heaviest charring is. Also, since a fire is somewhat translucent, I allow some of the mixture to show through in the open areas of the fire.

To strengthen the reflection on the side walls, I dab on some cadmium orange in spots, and do very little if any blending. For the reflection on the rear wall, I dab cadmium orange around the perimeter of the reflection, adding more orange along with cadmium yellow the closer I work to the flame. In this area, I do some blending, but keep it at a minimum.

I glaze raw umber onto the front two logs, and then mix ivory black and cremnitz white together and stipple this in spots all over the ashen rear log. No blending takes place while I do this. In the fire itself, I add some cremnitz white as well as strengthen the cadmium orange and cadmium yellow already there. Finally, for the glow under the log, I add a bit of rose madder genuine and spots of cadmium yellow.

SUGGESTED READING

Blake, Wendon. *Creative Color: A Practical Guide for Oil Painters*. New York: Watson-Guptill Publications, 1972. London: Pitman Publishing, 1972.

Cooke, Lester H. *Painting Techniques of the Masters*. New York: Watson-Guptill Publications, 1972. London: Pitman Publishing, 1973.

Dawley, Joseph. *Character Studies in Oil*. New York: Watson-Guptill Publications, 1972. London: Pitman Publishing, 1973.

————. *The Painter's Problem Book*. New York: Watson-Guptill Publications, 1973. London: Pitman Publishing, 1973.

Massey, Robert. *Formulas for Painters*. New York: Watson-Guptill Publications, 1967. London: Batsford, 1968.

Mayer, Ralph. *Artist's Handbook of Materials and Techniques*. New York: Viking Press, 1970. London: Faber and Faber, 1964.

Taubes, Frederic. *The Painter's Dictionary of Materials and Methods*. New York: Watson-Guptill Publications, 1971.

INDEX

Adjusting the Pendulum, 38
Alizarin crimson, 14
Apples demonstration, 111-115

Boy Eating Grapes, 116
Boy with a Pear, 128
Brass Umbrella Stand demonstration, 27-31
Breaking Bread, 18
Brights, 16
Bristles, 16
Brushes, types of, 15, 16
Brush holders, 16
Burnt sienna, 14
Burnt umber, 14

Cadmium orange, 14
Cadmium red, red light, red deep, 14
Cadmium yellow, yellow light, yellow deep, 15
Canvas, 16
Cerulean blue, 14
Character Studies in Oil, 94
Check, 74
Chess Players, 62
Chromium oxide green, 15
Cleaner, for brushes, 16
The Clock Collector, 6
Colors, explanations of, 13-15
Conch Shell demonstration, 51-55
Condensation Droplets on Glass demonstration, 87-91
The Connoisseurs, 26
"Controlled accidents," 55, 75
Copal, 13

Copper Tea Kettle demonstration, 21-25
Cremnitz white, 14
Crow Maiden, 140
Crystal Bowl with Flowers demonstration, 69-73

Dabbing, 17
Damar, 13
December Years, 80
Drag, or streak, 77, 91
Dusty Lantern demonstration, 39-43

Fan brushes, 16
Fat over lean, 17
Fireplace demonstration, 135-139
First One Today, 86
Flake white, 13
Frost, how to simulate, 90, 91

Girl in Blue, 68
Girl in Green, 10
Girl Winding the Clock, 104
Girl with a Cherry, 98
Glass of Water with Ice demonstration, 81-85
Glazing, 17, 111
Grapes demonstration, 117-121

Happy Days, 122
Hardboard panels, 16
Heavy Fabric with Design demonstration, 99-103

In the Flower Shop, 12
Ivory black, 15

Lemon yellow, 15
The Letter, 50
Liquin, 13

Man with a Bottle of Wine, 92
Man with an Orange, 110
Marble demonstration, 75-79
Materials and methods, 13-17

Naples yellow, 15
#2 watercolor brush, 16

Old Man with a Book of Etchings, 134
Oleo Pasto, 13
Overpainting, 17

Paint buildup, 17
Painting mediums, 13
Painting methods, 16-17
Painting surfaces, 16
Painting the Buoy, 44
Palette and knives, 15
Paynes gray, 15
Peaches demonstration, 129-133
Peeling Paint demonstration, 45-49
Pewter demonstration, 33-37
Phthalo blue, 14
Porcelain Bowl with Design demonstration, 63-67
Pulling-pushing technique, 90

Rags, 16
Raw sienna, 14
Raw umber, 15

Removal of brush hairs, 17
Rose madder, 14
Roses demonstration, 105-109

Sap green, 15
Scumbling, 17, 49, 54, 90, 111, 126, 138
Still Life, 32
Straw Basket demonstration, 57-61
Streak, or drag, 77, 91
Surfaces, types of, 16

Terre verte, 15
Texture, building up, 52, 53; in fabric, 99, 101
Tinting, 17
Transparent yellow, 15
Turpentine, 13

Ultramarine blue, 14
Underpainting, 16
Underpainting white, 13

Varnishes, 13
Velvet Beret demonstration, 93-97
Venetian red, 14
Viridian green, 15

Watermelon demonstration, 123-127
Wet into wet, 102, 111
The Wine Drinkers, 56
The Wine Maker and the Connoisseur, 20
Win-Gel, 13

Yellow ochre, 15

Edited by Donna Wilkinson
Designed by Bob Fillie
Composed in 10/12 Century